LOST &
FOUND

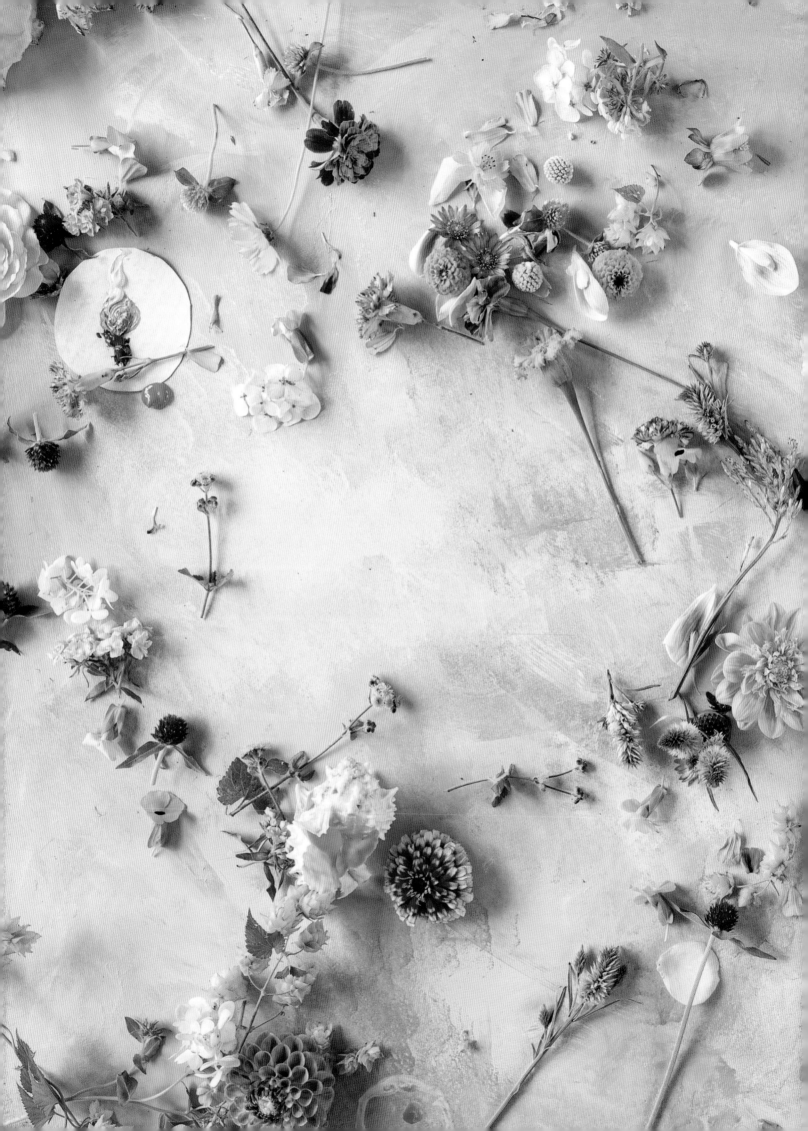

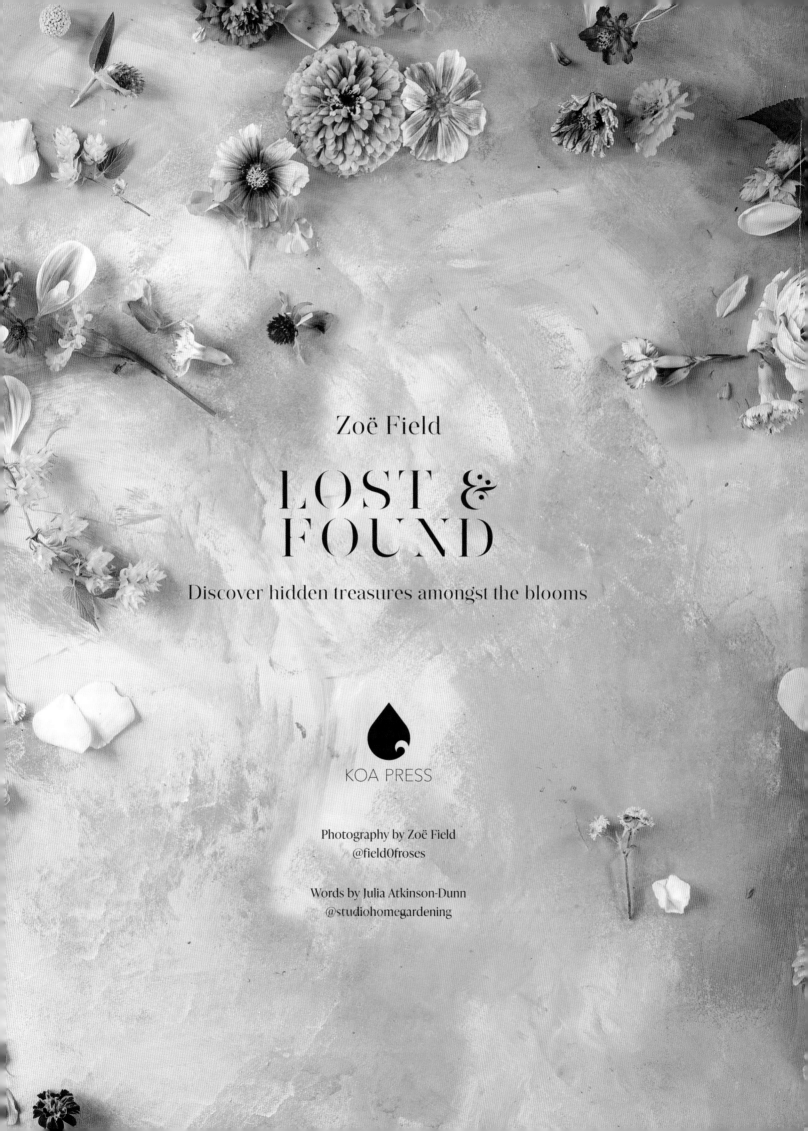

Zoë Field

LOST & FOUND

Discover hidden treasures amongst the blooms

KOA PRESS

Photography by Zoë Field
@field0froses

Words by Julia Atkinson-Dunn
@studiohomegardening

To the land ...
my teacher, provider and greatest inspiration.

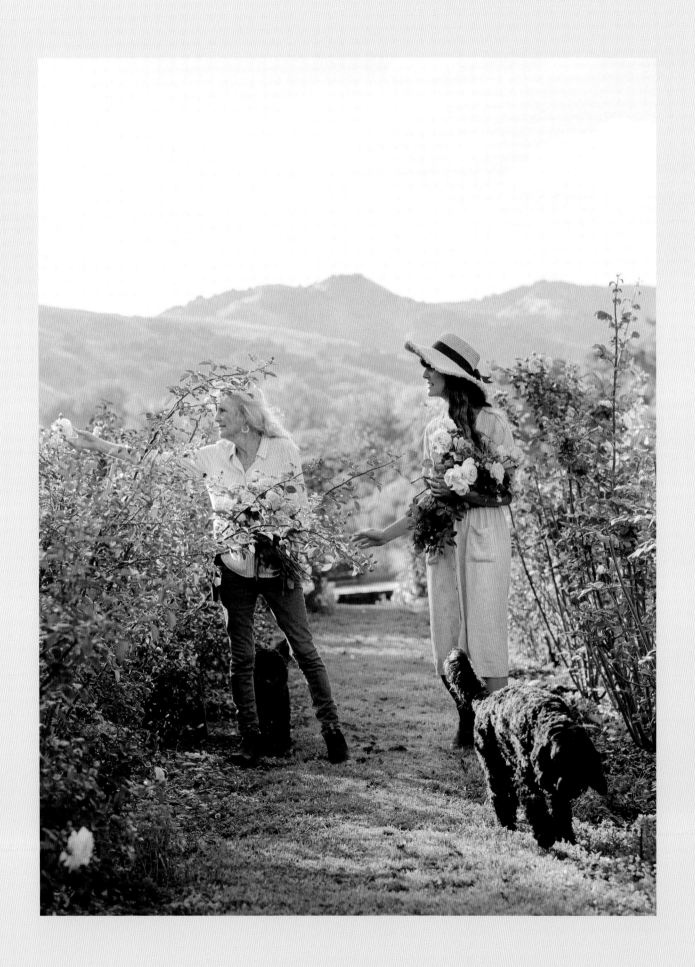

Late season in the rose field, with towering shoots and armfuls of roses still to be enjoyed.

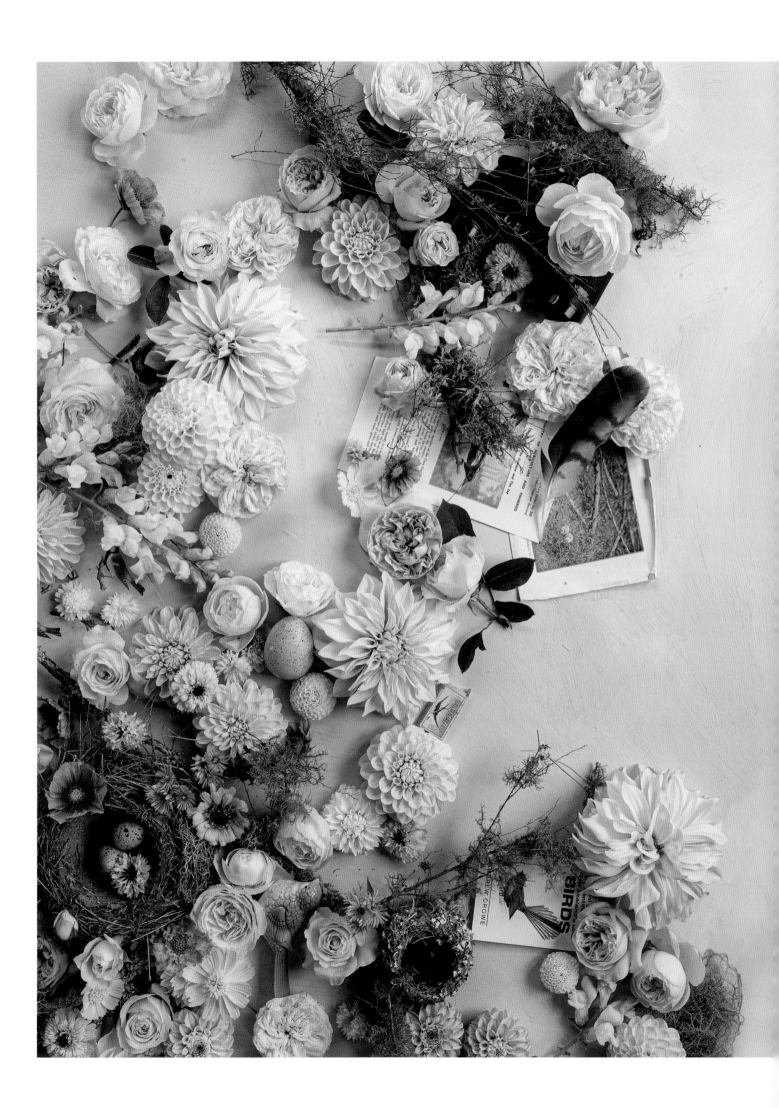

CONTENTS

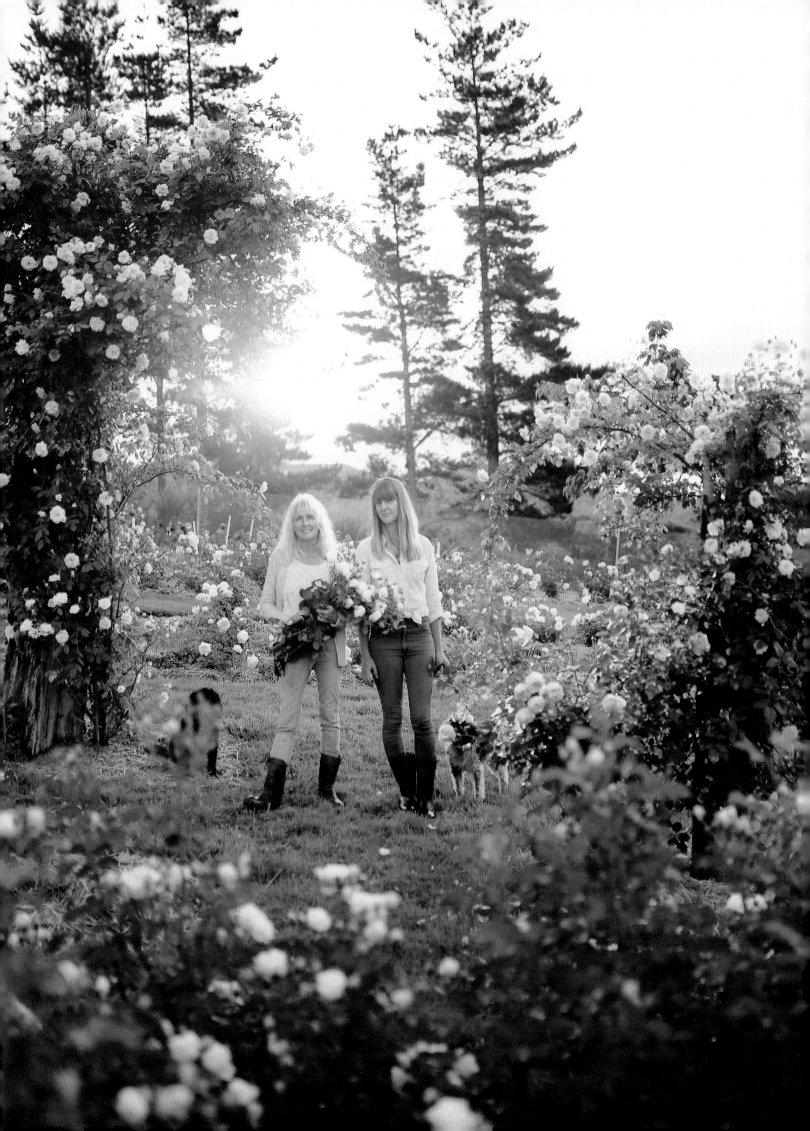

INTRODUCTION

I have this faint memory of visiting a flower farm on a school trip as a child. While I don't necessarily remember the flowers as such, it was the planting of the idea that if I wanted, I could create a living and a life out of something of such beauty.

Flowers wove their way through my story, from barefoot adventures in mum's garden to daisy chains threaded during school lunch breaks. I gardened all throughout my teen years – Mum would tend to her vegetables and I would fill the spaces with brightly coloured blooms. I experimented with beds of ranunculus and anemones, squealing with delight come spring as the beds burst into life after the long winter months. Fresh out of school, my first job was picking sweet pea seeds. Soon I got a job working at two local flower farms – one being the very farm I had visited as a child. From there I studied floristry, returning to work at a local florist store. I was so painfully shy; my hands would shake and I would trip over my words talking to customers. Yet when I worked with flowers I entered into a meditative state; in a way those blooms became my voice. Through them, I was able to connect with people, the flowers slowly helping to bring down my walls.

I saved up my first pay cheques and invested in a DSLR camera. After working all week, I'd happily spend my weekends photographing arrangements I'd created. I lived and breathed flowers; they were my lifeline.

Fast-forward to mum and I at a table strewn with paper, hand-drawn lines tracing out our field plans for rows of garden roses in every shade of yellow, orange, peach, red, white, pink and coral. Rose books, the pages of our favourite varieties dog-eared, were never far from reach. A nervous excitement bubbled at the endless possibilities that awaited us and soon after, a field of roses was born.

Our field expanded to include a vast variety of annuals and perennials: each season a new idea would be planted and grown. At first, we focused on supplying the flower markets, then selling directly to florists. As the project grew, we found ourselves diving into workshops, with international florists flying in to our remote farm to host three-day flower events. I dove back into my floristry, which I'd put on hold, enjoying flowering for local weddings. All the while, my camera continued to document the ride.

This book represents another season of growth. A combination of my love of photography, and a celebration of the beauty of flowers and the healing meditative peace that flowers give to a restless spirit.

While this book is about finding hidden objects amongst the blooms, it also offers a moment to slow down and really take in each image. I encourage you to identify your favourite flowers, inspiring colour combos, and interesting forms. Let your eyes wander as if walking the paths of a garden, finding treasures in every season and the smallest of details.

I hope this book offers a little respite from your day-to-day – a visual delight that takes your imagination on a journey.

Zoë x

Photo by Mandi Nelson

Mum and me, in amongst our field of roses.

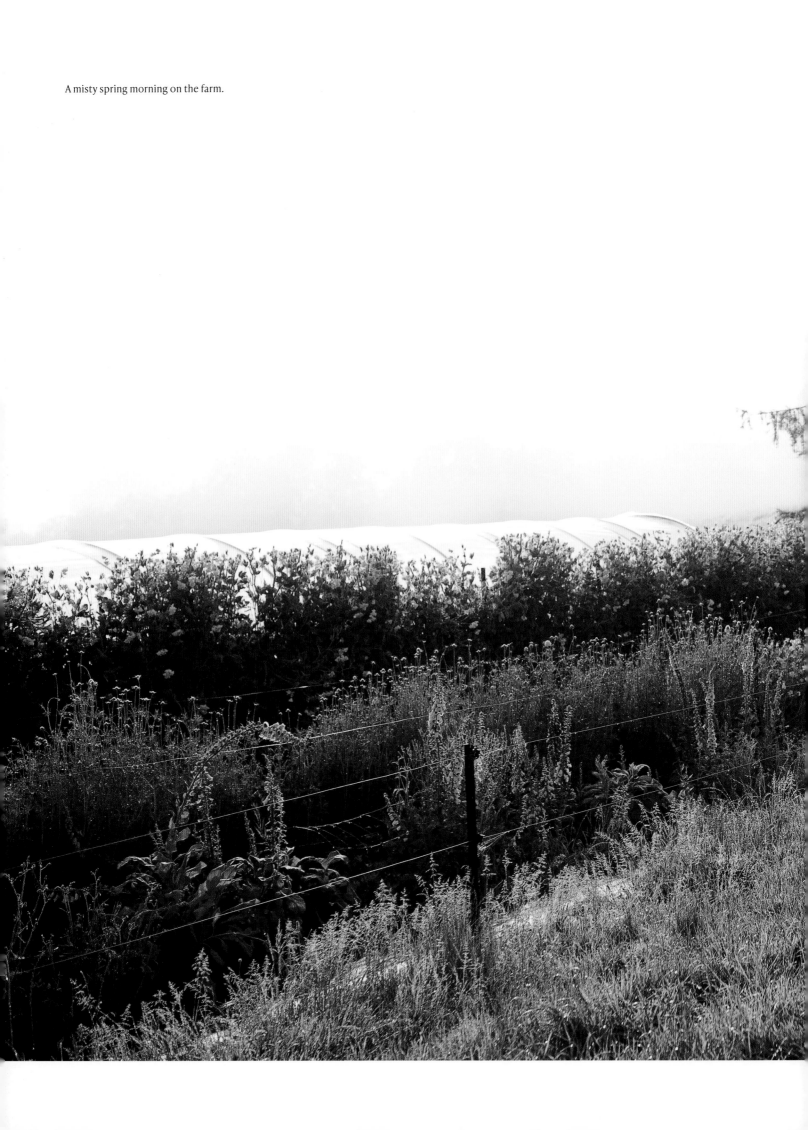

A misty spring morning on the farm.

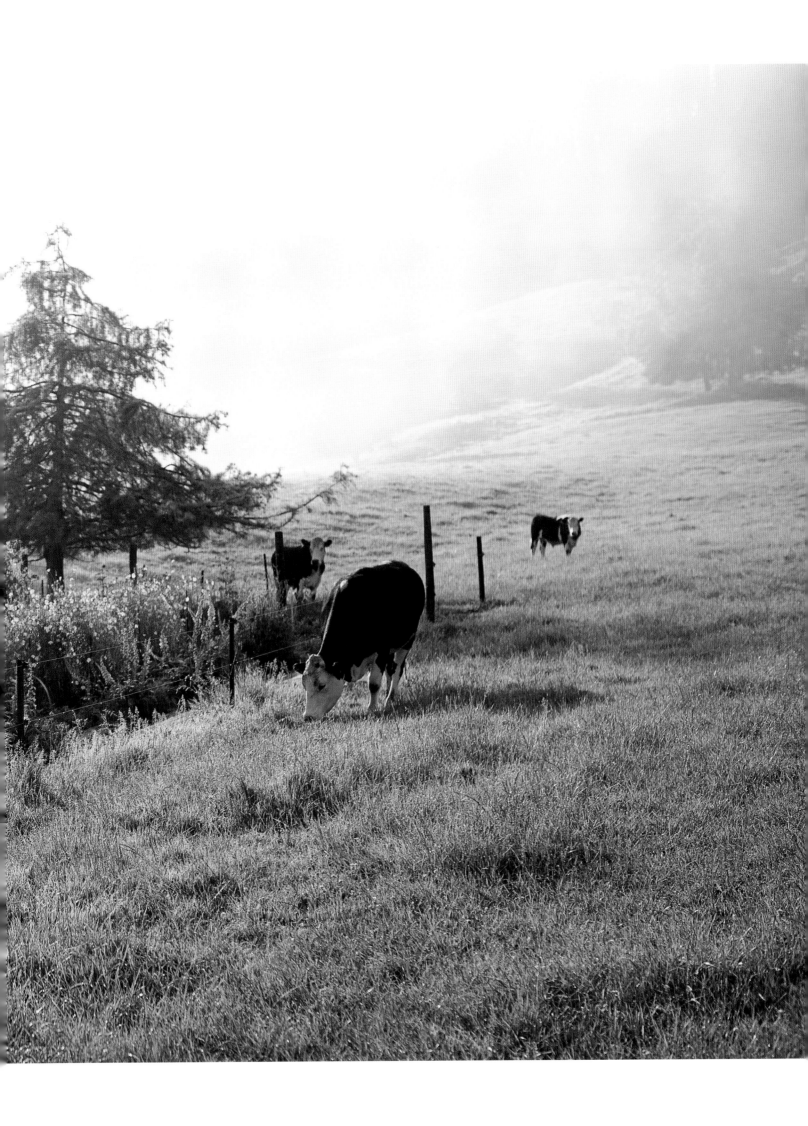

—THE—
FLOWER FARMER

In my wildest dreams, I couldn't have imagined this ranunculus to be as heavenly as it has turned out to be. Last year, I spent weeks of research tracking down the corms to trial, tipped off by a florist who had spotted the variety in a magazine. And here now, in all its impossibly ruffled splendour, a single stem – the deep crimson centre fading to delicate hints of mauve as the colour moves through its petaled skirt. I pop it gently into the bucket with many others, and decide I will keep this one just for me, to bring a daily smile from the window sill above the sink.

My buckets are filling as quickly as the morning dew evaporates. I love this quiet time at the start of the day, moving through my bustling rows of blooms, which are already alight with the hum of bees. I remember the months of bed preparation, the careful sowing of seeds in the glasshouse before the eventual planting out of seedlings. The hundreds of bulbs planted deep into the earth in autumn, now coming to beautiful fruition in the warmth of spring. The visual rewards more than make up for the hard physical labour.

After processing the morning's harvest, stripping off unneeded foliage and filtering out flowers that have passed their best, I settle for a cup of tea on the stoop of my shed. The energetic warmth of the fresh spring sun fills me with good feeling. I can hear the crunch of gravel as the florist pulls her car up the drive, the first of many collections of my farm-grown goods today. A day I know I will happily repeat for months on end.

— TURN THE PAGE TO SEEK & FIND —

1. A PAIR OF MUDDY GLOVES 2. A PIECE OF TWINE KNOTTED THREE TIMES
3. TWO KNIVES 4. A SPILLED SEED PACKET 5. FOUR DROPS OF DEW
6. NINE RUBBER BANDS 7. BROKEN SNIPS 8. A WORN-OUT LABEL
9. A WOODEN TAG FROM A DATE LONG PASSED 10. THE WORDS 'NEXT TIME'

Answers on page 162

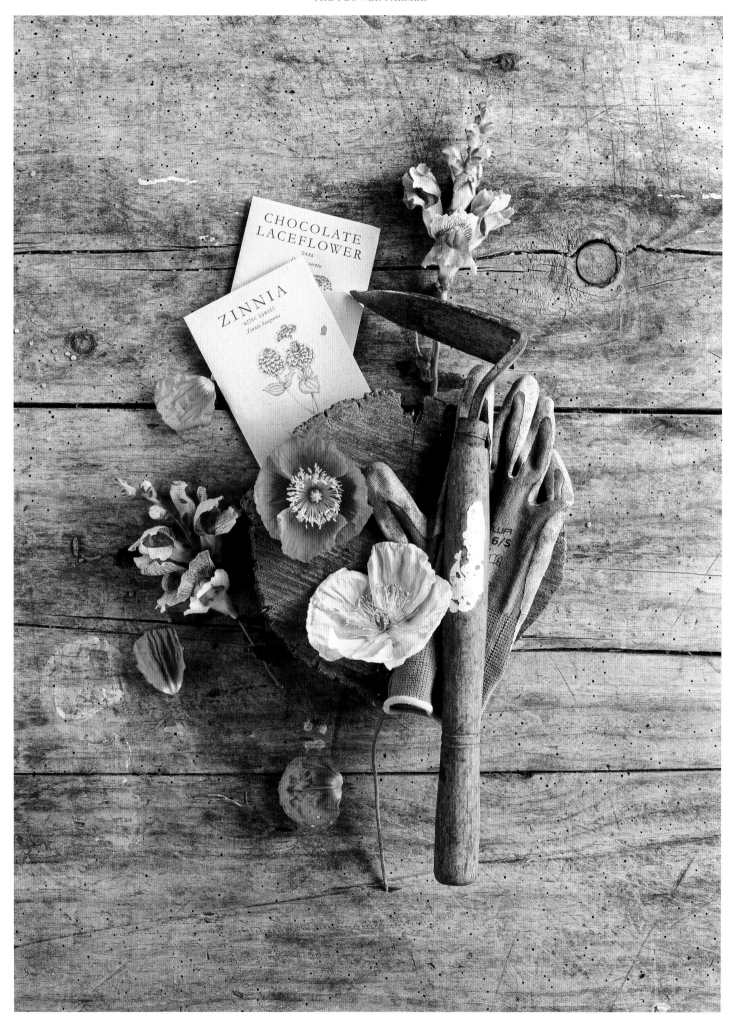

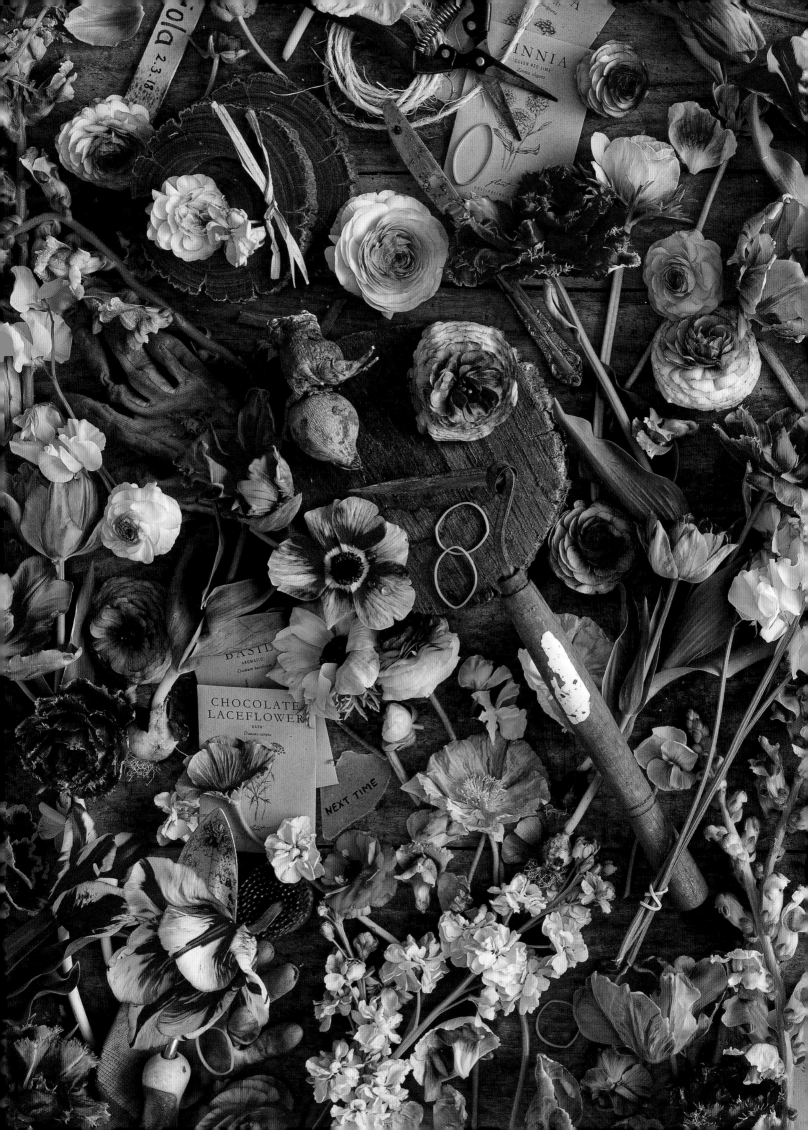

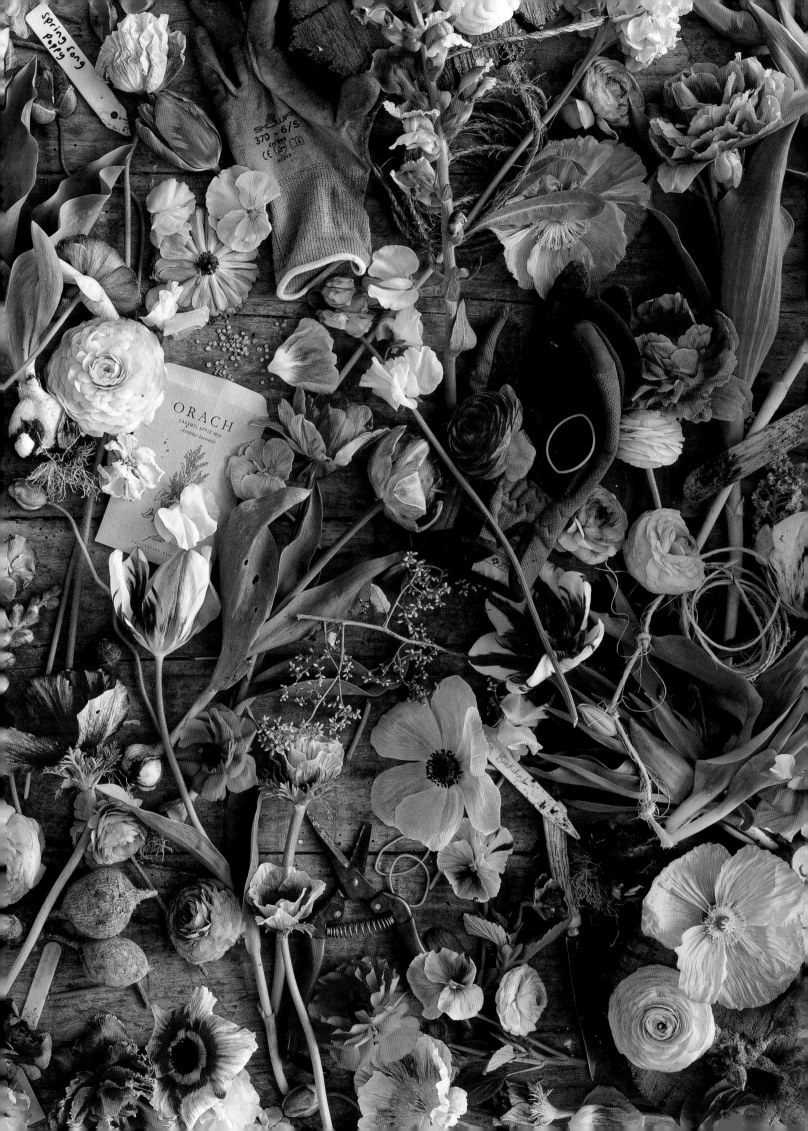

"

I remember the months of bed preparation, the careful sowing of seeds in the glasshouse before the eventual planting out of seedlings. The hundreds of bulbs planted deep into the earth in autumn, now coming to beautiful fruition in the warmth of spring.

"

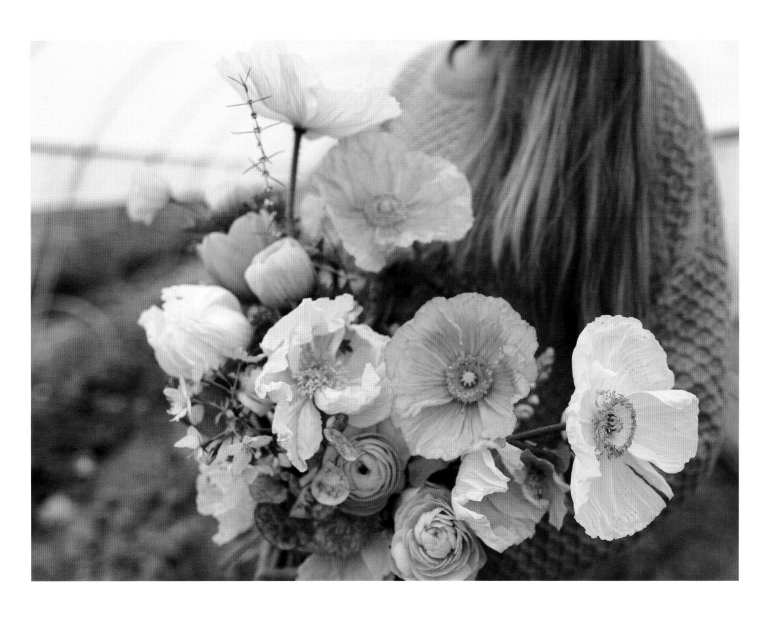

A simple spring bouquet of giant Colibri poppies, anemones and ranunculus.

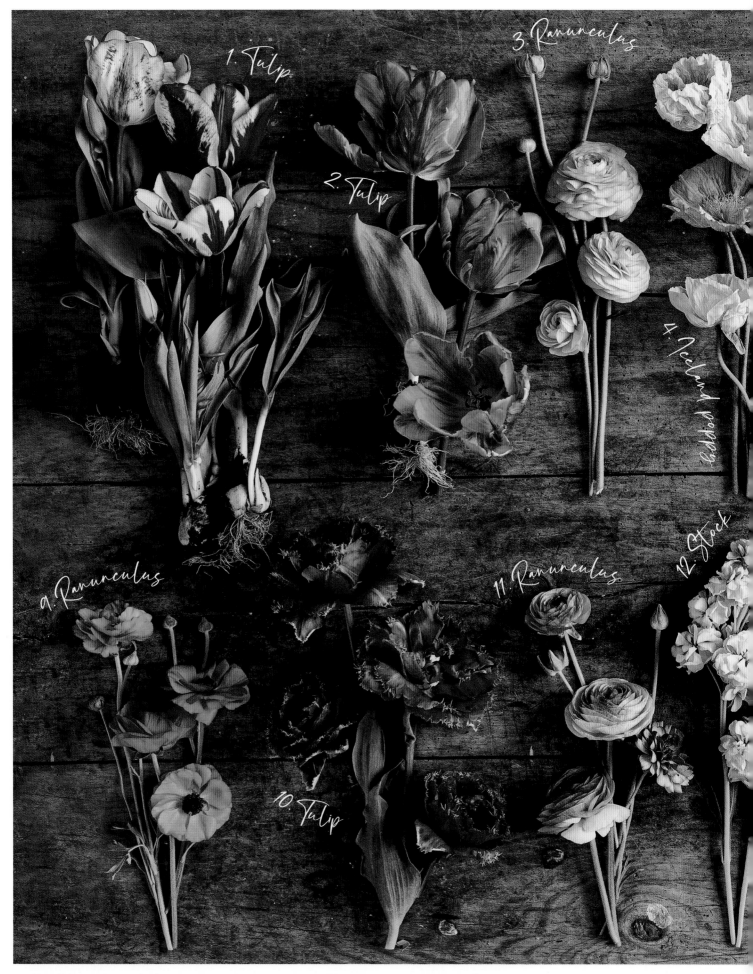

1. *Tulip*

2. *Tulip*

3. *Ranunculus*

4. *Iceland poppy*

9. *Ranunculus*

10. *Tulip*

11. *Ranunculus*

12. *Stock*

1. *Tulipa* 'Flaming Kiss' **2.** *Tulipa* 'Princess Irene' **3.** *Ranunculus asiaticus* 'Elegance Salmone' **4.** *Papaver nudicaule* 'Springsong' **5.** *Tulipa* 'Pretty Princess'
6. *Antirrhinum majus* 'Tetra Ruffled Giants Mix' **7.** *Lathyrus odoratus* 'Piggy Sue' **8.** *Tulipa* 'Orange Princess' **9.** *Ranunculus asiaticus* Orange **10.** *Tulipa* 'Mascotte'

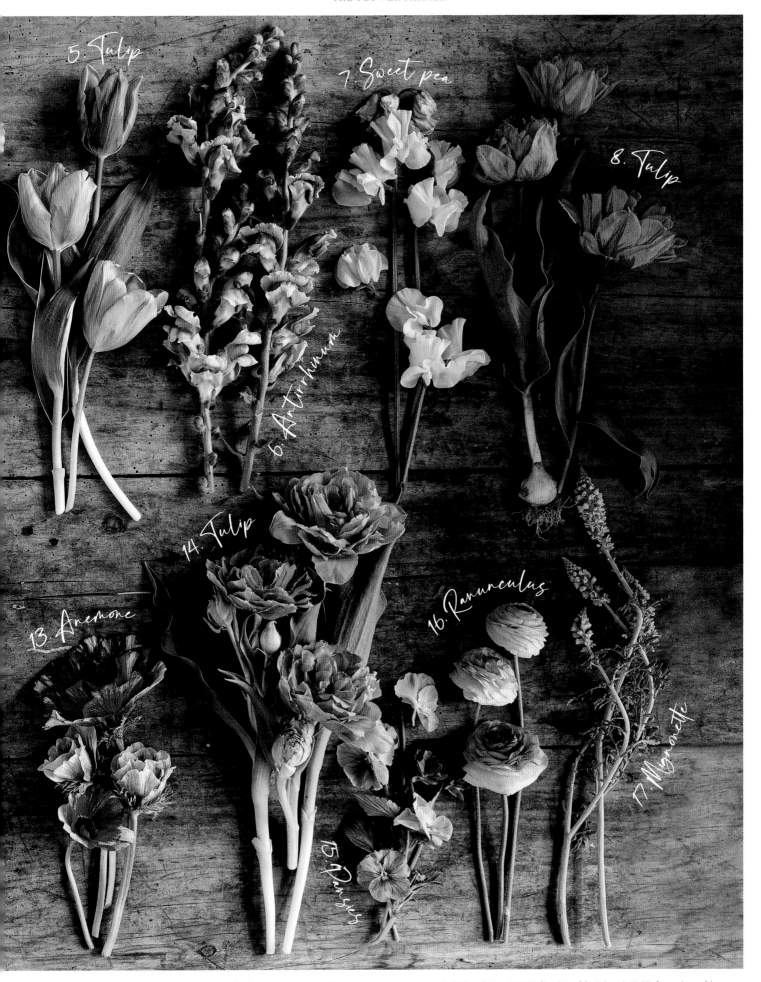

5. Tulip
7. Sweet pea
8. Tulip
6. Antirrhinum
14. Tulip
13. Anemone
16. Ranunculus
17. Mignonette
15. Pansies

11. *Ranunculus asiaticus* 'Purple Jean' **12.** *Matthiola incana* 'Katz Apricot' **13.** *Anemone coronaria* 'Mistral Tigre' **14.** *Tulipa* 'Double Prince' **15.** *Viola x wittrockiana* 'Antique Shades' **16.** *Ranunculus asiaticus* 'La Belle' **17.** *Reseda alba* White Mignonette

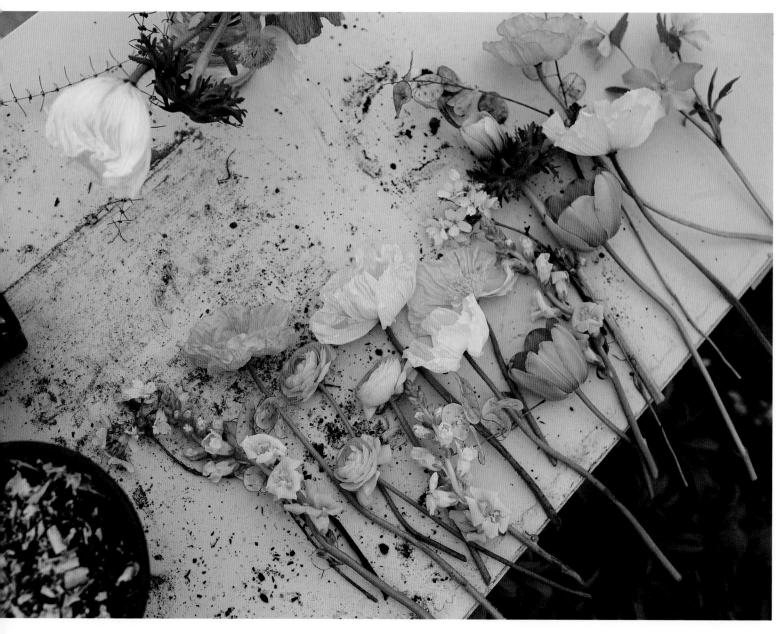

Opposite: Spring bouquet ingredients laid out ready for arranging. Light pink chantilly snapdragons, Colibri poppies, salmon ranunculus, tulips, anemones and hellebores. **Below:** First spring pickings of the season including 'Springsong' poppies, stock, daffodils, 'Purple Jean' and 'La Belle' ranunculus.

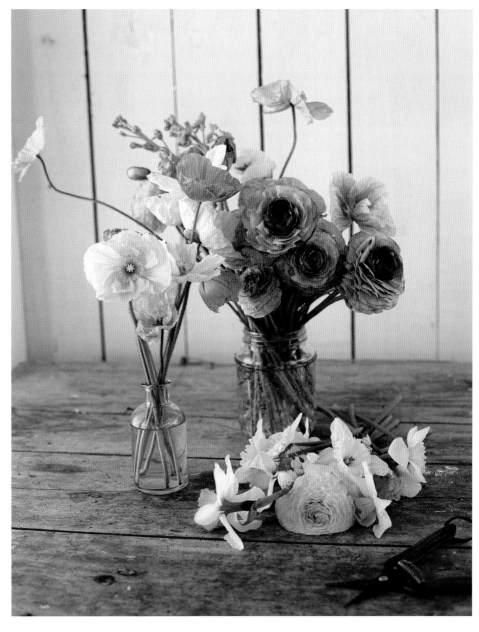

—THE—
WRITER

It was pine needles and the roaring nor' west wind of my childhood that first forced me to write. I felt a need to put into words the feelings, sights and imagined worlds found in the summer afternoons spent at the tree hut. The realms built in my head where the dry grass of the paddock rippled like a honey sea and we hunted beasts through the broom with our bamboo and chook-feather spears.

Words were the bridge from reality into fantasy.

Even as an adult, I can lose hours in the garden. Finding a spot to be still, while sentences to share the magic I see file through my mind. I describe my flowers in minute detail and tell stories of the passing seasons in the hope I can open the eyes of my readers – urging them to slow a moment and connect with the life cycling past outside.

Notebooks are filled in the early hours when I wake in urgency with an idea, while dreams of secret gardens capture my sleep. My books are born from the building of a simple bedside posy and the first blooms of spring. Words always tickling my tongue as I grow and play with Mother Nature's treasures. She will forever be my muse.

——— TURN THE PAGE TO SEEK & FIND ———
1. CRUMPLED-UP PAPER 2. TWO PENS 3. A DICTIONARY 4. EIGHT BOOKS
5. FIVE POST-IT NOTES 6. READING GLASSES 7. AN INK BLOT
8. A PAGE TORN FROM A BOOK 9. A COLD, FORGOTTEN CUP OF TEA
10. SIX UPPERCASE LETTERS THAT SPELL OUT A WORD

Answers on page 163

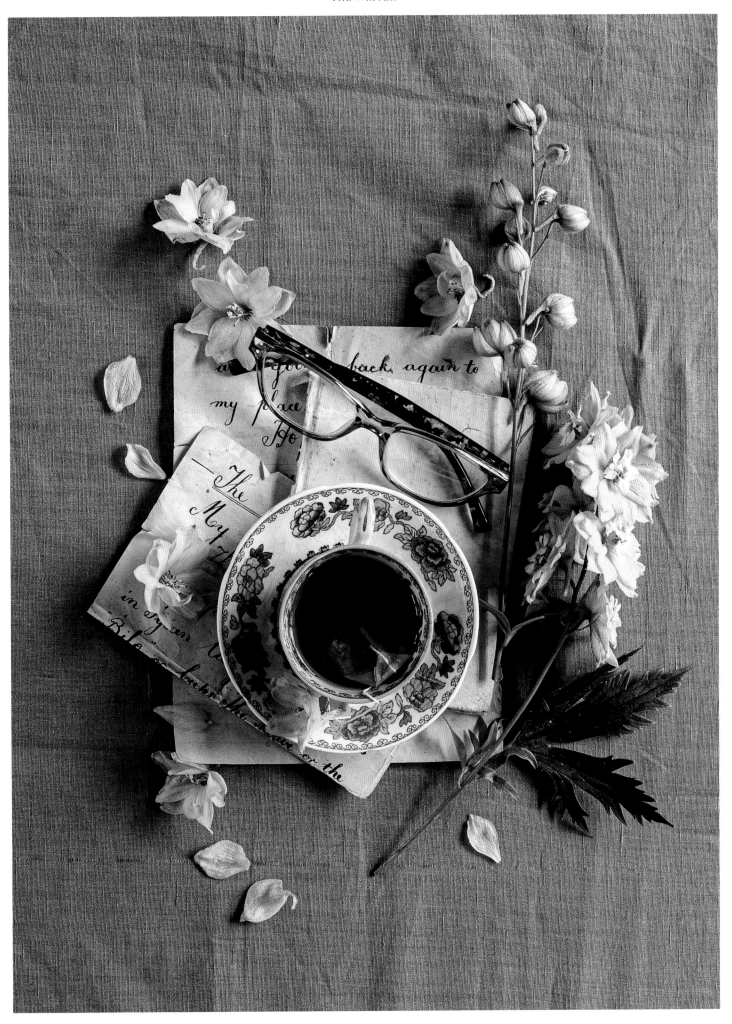

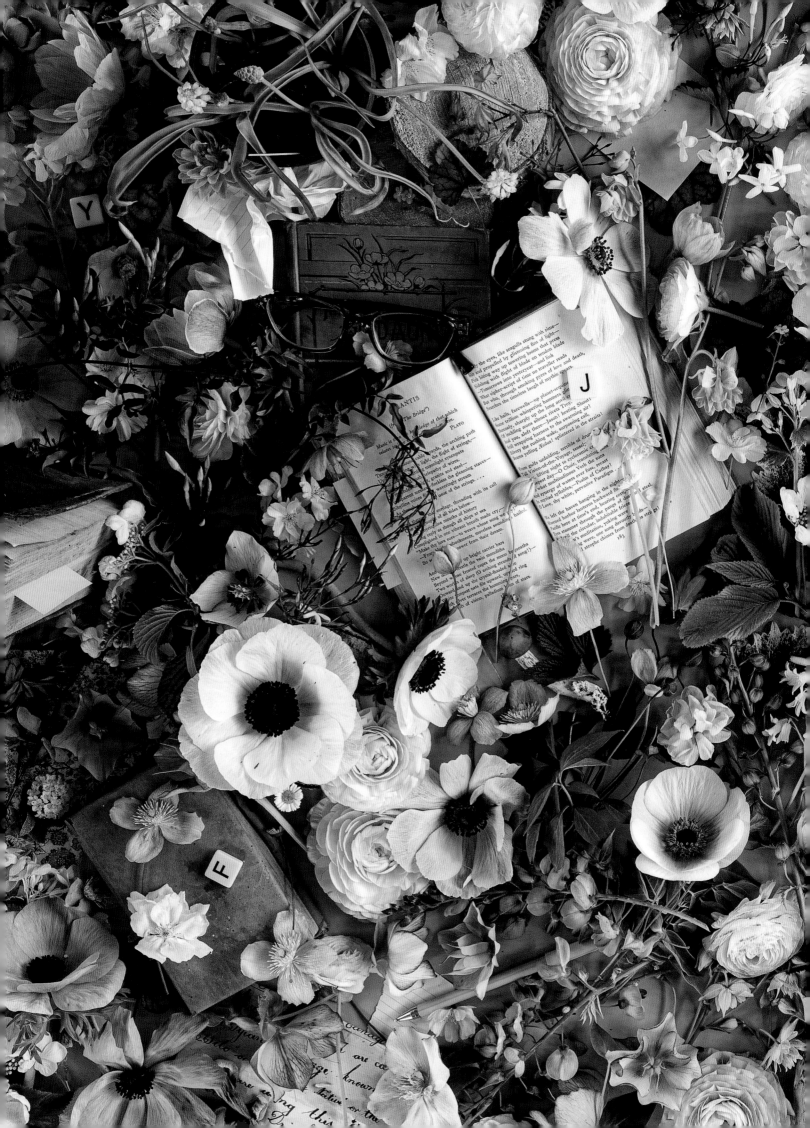

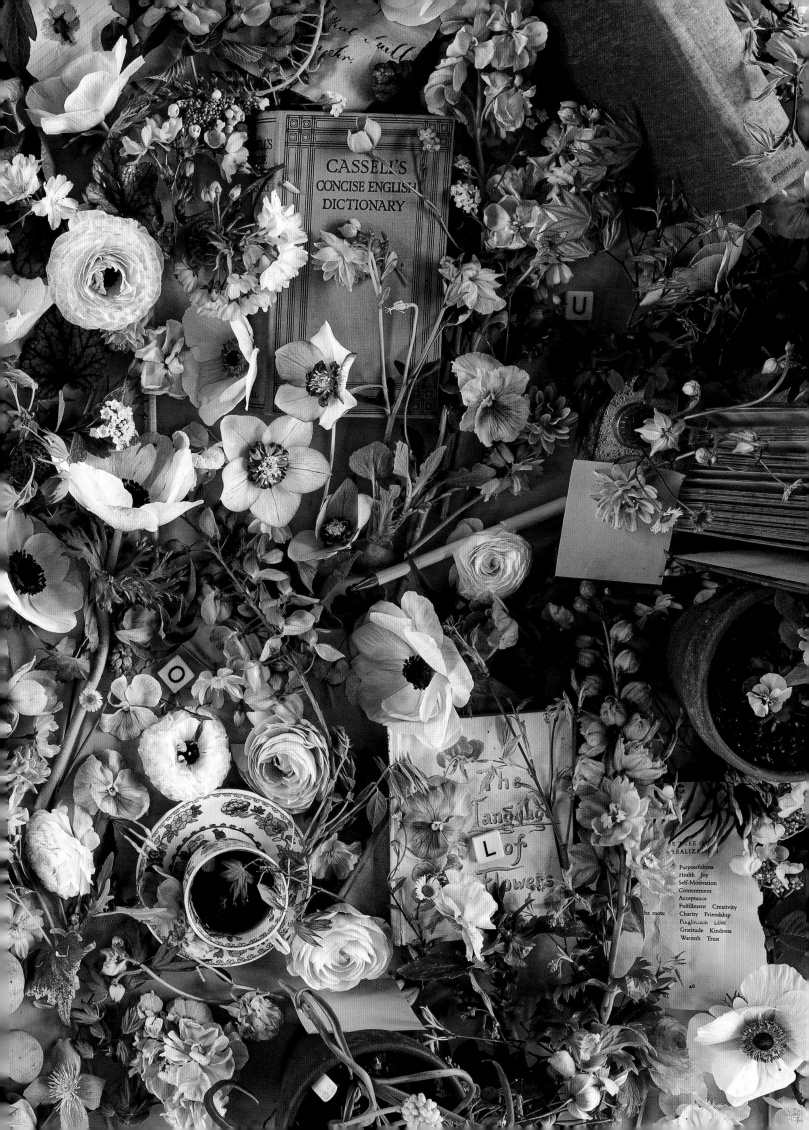

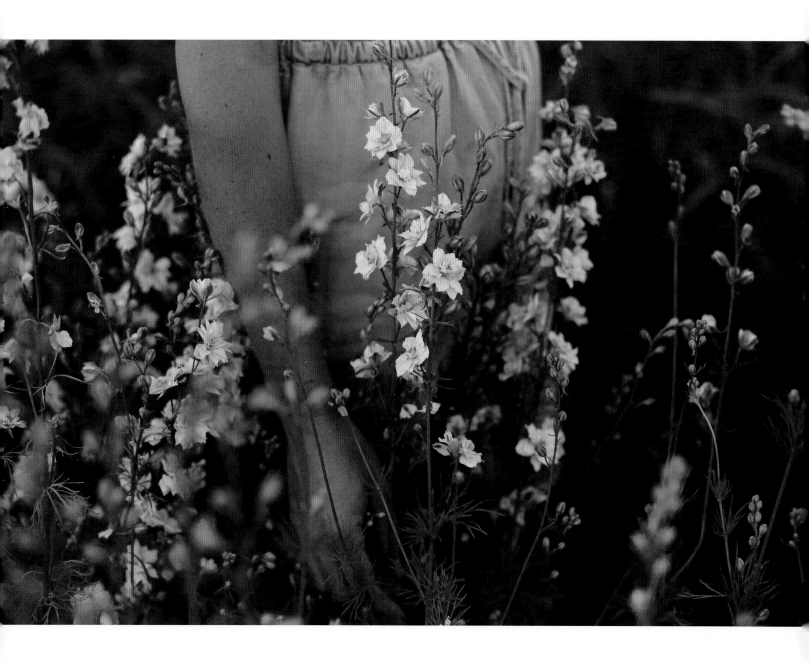

Wandering amongst the larkspur 'Smokey Eyes'.

My books are born from the building of a simple bedside posy and the first blooms of spring. Words always tickling my tongue as I grow and play with Mother Nature's treasures.

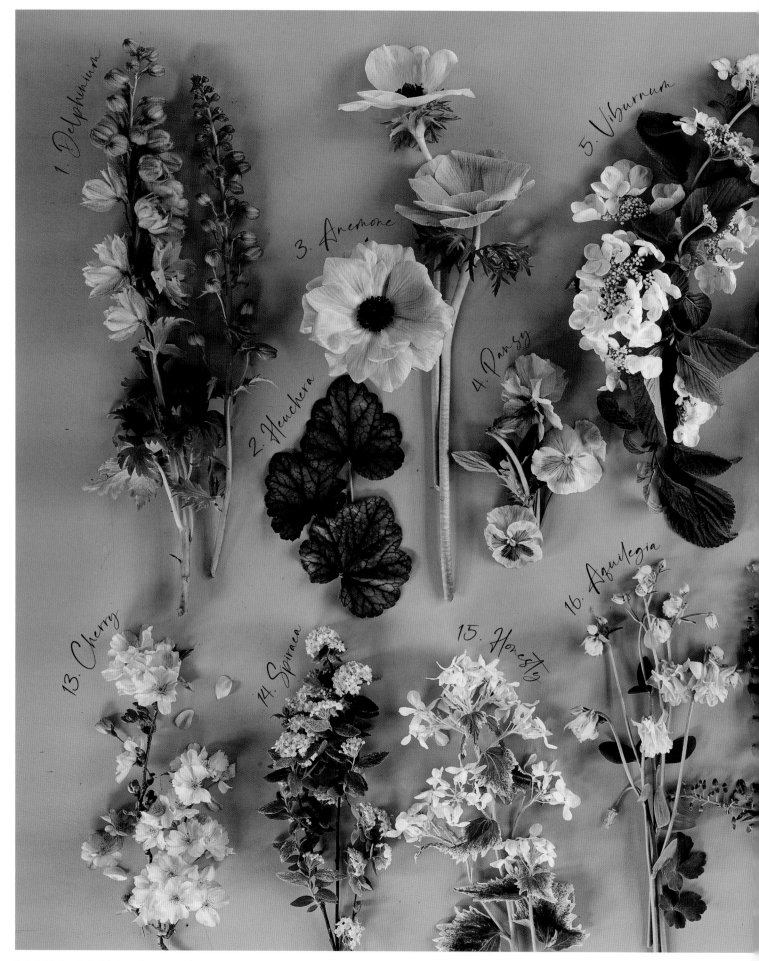

1. *Delphinium hybrida* 'Astolat' 2. *Heuchera americana hybrid* 'Peppermint Spice' 3. *Anemone coronaria* 'Mistral Rosa Chiaro' 4. *Viola x wittrockiana* 'Delta Pink Shades' 5. *Viburnum plicatum* 'Mariesii' 6. *Ranunculus asiaticus* 'Elegance Bianco Sfumato' 7. *Heuchera* 'Sugar Plum' 8. *Myosotis sylvatica* 9. *Helleborus orientalis* Anemone centred 10. *Aquilegia vulgaris* var. *stellata* 'Barlow Mix' 11. *Muscari armeniacum* 'Valerie Finnis' 12. *Matthiola incana* 'Katz Cherry Blossom'

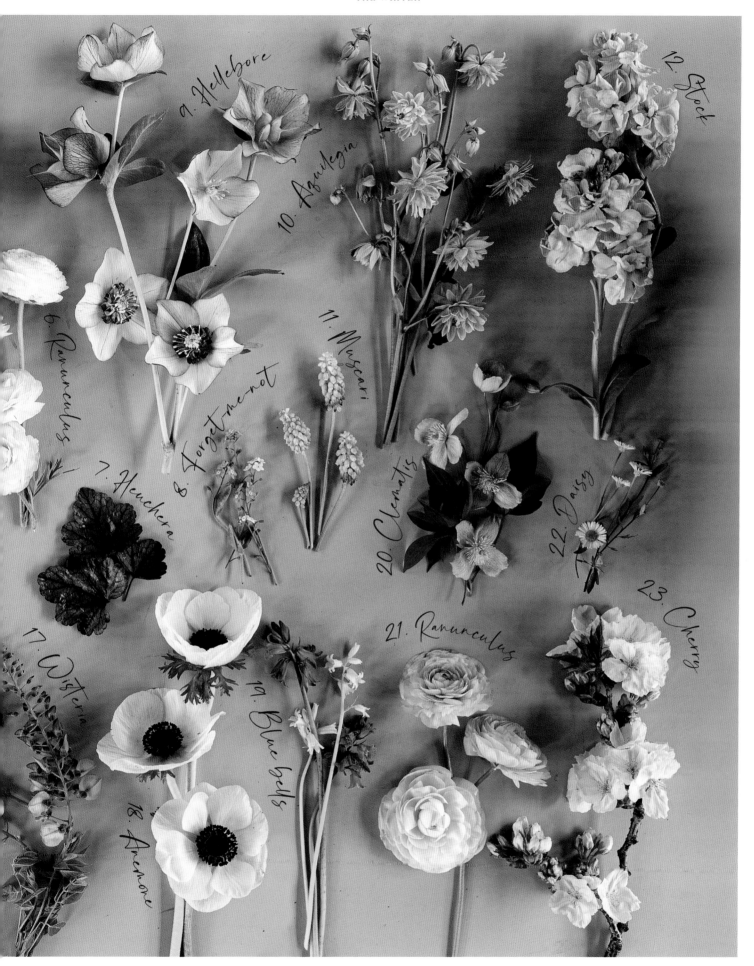

9. *Hellebore*
10. *Aquilegia*
11. *Muscari*
12. *Stock*
6 *Ranunculus*
7. *Heuchera*
8. *Forget-me-not*
20. *Clematis*
22. *Daisy*
23. *Cherry*
17. *Wisteria*
19. *Bluebells*
18. *Anemone*
21. *Ranunculus*

13. *Prunus* 'Accolade' **14.** *Spiraea x vanhouttei* 'Pink Ice' **15.** *Lunaria annua* var. *albiflora* 'Alba Varieagata' **16.** *Aquilegia vulgaris* 'Petticoats' **17.** *Wisteria sinensis*
18. *Anemone coronaria* 'Mistral Bianco Centro Nero' **19.** *Hyacinthoides* **20.** *Clematis montana* var. *rubens* 'Elizabeth' **21.** *Ranunculus asiaticus* 'Elegance Pastello'
22. *Erigeron karvinskianus* Mexican Daisy **23.** *Prunus serrulata* 'Tai-Haku'

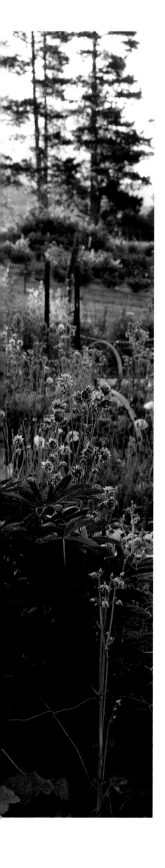

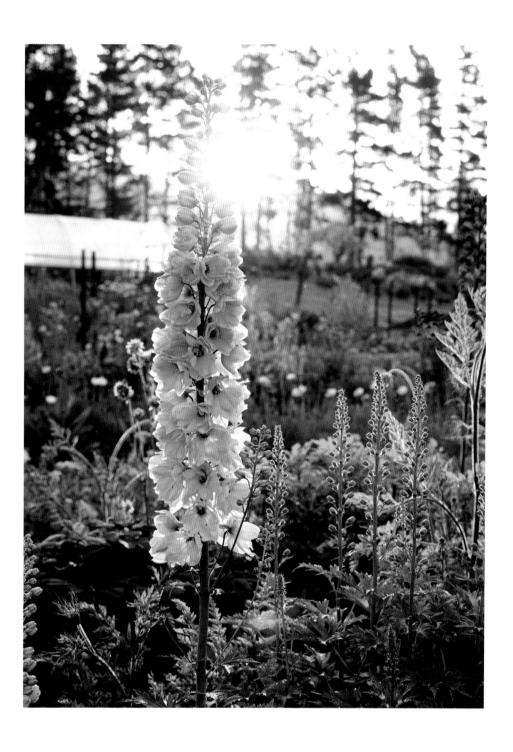

Opposite: Glowing spring views in the cutting field.
Above: *Delphinium hybrida* Pacific Giant 'Astolat'.

—THE—
FLORIST

I spin the bouquet around in my hand, dropping it to rest naturally at waist height and check its reflection in the studio mirror. Deliciously romantic with its spires of peach foxgloves, frothy pink peonies and hints of new season's rose. Unruly tendrils of fragrant jasmine swoop off with a mind of their own, just the way I like it. A satisfied smile creeps across my face as I rest the bouquet in a bucket of water and imagine the bride gripping these flowers close as she walks toward her love.

I turn to the table vases, already lined up to attention. Moving between them, I snip and scatter delicate poppies and frilly sweet peas, freshly harvested in the morning dew from my mother's garden. The knowledge that a little piece of her will be sprinkled around the wedding makes my sentimental heart glow.

The rest of my day has me wrestling chicken wire into flower supports, spiking my fingers on thorns and losing my snips under piles of foliage. I feel physically sapped as I drive my van home with the setting sun, only to be recharged at the sight of wild roadside buttercups. I make a mental note to stop and pick some in the morning. Seasonal blooms are my life's fuel.

—— TURN THE PAGE TO SEEK & FIND ——

1. FLORISTRY TAPE **2.** THREE PEARL PINS **3.** FIVE WATER TUBES
4. THREE BRASS VASES **5.** WIRE WRAPPED ROUND A STEM
6. A CANDLE HALF BURNT THROUGH **7.** THREE CERAMIC VASES
8. A BOBBY PIN **9.** SIX ZIP TIES **10.** SEVEN KENZAN (FLOWER FROGS)

Answers on page 163

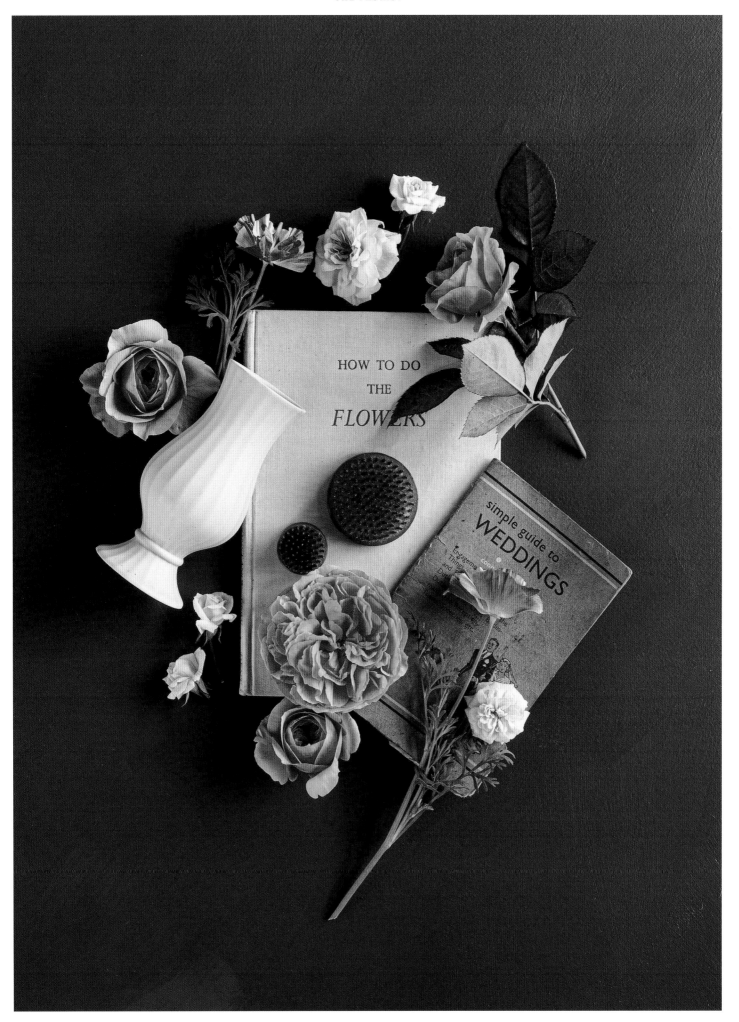

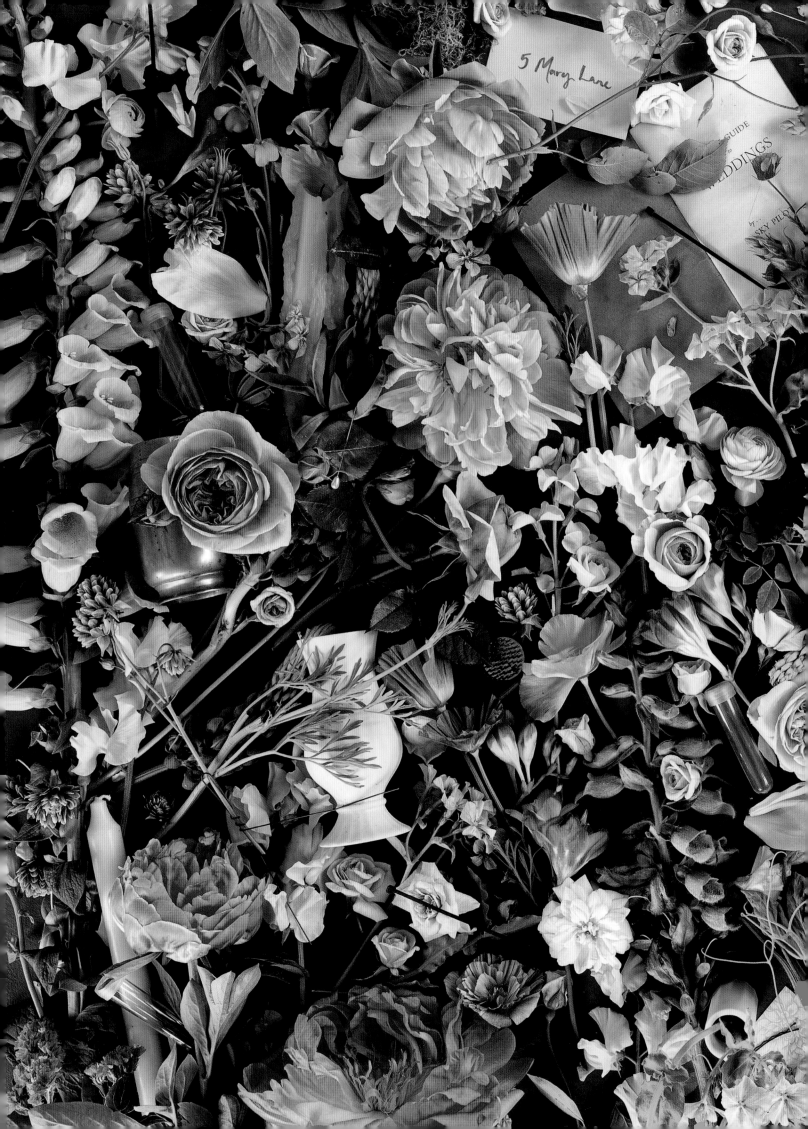

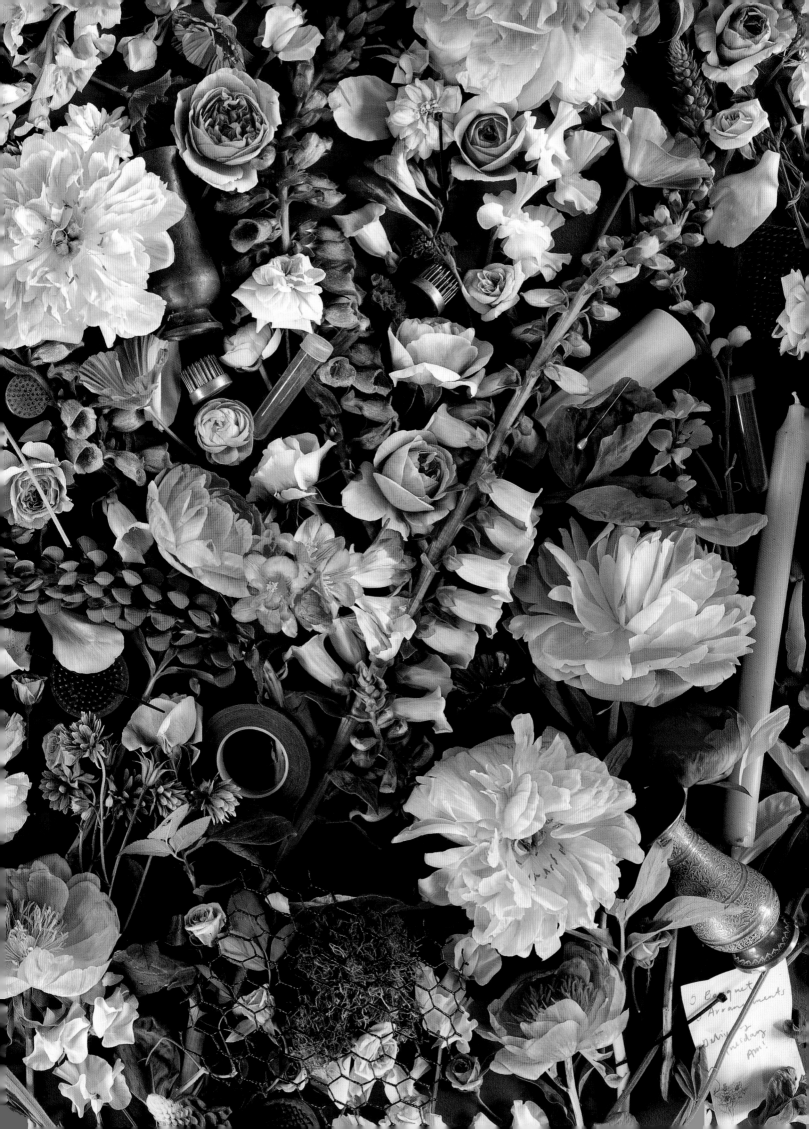

"

Deliciously romantic with its spires of peach foxgloves, frothy pink peonies and hints of new season's rose. Unruly tendrils of fragrant jasmine swoop off with a mind of their own, just the way I like it.

"

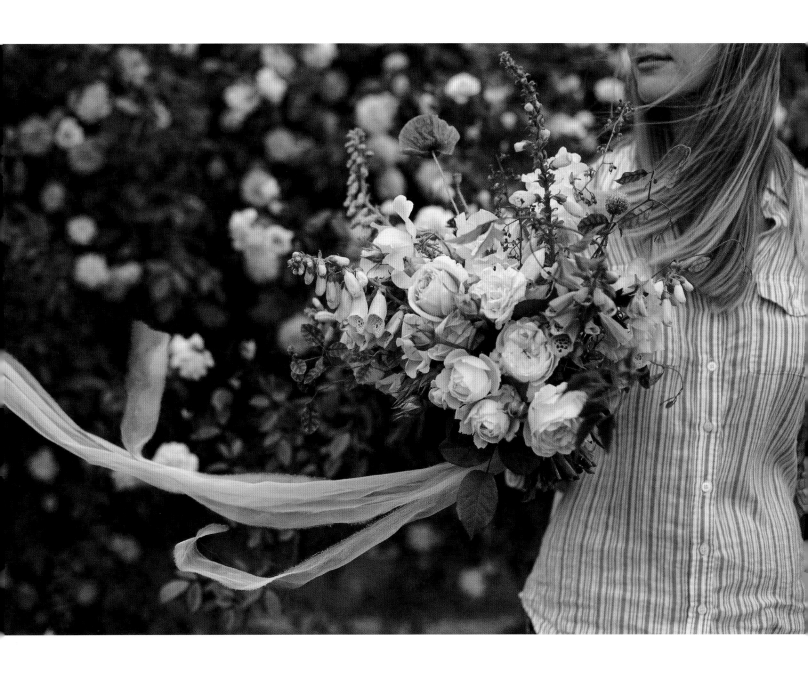

Bouquet of roses 'Winchester Cathedral', 'Ali Mau', 'Sally Holmes' with foxgloves, Shirley poppies, sweet peas, heuchera seed heads, Montana clematis vines and putaputawētā foliage.

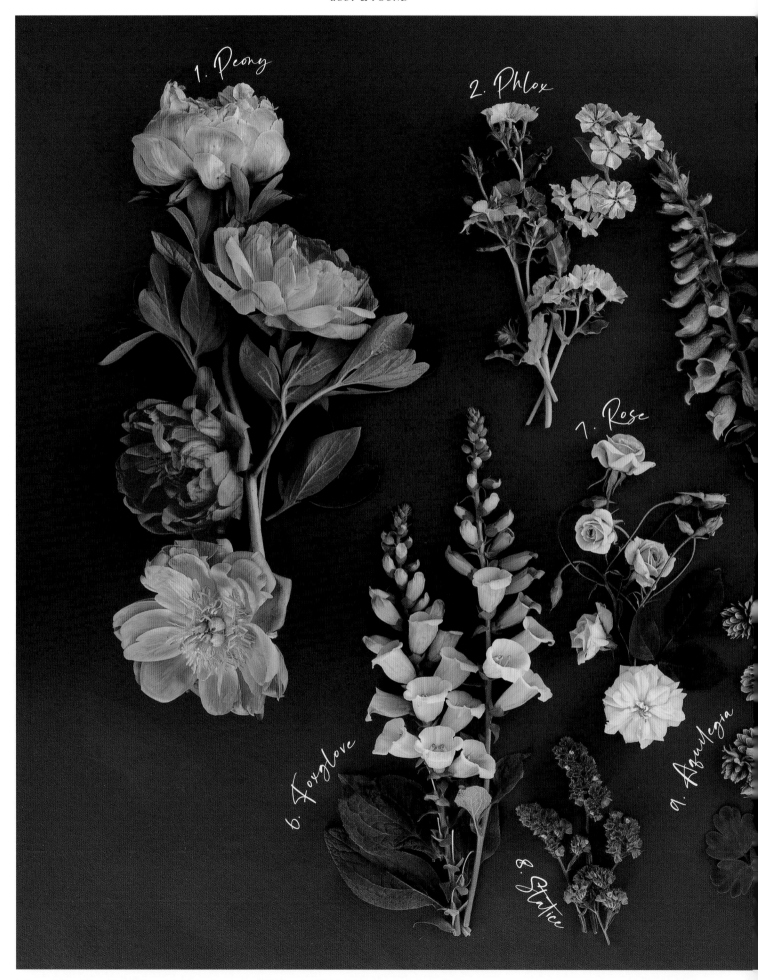

1. *Paeonia lactiflora* 'Coral Charm' 2. *Phlox drummondii* 'Crème Brûlée' 3. *Digitalis purpurea* 'Polkadot Pippa' 4. *Eschscholzia californica* 'Apricot Chiffon'
5. *Rosa* 'Ali Mau' 6. *Digitalis purpurea* 'Dalmatian Peach' 7. *Rosa* 'Cecile Brunner' 8. *Statice sinuata* 'Peach mix' 9. *Aquilegia vulgaris* var. *stellata* 'Nora Barlow'

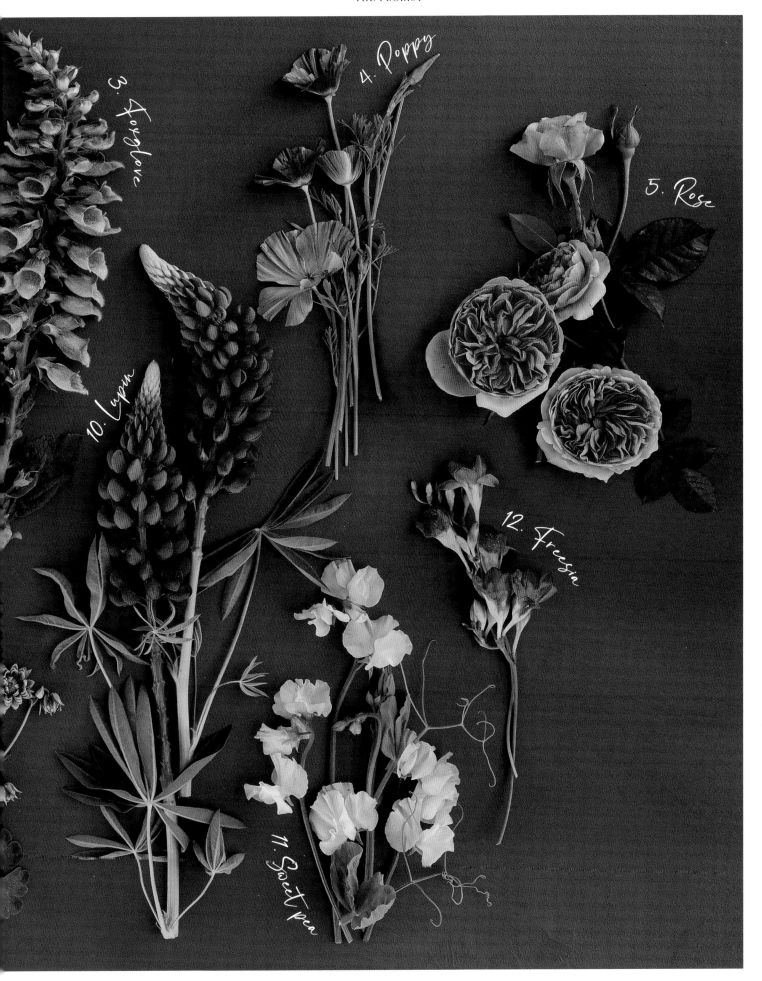

4. Poppy

3. Foxglove

5. Rose

10. Lupin

12. Freesia

11. Sweet pea

10. *Lupinus x russellii* 'My Castle' **11.** *Lathyrus odoratus* 'Piggy Sue' **12.** *Freesia* 'Sandra'

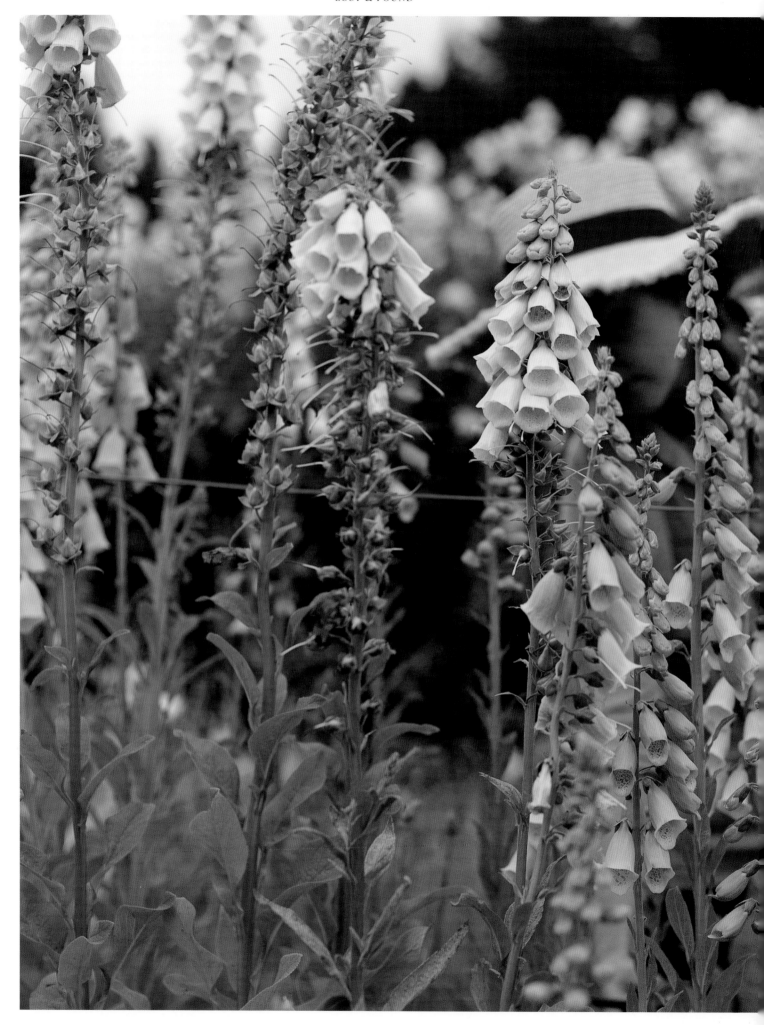

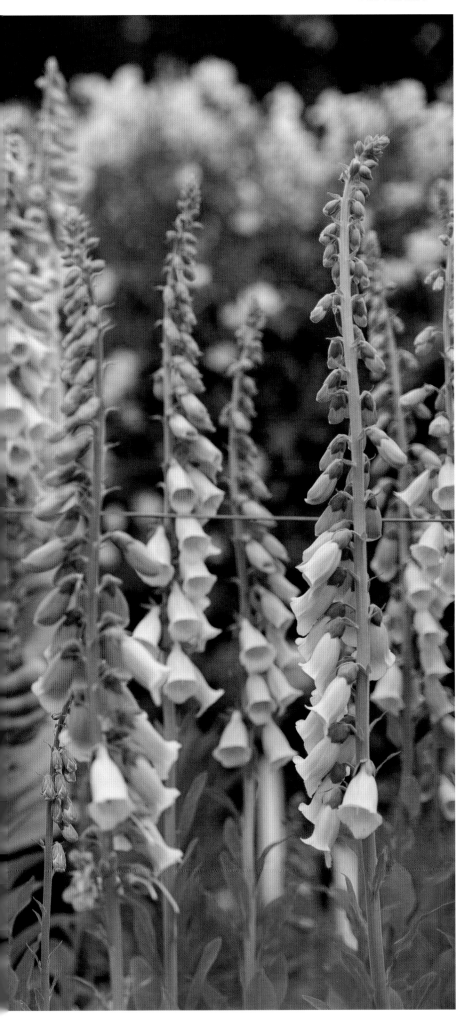

Tending to the spires of
'Sutton's Apricot' foxgloves.

— THE —
BEEKEEPER

'Honey' has always felt like too short a word for the resulting riches of such an intricate, collaborative natural process. I ponder this, attempting to think up more notable descriptions, as I wade back through the grass from my hives, armed with panels of honeycomb. 'Nectar of the gods; nature's gold; bee gold; bee syrup; plant gold; plant syrup . . .' Yet, of course, the word honey has such lovely connotations that we also use it to talk affectionately to our most precious. 'I love you, honey.' Perhaps this is recognition enough of its importance.

I hold my bee friends in great esteem. They exist in harmony, gracefully following the rules of their society, working tirelessly for the collective good of their hive. They build, gather, and protect their own, answering the urgent calls of the ripening blooms around them. Flowers have evolved to attract and service these harvesters, with their form, fragrance and colour marketing exclusively to their preferred pollinators. How wondrous!

As I pull into the yard, my own little 'honeys' skip around the corner to meet me, clutching after-school honey sandwiches in their sticky fingers. Bursting with excitement, they tell me what they have learnt in class that day – the vital role of bees in the life cycle of the world – and how they were able, with great pride, to share the work their own mum has in caring for the local population. We decide to pack some honeycomb to share with the class tomorrow.

— TURN THE PAGE TO SEEK & FIND —

1. A SMOKER 2. A PAIR OF LEATHER GLOVES 3. FOUR BEES
4. A BRUSH 5. SIX BEESWAX CANDLES 6. A LIGHTER
7. FRESH HONEYCOMB 8. THREE POTS OF HONEY 9. A DRIZZLER
10. A PACKET OF 'HONEY BEE GARDEN' SEEDS

Answers on page 164

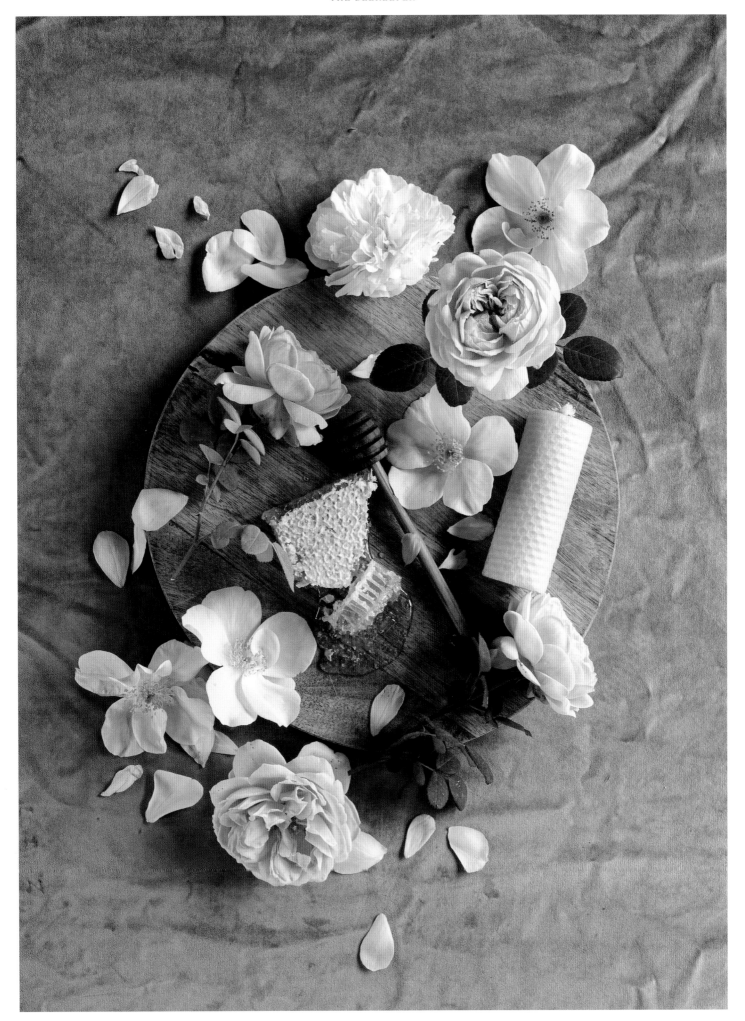

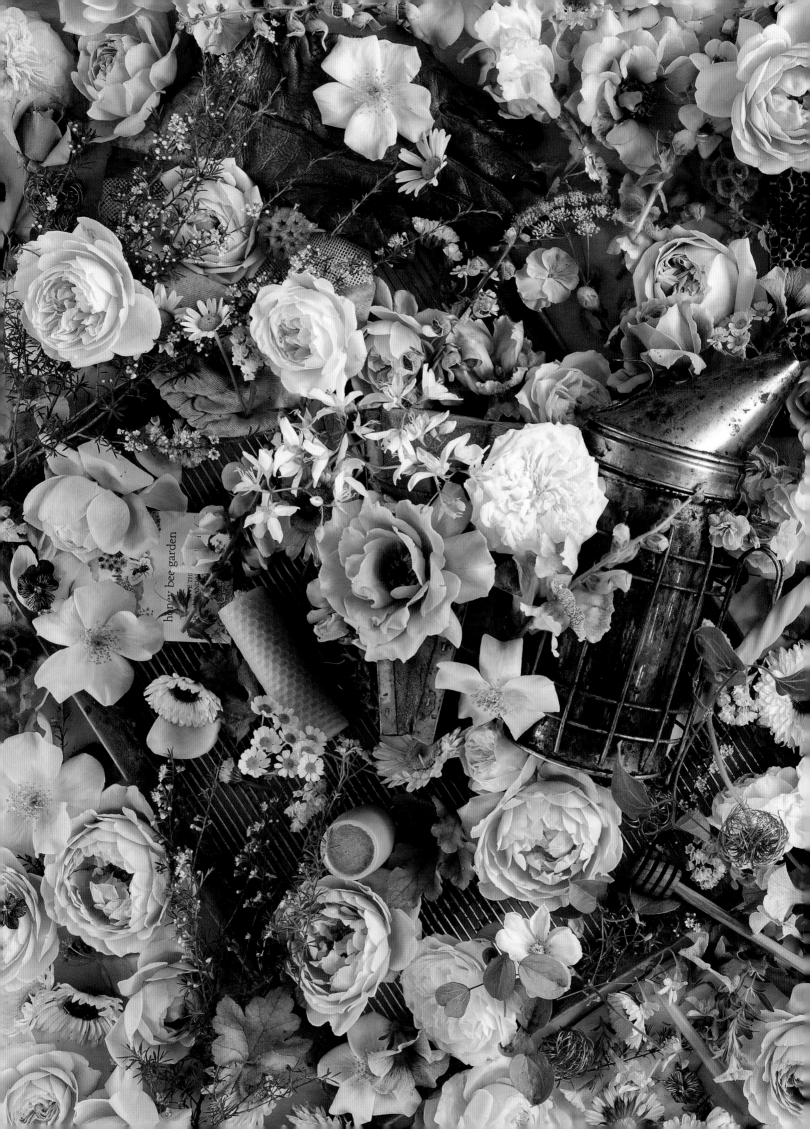

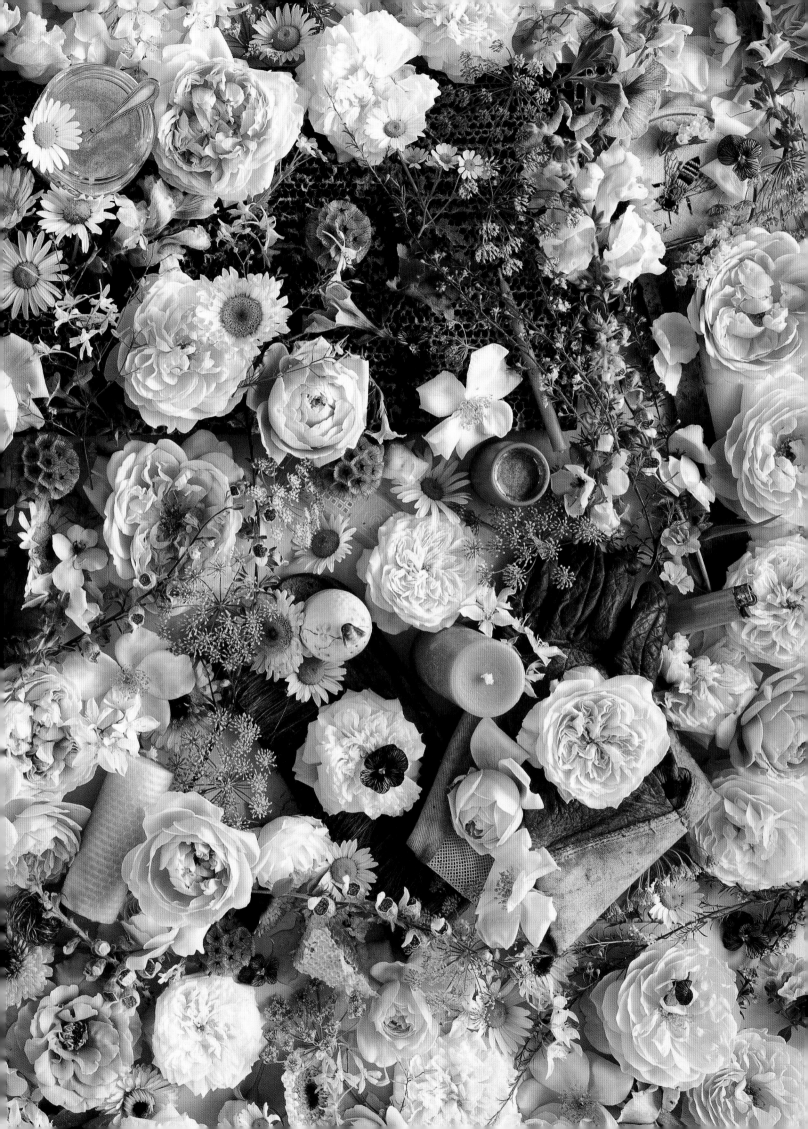

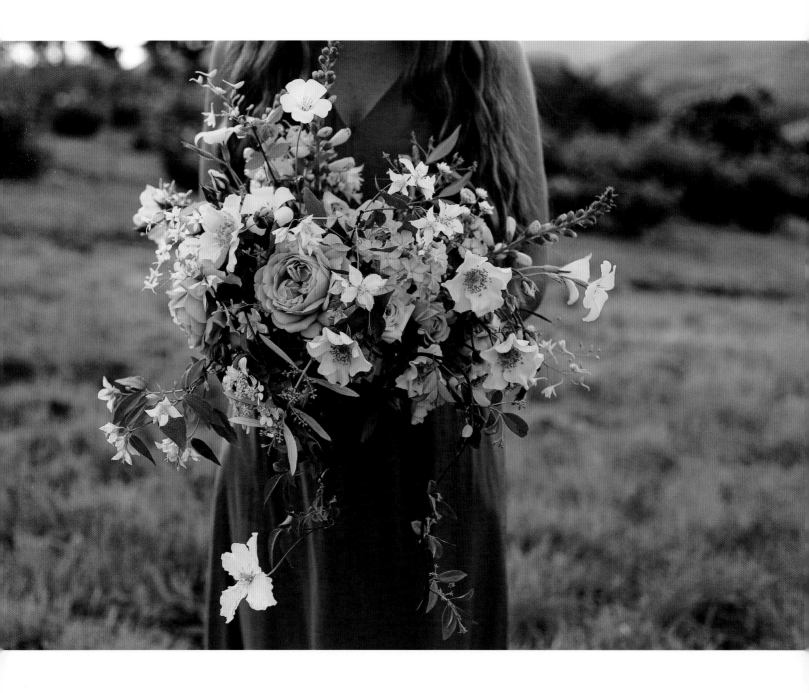

Late spring wedding bouquet filled with 'Golden Celebration' and 'Sparrieshoop' roses, philadelphus, phlox 'Crème Brûlée', agrostemma 'Ocean Pearls', orlaya, 'Camelot Cream' foxglove, *Consolida regalis* 'Snow Cloud', ammobium, and white *Clematis montana* var. *grandiflora*.

"

Flowers have evolved to attract and service these harvesters, with their form, fragrance and colour marketing exclusively to their preferred pollinators. How wondrous!

"

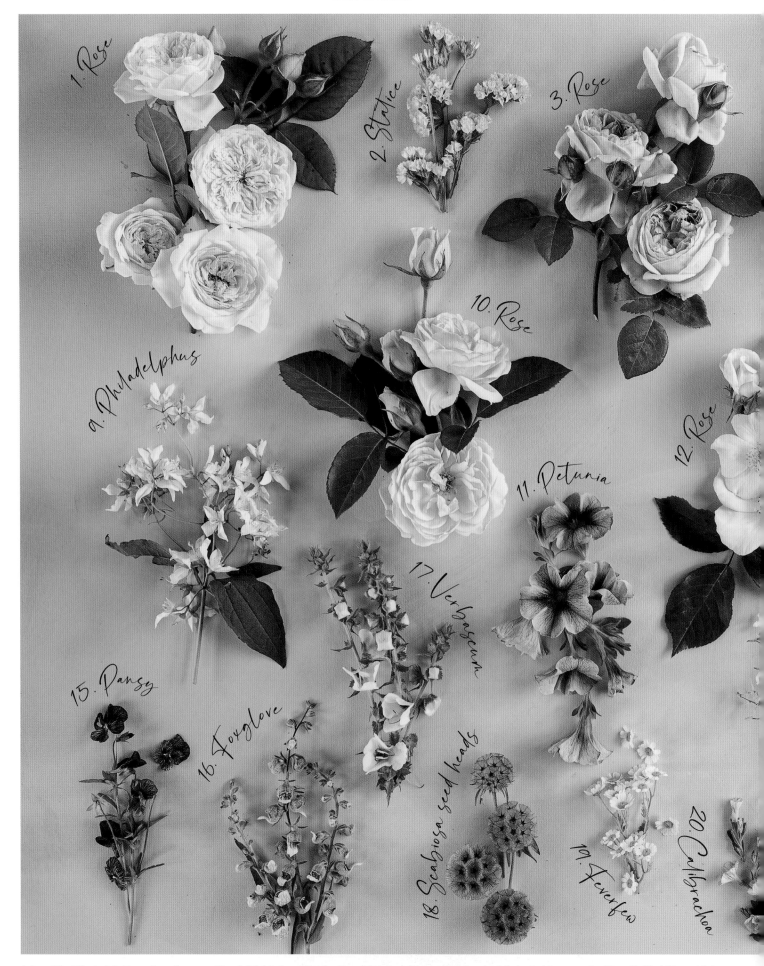

1. Rose

2. Statice

3. Rose

9. Philadelphus

10. Rose

11. Petunia

12. Rose

15. Pansy

16. Foxglove

17. Verbascum

18. Scabiosa seed heads

19. Feverfew

20. Calibrachoa

1. *Rosa* 'The Pilgrim' **2.** *Limonium sinuatum* 'Peach Mix' **3.** *Rosa* 'Charles Darwin' **4.** *Rosa* 'Golden Celebration' **5.** *Antirrhinum majus* 'Tetra Ruffled Giants Mix' **6.** *Rosa* 'Charlotte' **7.** *Rosa* 'Symphony' **8.** *Calendula officinalis* 'Cantaloupe' **9.** *Philadelphus coronarius* 'Birchlands' **10.** *Rosa* 'Graham Thomas' **11.** *Petchoa x hybrida* 'BeautiCal Caramel Yellow' **12.** *Rosa* 'Sally Holmes' **13.** *Rosa* 'Julia's Rose' **14.** *Clematis* 'Guernsey Cream' **15.** *Viola cornuta* 'Tiger Eye' **16.** *Digitalis lanata*

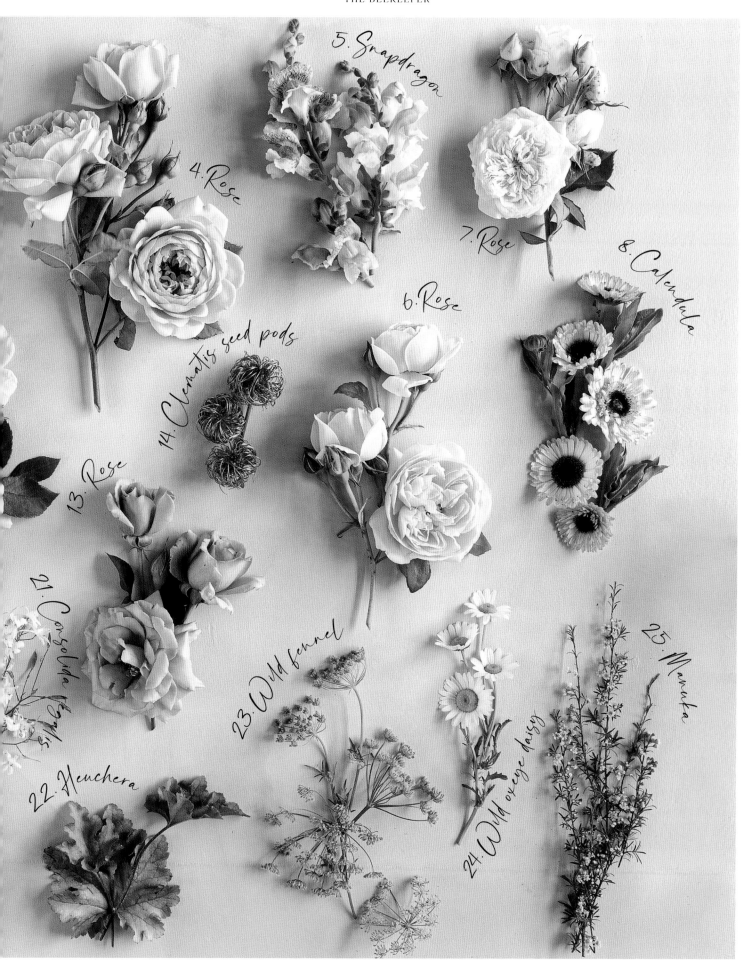

5. Snapdragon

4. Rose

7. Rose

8. Calendula

6. Rose

14. Clematis seed pods

13. Rose

21. Consolida regalis

23. Wild fennel

25. Manuka

22. Heuchera

24. Wild oxeye daisy

'Cafe Crème' **17.** *Verbascum densiflorum* **18.** *Scabiosa stellata* **19.** *Tanacetum parthenium* **20.** *Calibrachoa* Yellow **21.** *Consolida regalis* 'Snow Cloud'
22. *Heuchera* 'Marmalade' **23.** *Foeniculum vulgare* **24.** *Leucanthemum vulgare* **25.** *Leptospermum scoparium*

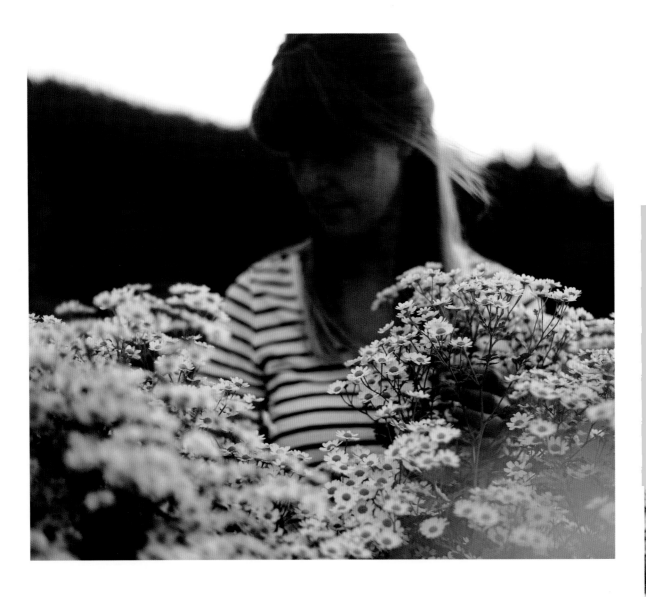

Wandering amongst the
clouds of feverfew.

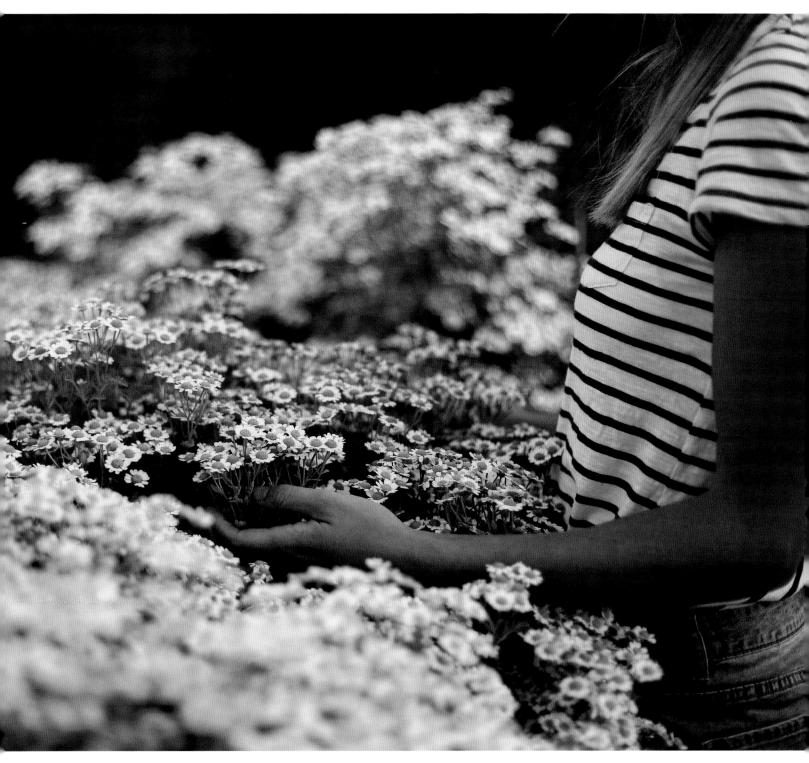

—THE—
POTTER

I was a messy child. Always playing in the mud, squelching slime between my fingers down at the creek, and reaching for the fingerpaints at kindergarten. As an adult I have found the same deep satisfaction in having my hands in the soil of the garden and creating with clay, growing and building with a pleasing level of disarray.

Deeply inspired by the steady travel of the seasons outside, I find myself making in response to both what I need and what I see. Bud vases spring forth for wind-fall roses, forage bowls and ceramic frogs follow for delicate grasses and woody arms of lilac. As stems lengthen outside, vessels grow larger inside. In winter, decorative hanging plaques are etched and stamped with the memories of my favourite specimens, a tribute to the floral chorus I look forward to seeing again soon.

My goal as a gardener and potter is finding the balance between pretty and functional. In the same way I curate my plants for best viewing and construct my raised beds to be easily reached from all sides, I form vessels that support and display with ease. Beautiful bulbous bases work to compliment vase height, designed to avoid toppling at all costs. Necks and openings are made to prop up stems that will rise to pleasing heights and fullness, completing the marriage of vase and bloom.

I will never be bored with either creative pursuit.

—————— TURN THE PAGE TO SEEK & FIND ——————

1. A WIRE WITH TOGGLE ENDS **2.** A MUDDY HANDPRINT **3.** A SPONGE
4. SIX SCULPTING TOOLS WITH WOODEN HANDLES **5.** GLAZE
6. A QUICK SKETCH **7.** A BROKEN DISH **8.** THREE STAMPS
9. A PENCIL **10.** THE MAKER'S MARK

Answers on page 164

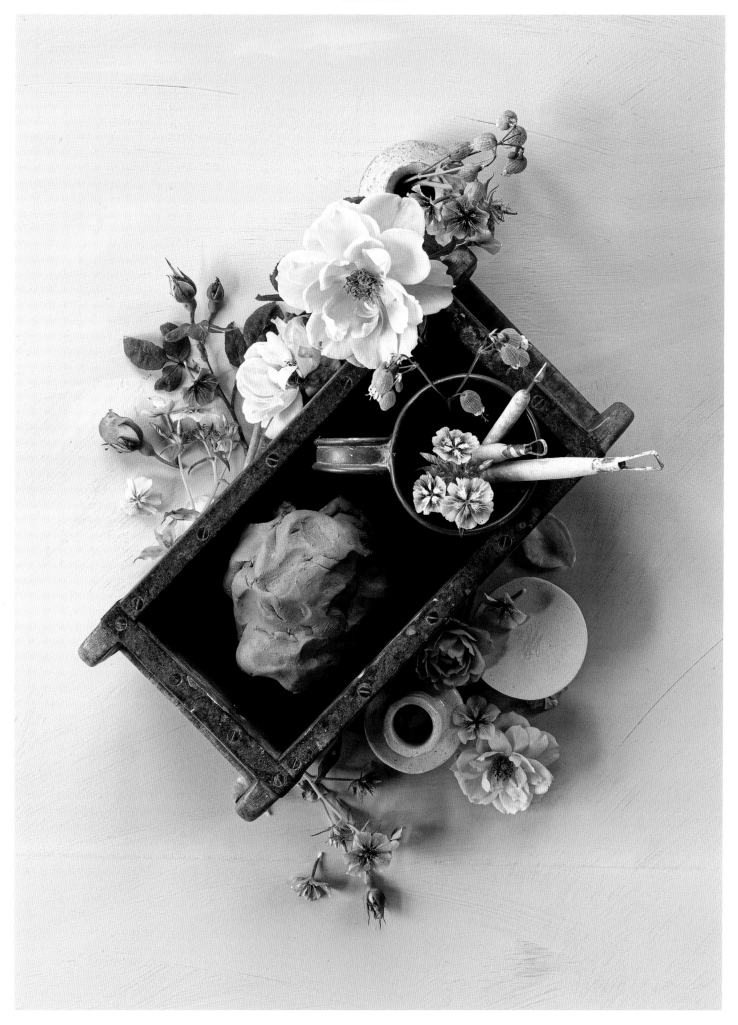

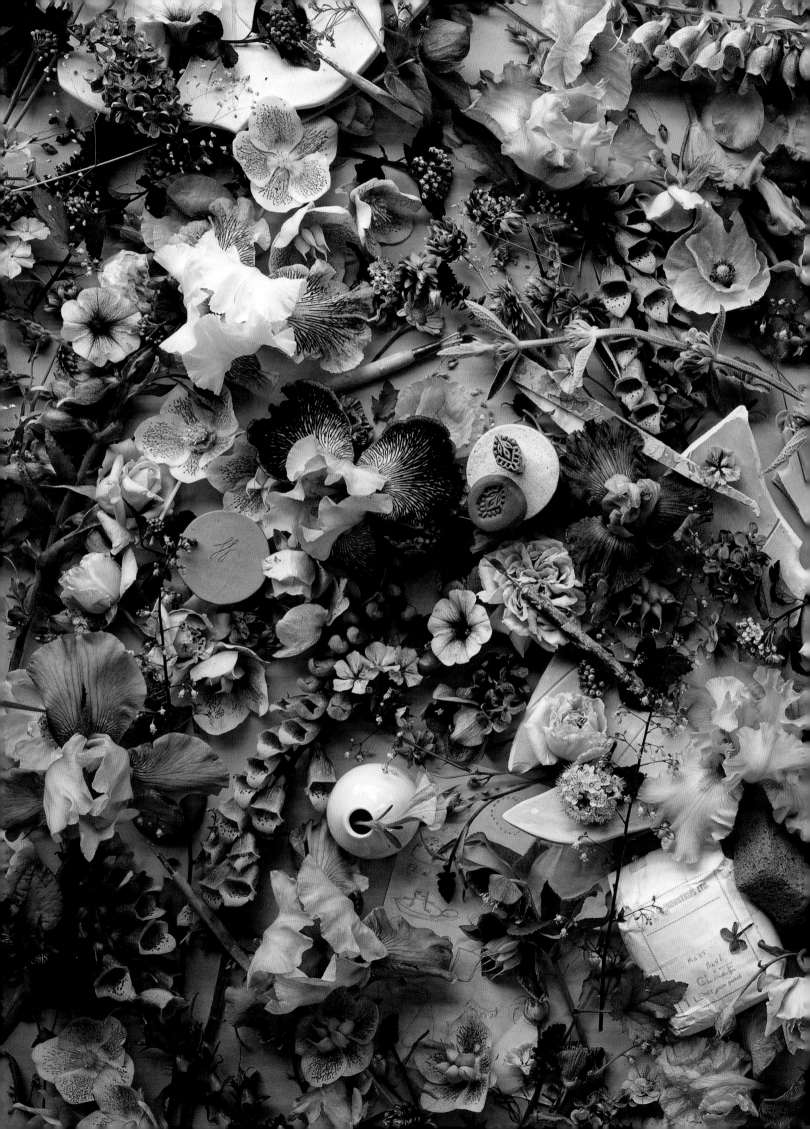

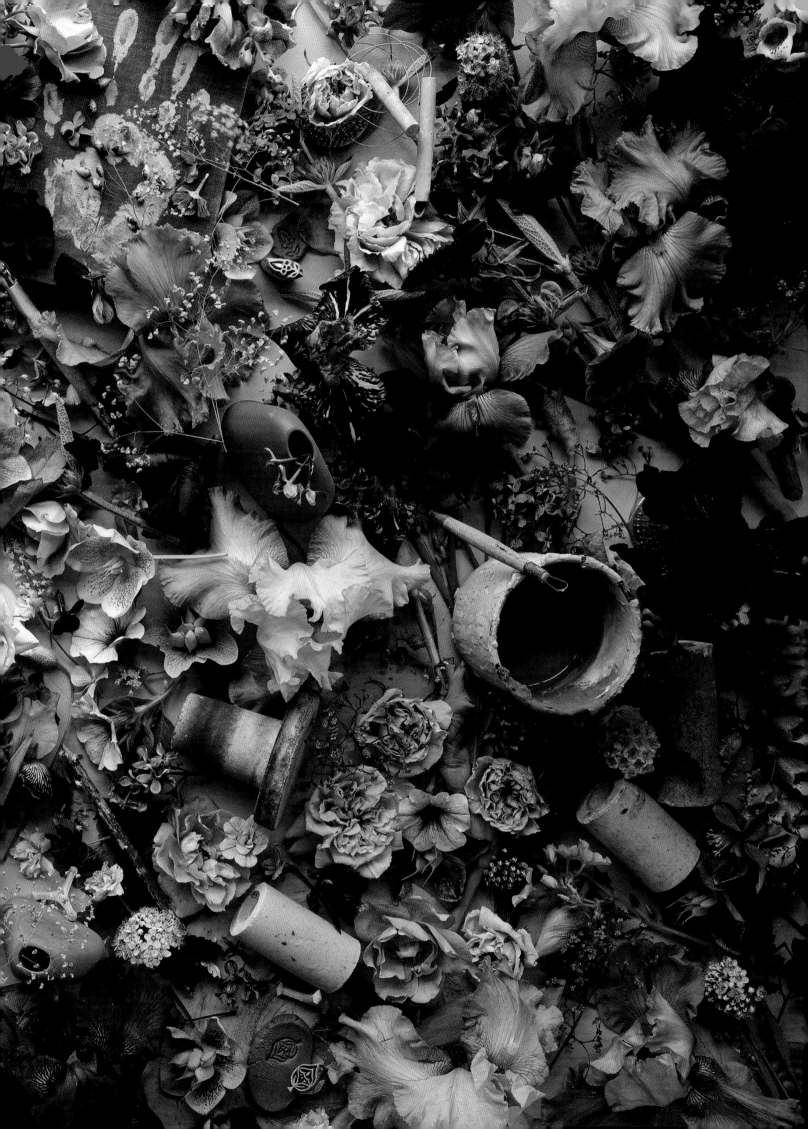

As stems lengthen outside, vessels grow larger inside. In winter, decorative hanging plaques are etched and stamped with the memories of my favourite specimens, a tribute to the floral chorus I look forward to seeing again soon.

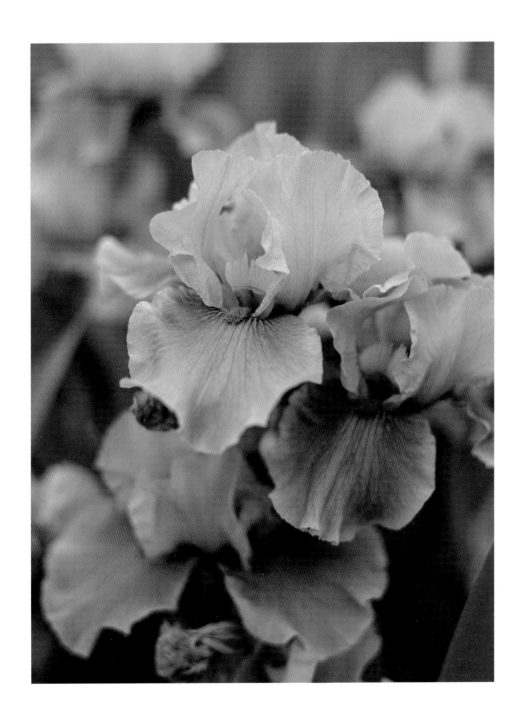

Warming tones of iris 'Cameo Wine'.

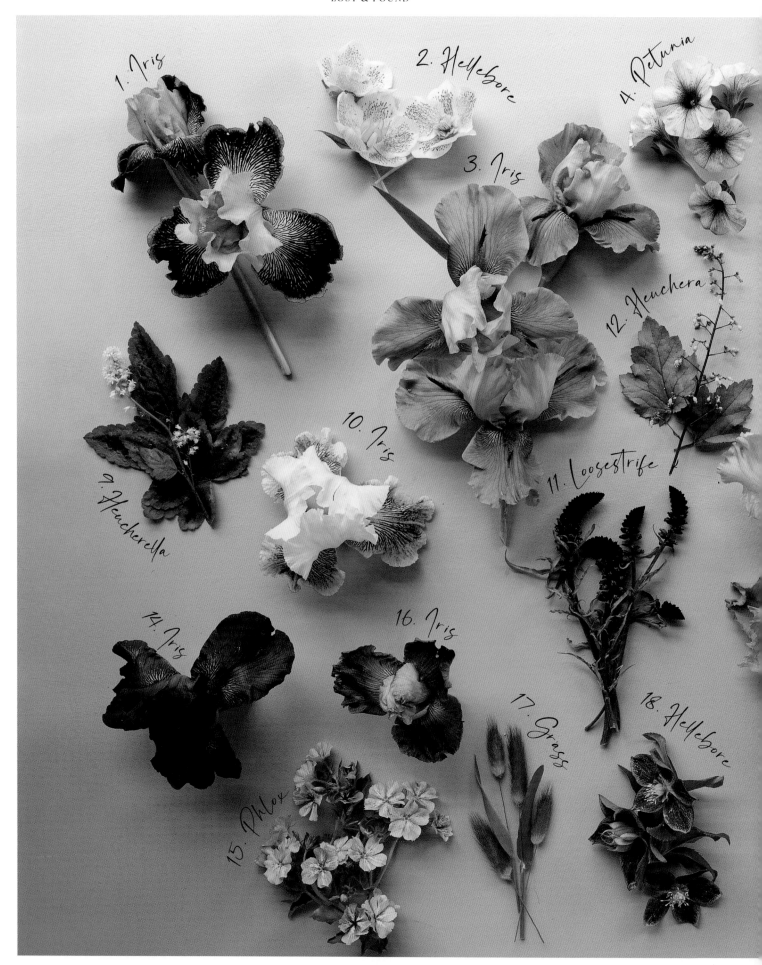

1. *Iris germanica* 'Irwell Courage' 2. *Helleborus hybridus* 'Single White Spotted' 3. *Iris germanica* 'Thornbird' 4. *Petchoa x hybrida* 'BeautiCal French Vanilla'
5. *Digitalis purpurea* 'Polkadot Petra' 6. *Rosa* 'Lavender Pinocchio' 7. *Iris germanica* 'Bygone Era' 8. *Briza maxima* Greater Quaking Grass 9. *Heucherella* 'Brass
Lantern' 10. *Iris germanica* 'Candy Cane Cutie' 11. *Lysimachia atropurpurea* 'Beaujolais' 12. *Heuchera* 'Marmalade' 13. *Iris germanica* 'Harlem Hussy'

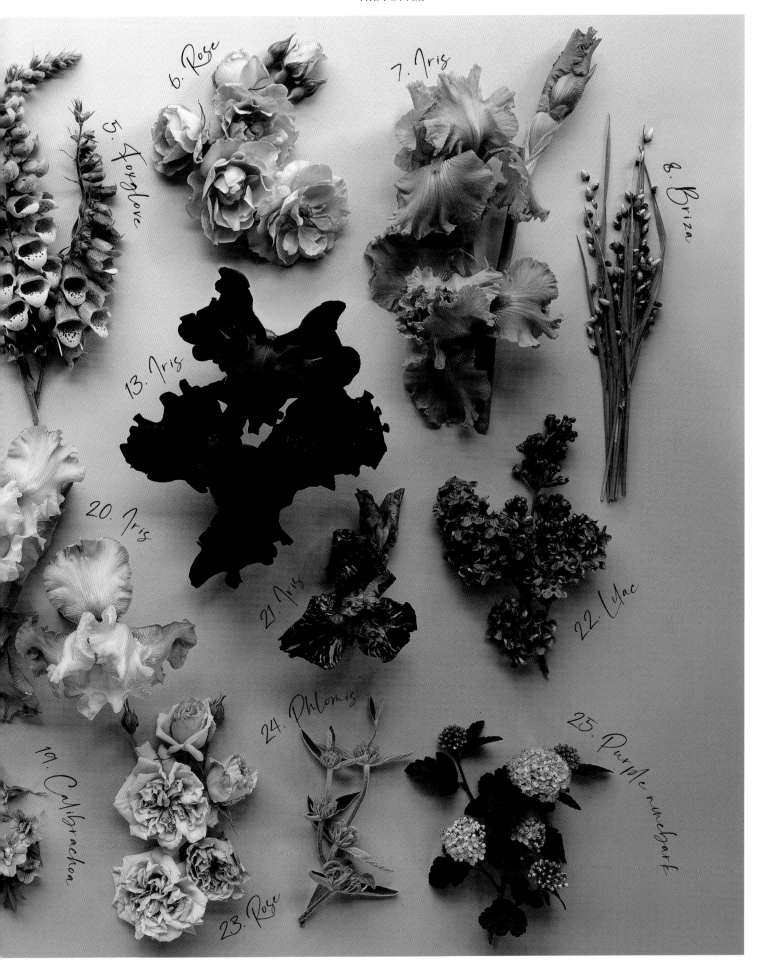

6. Rose

7. Iris

5. Foxglove

8. Briza

13. Iris

20. Iris

21. Iris

22. Lilac

19. Calibrachoa

24. Phlomis

25. Purple ninebark

23. Rose

14. *Iris germanica* 'Eric's Dream' **15.** *Phlox drummondii* 'Crème Brûlée' **16.** *Iris germanica* 'Irwell Surprise' **17.** *Lagurus ovatus* Bunny Tail Grass **18.** *Helleborus x hybridus* 'Single Red Spotted' **19.** *Calibrachoa x hybrida* 'Double Pink' **20.** *Iris germanica* 'Celebration Song' **21.** *Iris germanica* 'Gnus Flash' **22.** *Syringa vulgaris* 'Souvenir de Louis Spaeth' **23.** *Rosa* 'Ash Wednesday' **24.** *Phlomis purpurea* Jerusalem Sage **25.** *Physocarpus opulifolius*

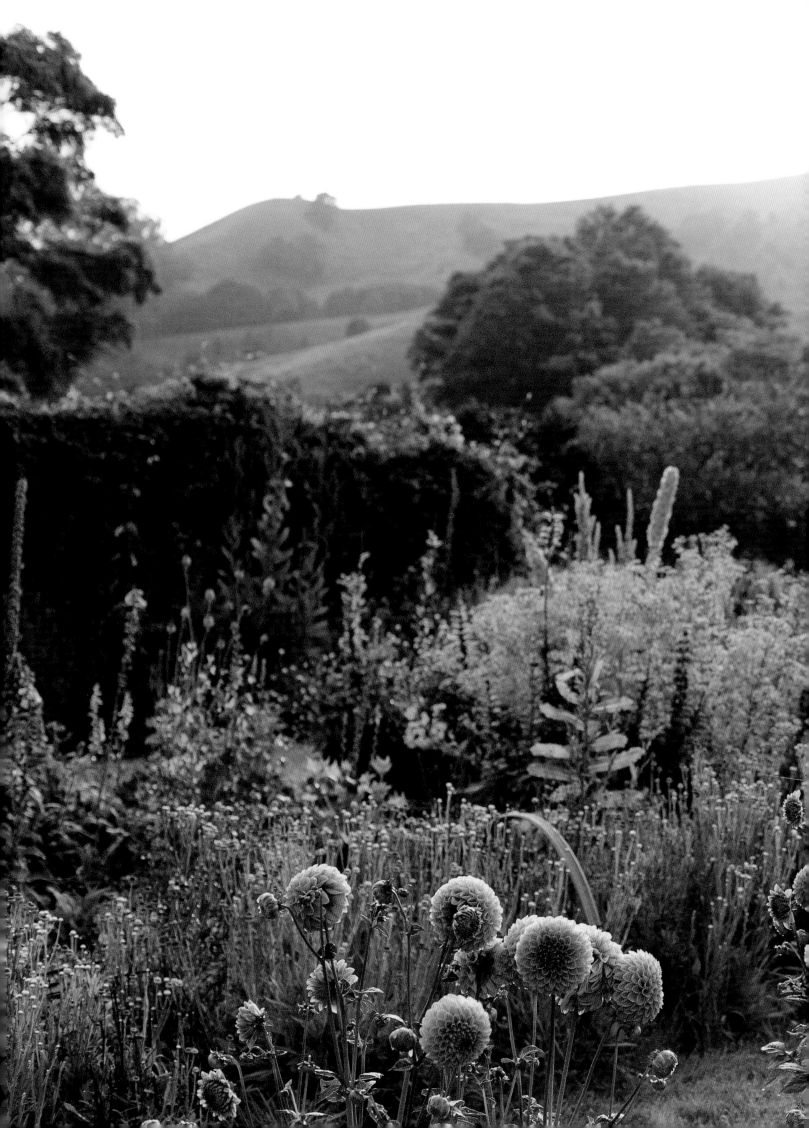

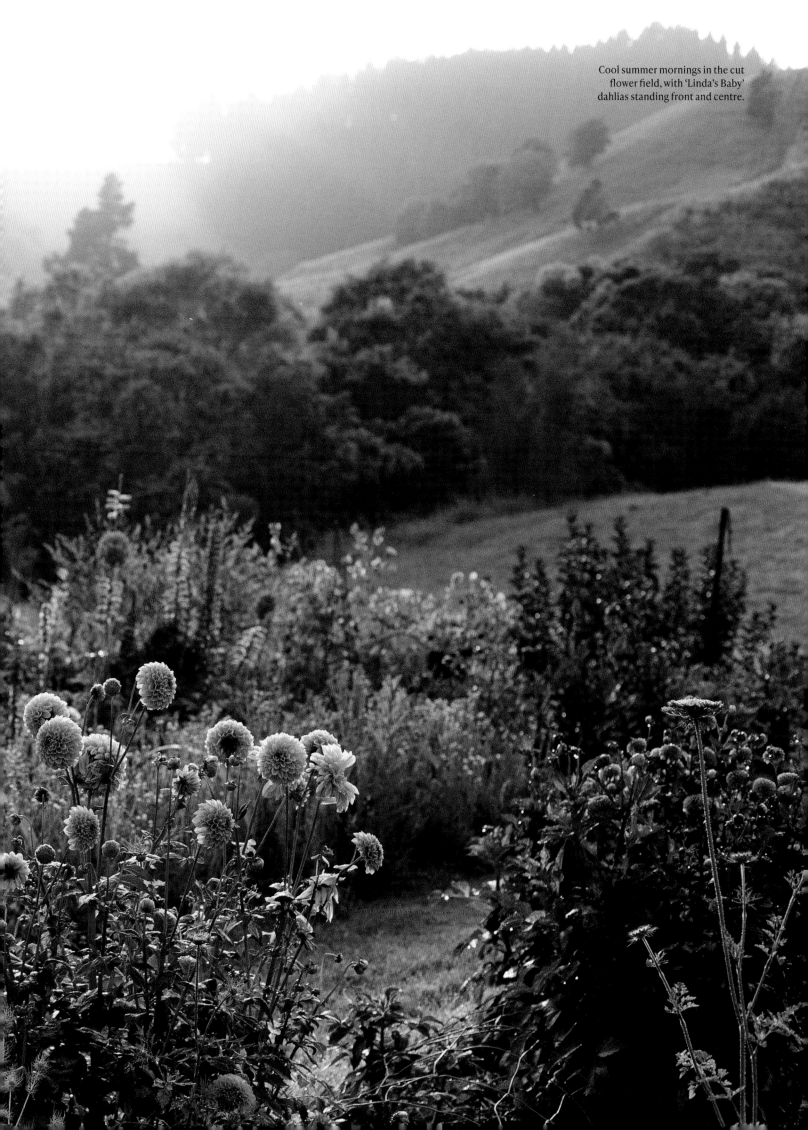

Cool summer mornings in the cut
flower field, with 'Linda's Baby'
dahlias standing front and centre.

—THE—
MUSICIAN

For me, the visual crescendo of a flower border in the last weeks of summer feels the same as a symphony reaching its climax. The lambs running the fence line at dusk, the same as an acoustic folk song gently warming my ears. Twinkling flutes are the birds' morning chorus. A drum's booming solo, claps of thunder. If it was ever possible for eyes and ears to morph into each other, it would happen in my body.

I find a spot in the middle of the garden, comfortably propped up against the foot of the plum tree, guitar resting across my thighs. Opposite me, dahlias bask in the sunlight, bobbing their heads to the beat of the wind. The bronze-headed sunflowers softly tick-tock back and forth like giant metronomes, my fingers picking strings to their timing.

I close my eyes to listen without the distraction of sight, picking up the urgent conversation of a pair of fantails as they dart between the branches above. Their tiny cheeps fade in and out as the wind carries them away, pushing me to find the high-pitched notes to match their tone. In the garden bed behind me, the pea straw crackles in the heat, a textured sound that my guitar can't quite reflect. Yet another inspired musical challenge presented to me by my musical muse, the garden.

—— TURN THE PAGE TO SEEK & FIND ——

1. A HARMONICA ON A SET OF KEYS 2. A MICROPHONE
3. A TAMBOURINE 4. THREE GUITAR PICKS 5. FOUR CASSETTE TAPES
6. A PAIR OF DRUMSTICKS 7. A GOLDEN RECORD 8. PIANO KEYS
9. 'THE MINOR CHORDS' 10. SCRIBBLED LYRICS

Answers on page 165

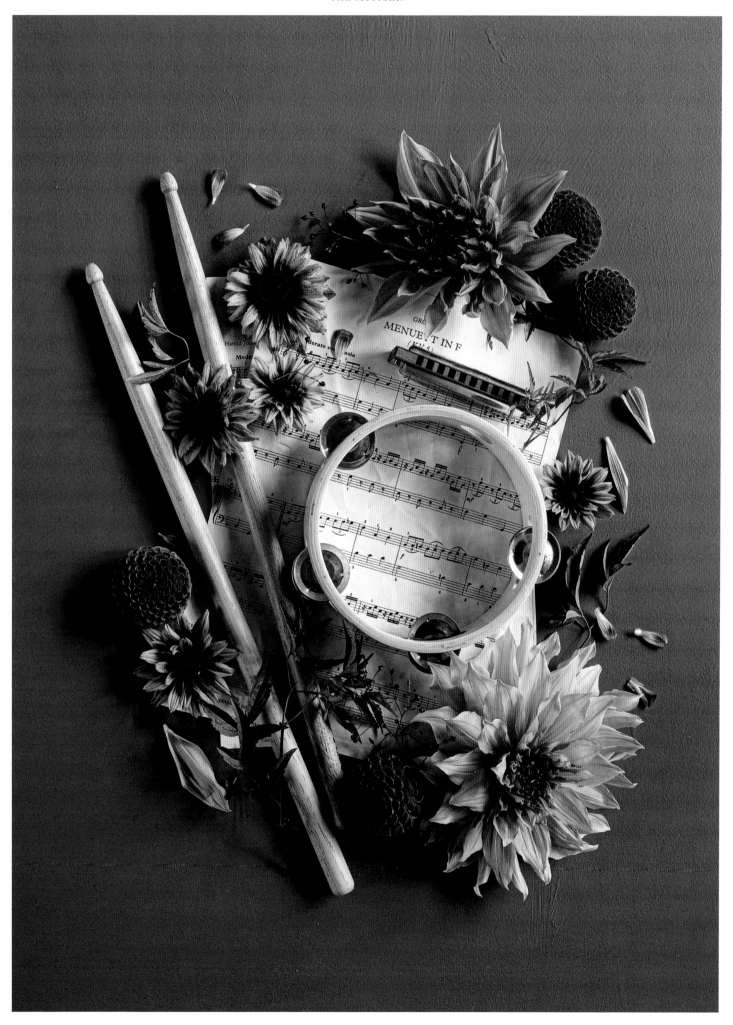

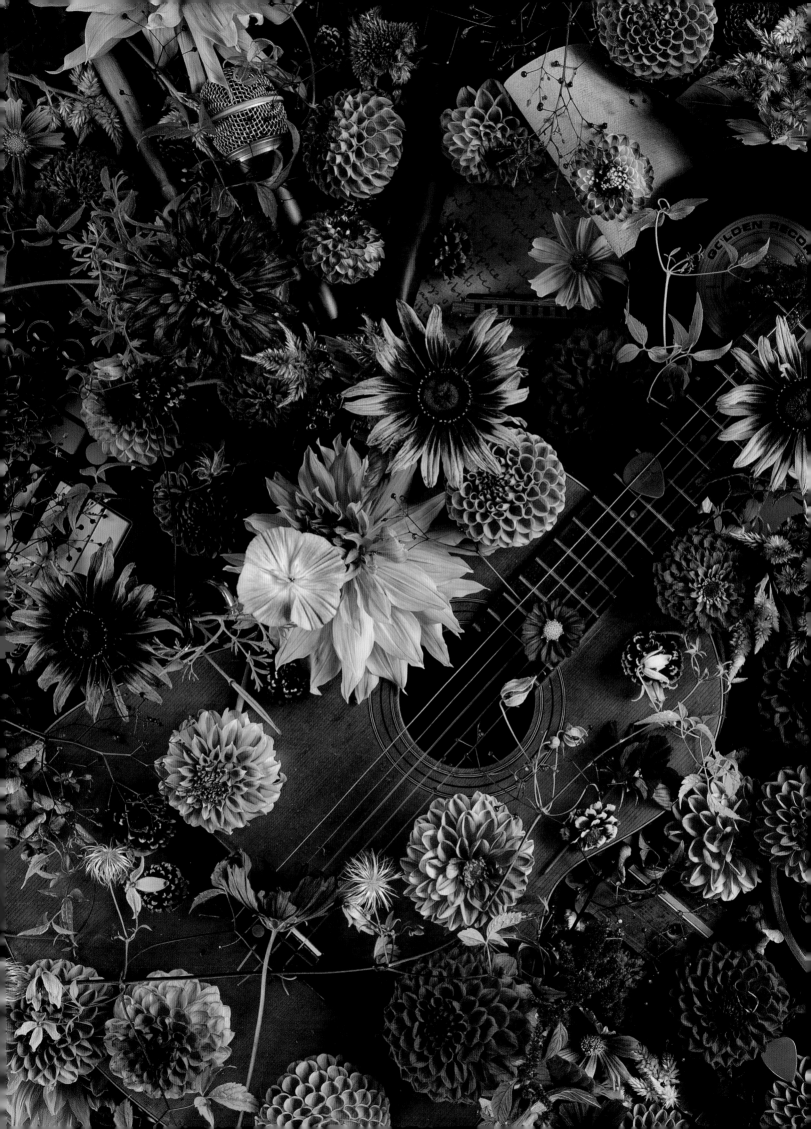

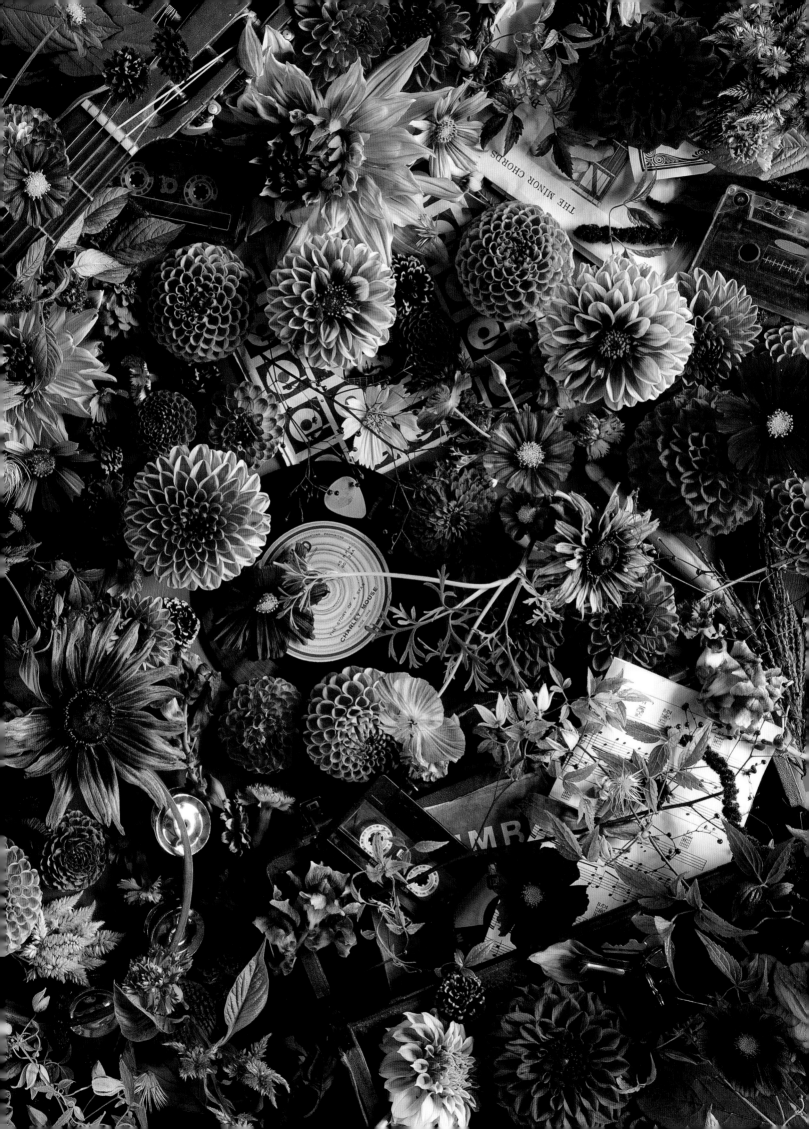

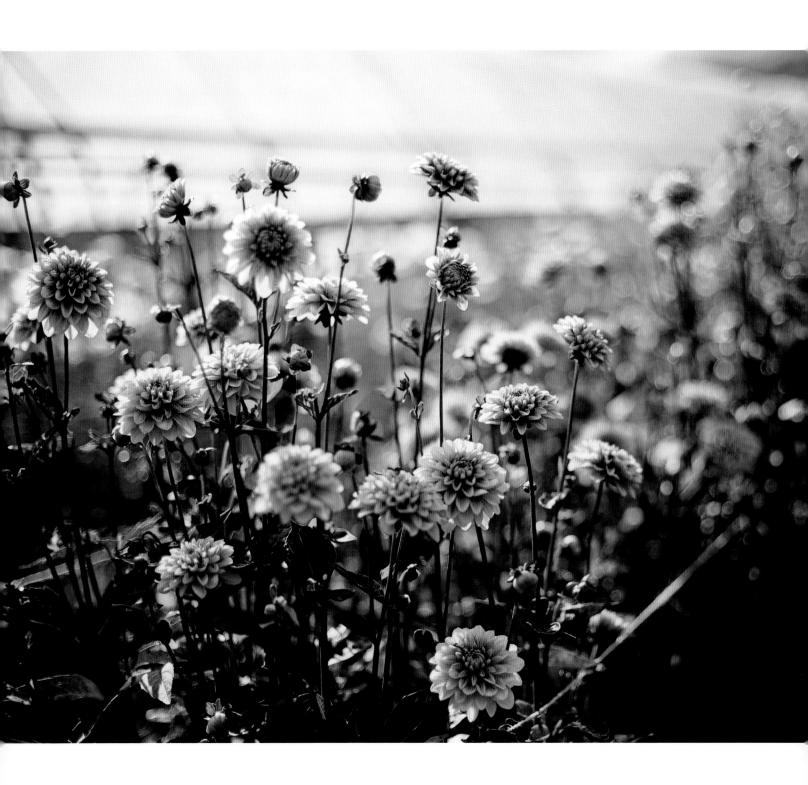

Dahlia 'Strawberry Cream' basking in the sunlight.

Opposite me, dahlias bask in the sunlight, bobbing their heads to the beat of the wind. The bronze-headed sunflowers softly tick-tock back and forth like giant metronomes, my fingers picking strings to their timing.

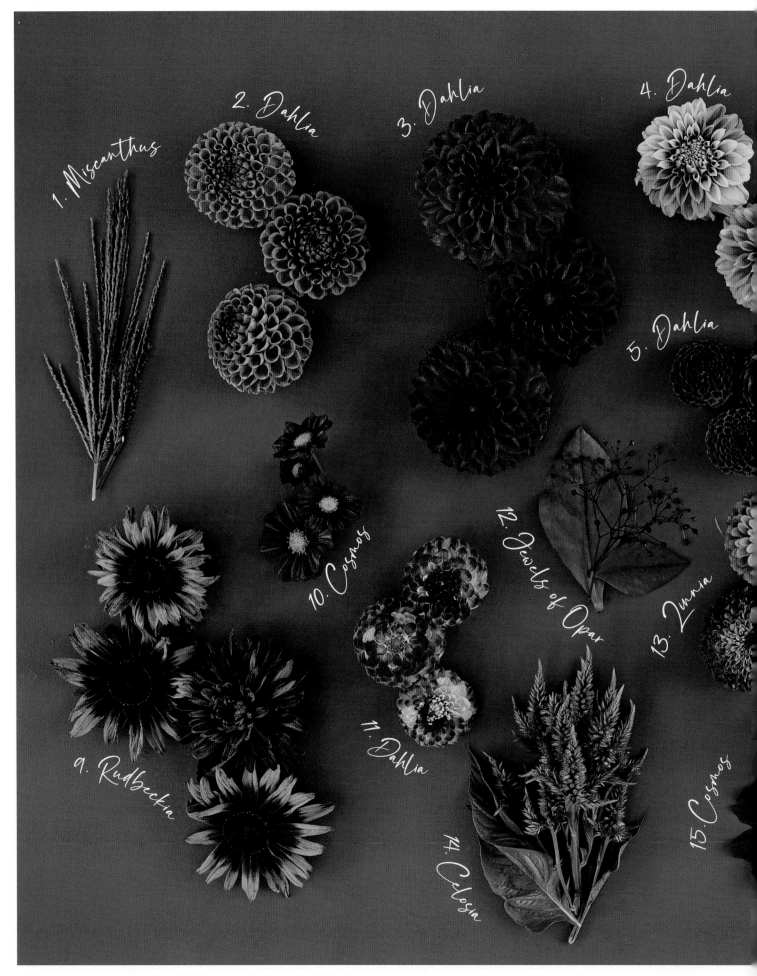

1. *Miscanthus sinensis* 'Morning Light' 2. *Dahlia* 'Cornell Bronze' 3. *Dahlia* 'Ailsa Bailey' 4. *Dahlia* 'Peaches N' Cream' 5. *Dahlia* 'Kokopuff' 6. *Dahlia* 'Sherwood's Peach' 7. *Dahlia* 'Wine Eyed Jill' 8. *Cosmos bipinnatus* 'Apricot Lemonade' 9. *Rudbeckia hirta* 'Sahara' 10. *Cosmos* bipinnatus 'Xsenia' 11. *Dahlia* 'Hollyhill Calico'

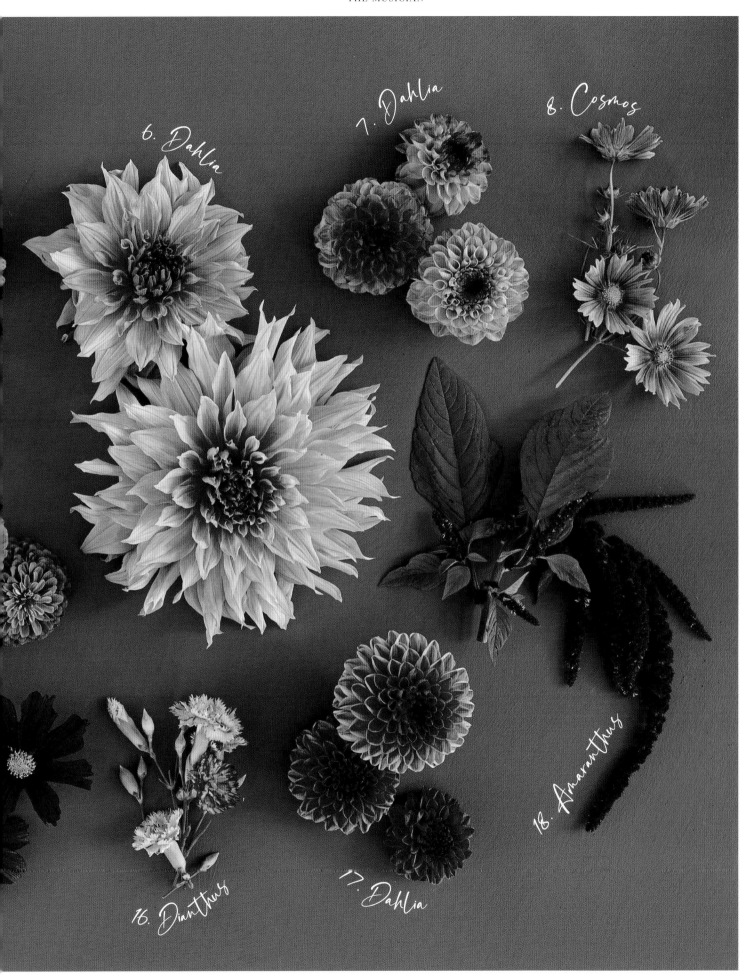

6. Dahlia

7. Dahlia

8. Cosmos

16. Dianthus

17. Dahlia

18. Amaranthus

12. *Talinum paniculatum* 13. *Zinnia elegans* 'Queen Lime Orange' 14. *Celosia argentea spicata* 'Celway Terracotta' 15. *Cosmos bipinnatus* 'Rubenza' 16. *Dianthus caryophyllus* 'Chabaud Orange Sherbet' 17. *Dahlia* 'Daisy Duke' 18. *Amaranthus caudatus* Love-Lies-Bleeding

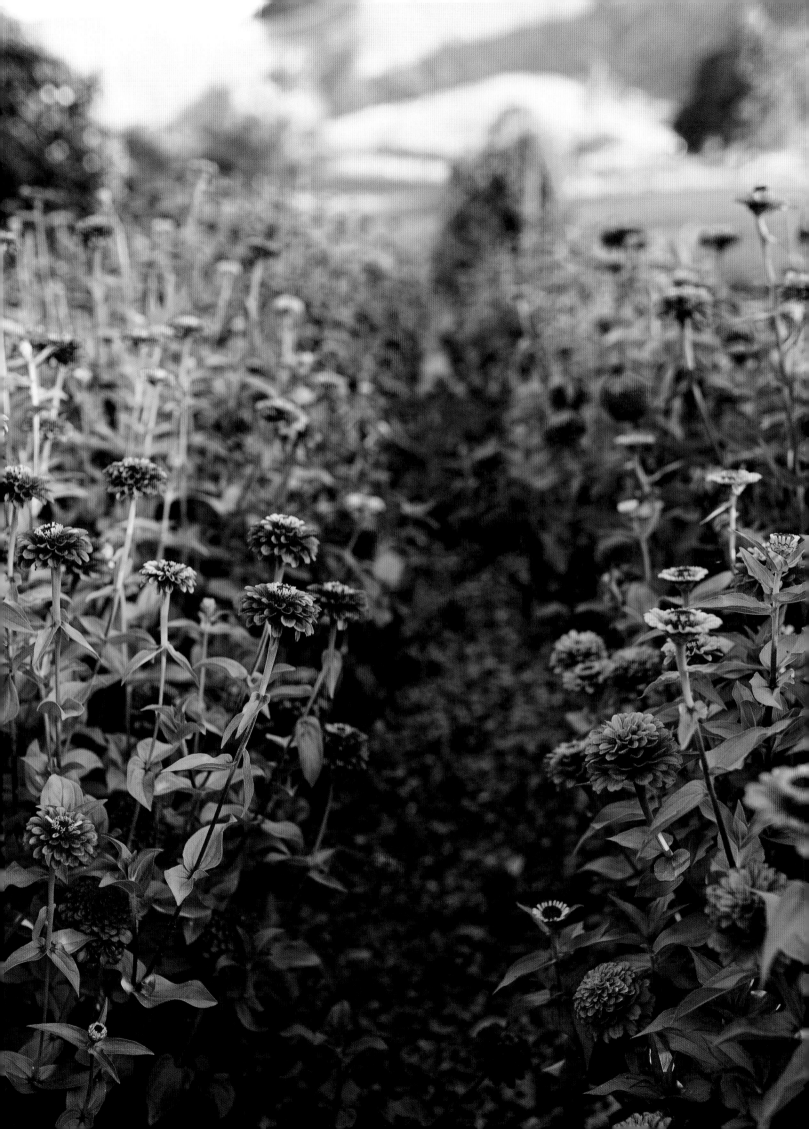

Opposite: Rainbow rows of zinnias – 'Queen Lime Red' and 'Queen Lime Orange' – a summer staple.
Below: An abundant armful of favourite zinnia 'Queen Lime Red'.

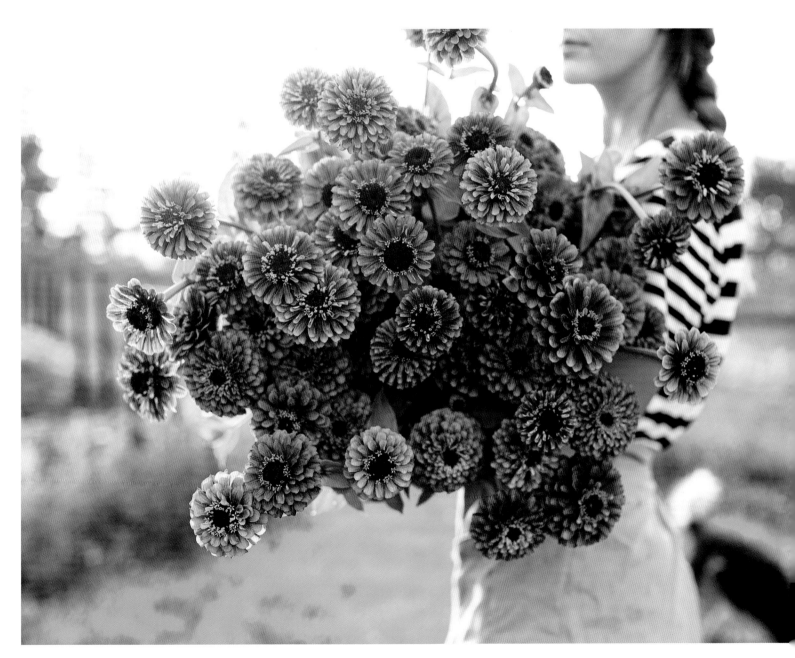

—THE—
EMBROIDERER

As the summer gloaming stretched its golden fingers across the garden, I settle into my old chair by the window. Though a little tattered around the edges, it has become a comfortable collaborator - cradling me as I stitch, supporting my cup of tea on its arm. I loop a length of colour around my finger, then the needle resumes its work, allowing my thoughts to wander at will.

Warm light twinkles through the old rose that rambles up and across the corner of the cottage, bringing with it wafts of delicious scent. Its tentacled arms shift in the breeze, the silky smoothness of its petals fading pink to amber like the sunset. These tones and textures bury themselves in my mind, to reappear in my stitched artwork.

The garden beds I have worked with my hands now serve as inspiration for my thread, which traces their lines in embroidered imitation. I strive to interpret the detail of leaf, petal and stem into stitch and knot, to capture this ephemeral beauty in a form that lives on forever. My garden exists as a palette to be rifled through, where my memories can be drawn in yarn.

———— TURN THE PAGE TO SEEK & FIND ————

1. FOUR NEEDLES 2. THREE WOODEN HOOPS 3. A BOWL OF BEADS
4. A PINCUSHION 5. THREE YELLOW THREADS 6. TWO BALLS OF YARN
7. PINK EMBROIDERED FLOWERS 8. A MEASURING TAPE
9. A SKETCH OF A ROSE 10. SCISSORS

Answers on page 165

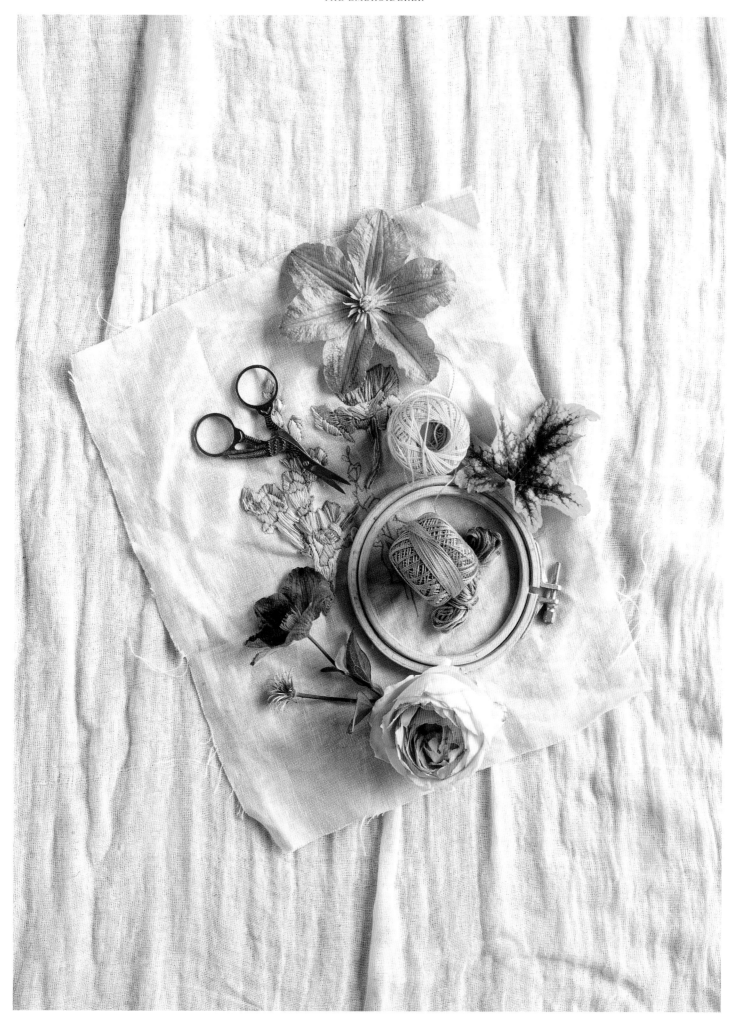

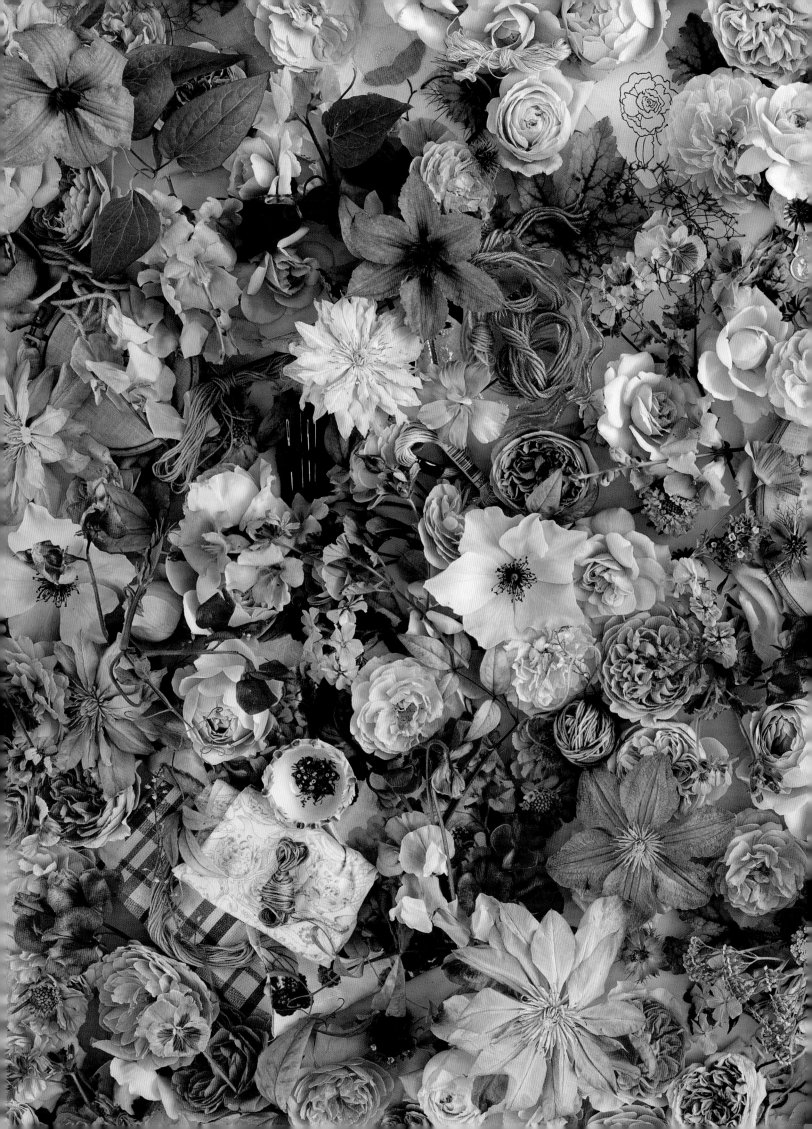

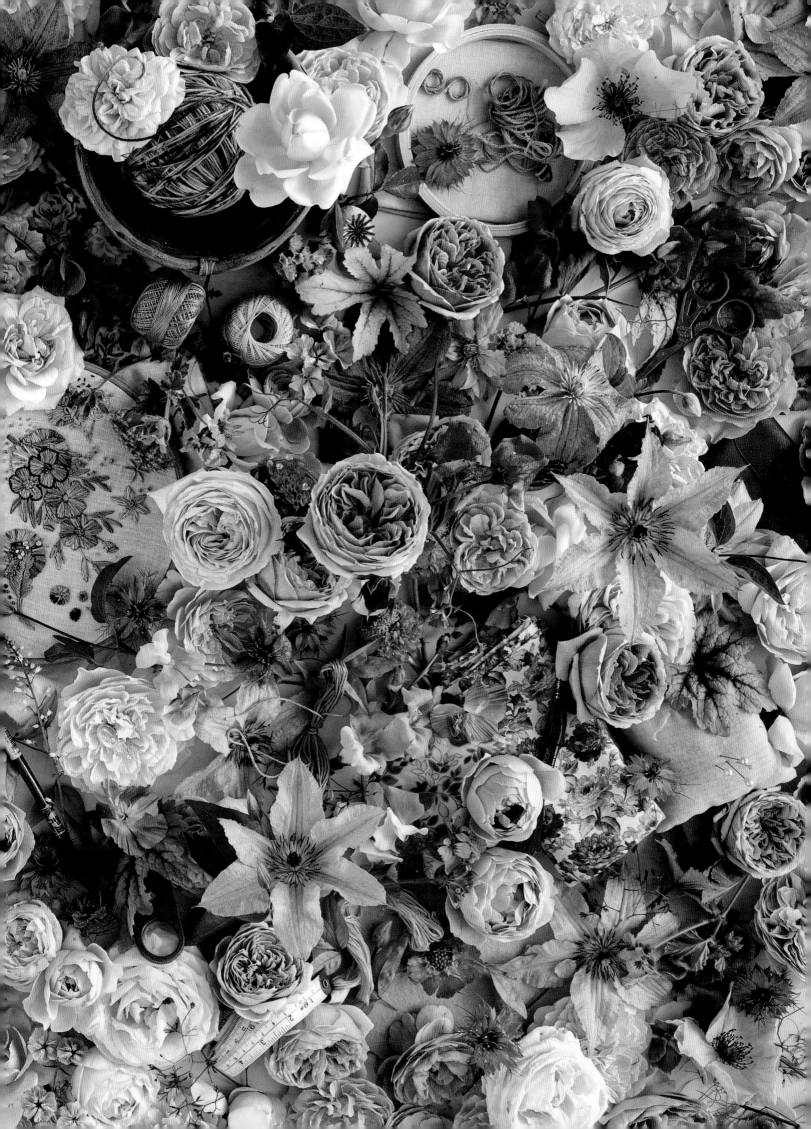

"The garden beds I have worked with my hands now serve as inspiration for my thread, which traces their lines in embroidered imitation. I strive to interpret the detail of leaf, petal and stem into stitch and knot, to capture this ephemeral beauty in a form that lives on forever."

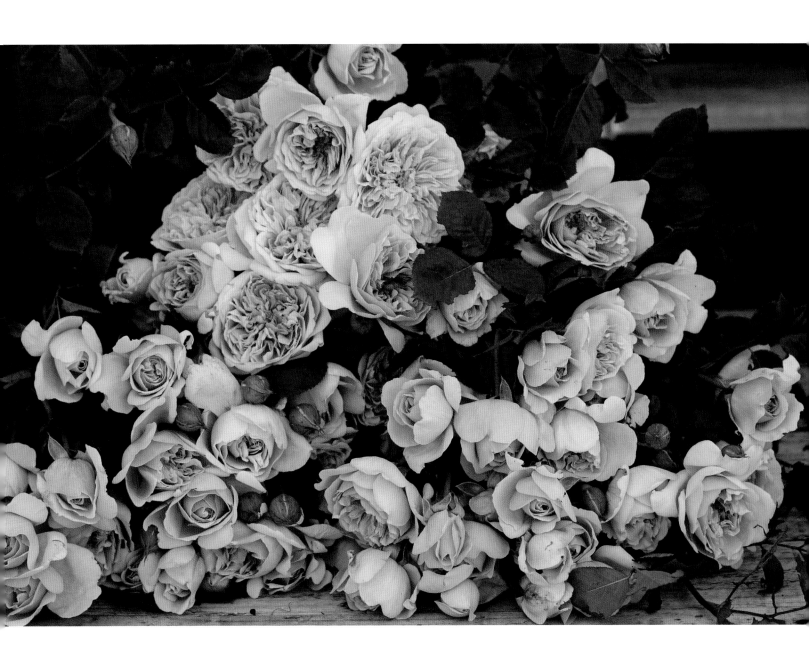

Freshly cut aromatic bunches of 'Tea Clipper' rose.

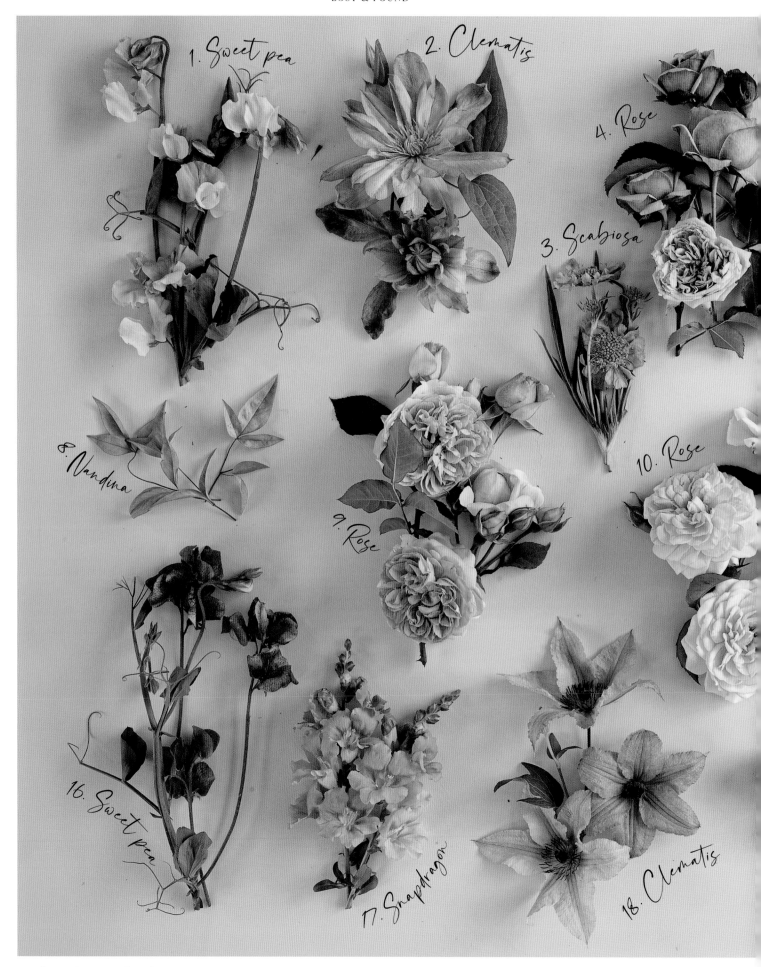

1. Sweet pea
2. Clematis
4. Rose
3. Scabiosa
8. Nandina
9. Rose
10. Rose
16. Sweet pea
17. Snapdragon
18. Clematis

1. *Lathyrus odoratus* 'Frilly Milly' **2.** *Clematis* 'Violet Elizabeth' **3.** *Scabiosa caucasica* 'Fama Blue' **4.** *Rosa* 'Pretty Jessica' **5.** *Rosa* 'Molineux' **6.** *Rosa* 'Jude the Obscure' **7.** *Rosa* 'Pierre de Ronsard' or 'Eden' **8.** *Nandina domestica* **9.** *Rosa* 'Radio Times' **10.** *Rosa* 'Pegasus' **11.** *Scabiosa atropurpurea* **12.** *Heucherella* 'Alabama Sunrise' **13.** *Rosa* 'Strawberry Hill' **14.** *Nigella sativa* **15.** *Clematis* 'Comtesse de Bouchaud' **16.** *Lathyrus x hammettii* 'Future Shock' **17.** *Antirrhinum majus*

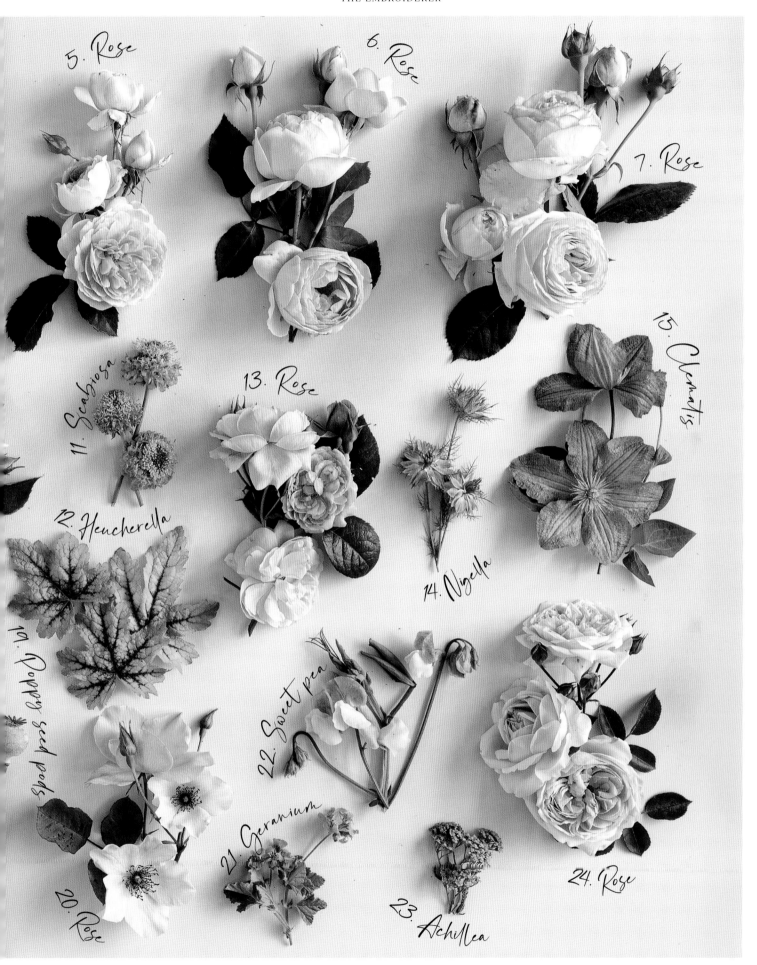

5. Rose
6. Rose
7. Rose
11. Scabiosa
13. Rose
15. Clematis
12. Heucherella
14. Nigella
19. Poppy seed pods
22. Sweet pea
21. Geranium
20. Rose
23. Achillea
24. Rose

'Chantilly Light Salmon' **18.** *Clematis* 'Hagley Hybrid' **19.** *Papaver somniferum* Bread Seed Poppy **20.** *Rosa* 'Dainty Bess' **21.** *Pelargonium crispum* Lemon Scented Geranium **22.** *Lathyrus odoratus* 'Cold Steel' **23.** *Achillea millefolium* 'Peach' **24.** *Rosa* 'Wildeve'

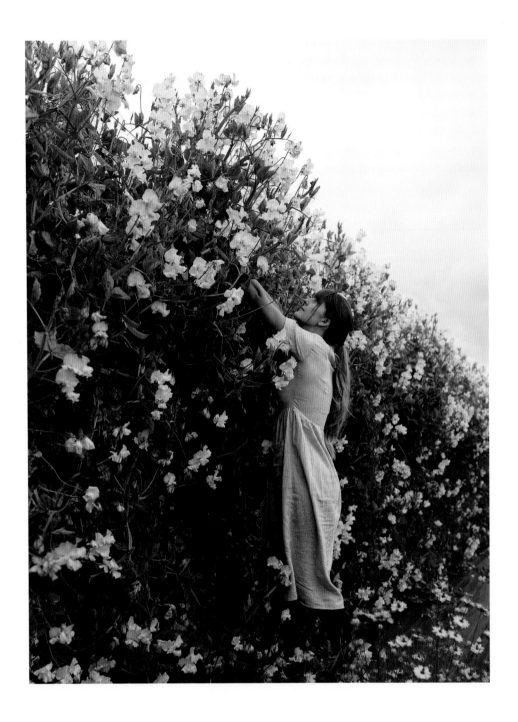

Opposite: Sweet pea walls of 'Mollie Rilstone'. **Below:** Freshly cut bunches of sweet pea 'Piggy Sue'.

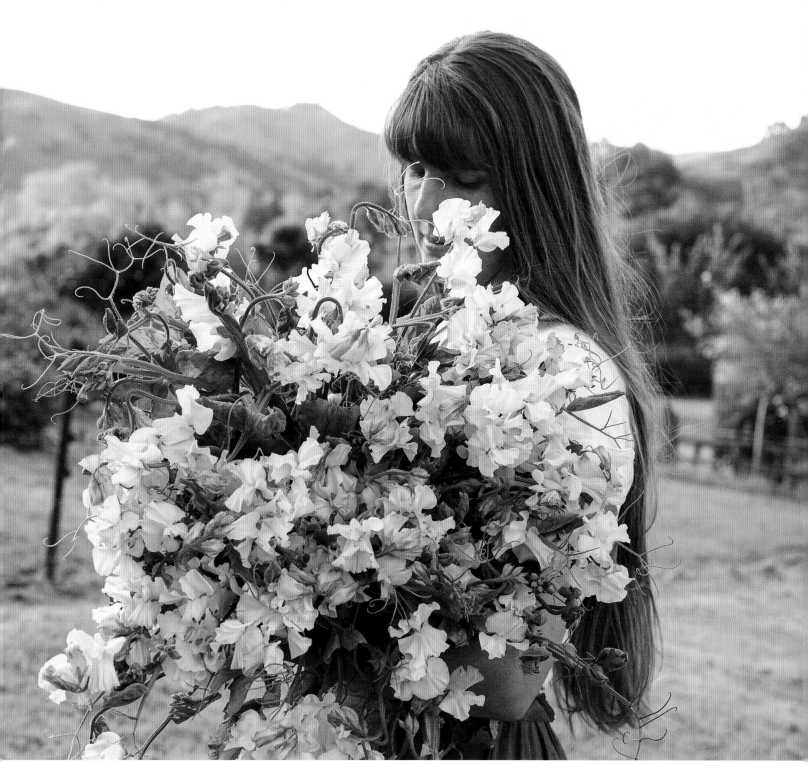

—THE—
STARGAZER

The neighbour's living-room light switched off for the night, the signal that my garden would finally be plunged into darkness. Despite living in town, I was one of the lucky ones with a backyard positioned far from the streetlights, protected by the shadow of the house.

I stepped out the door, woollen hat on head, torch in hand, moving silently to the lawn, where I got down to the ground and then collapsed softly onto my back. My fingers burrowed into the grass to connect with the earth below.

The Milky Way was startling, even to the naked eye. Her trail across the sky seemed dusted with violet, pulling me upward into infinite galaxies. I tracked across it slowly, trying to focus on twinkles that distracted but then disappeared the moment I paused. Turning my head slightly, I found the Southern Cross, a strong and reliable anchor for my eyes to rest on. Relaxed and quiet, my smallness was laid bare by the endless expanse above. My mind flooded with the wonder, the mystery, the rhythm of this universe that surrounds us all.

Shuffling to move out from under the silhouetted arms of the cherry tree, I found the moon in her final phase, a perfect waning crescent, and thought about how her steady cycle of transformation impacted the very fabric of life in my garden. I drew in and let a deep breath out, basking in the moon's soft glow and reflecting on the month gone by, letting my thoughts wander up to join her in space.

——— TURN THE PAGE TO SEEK & FIND ———

1. A MOON CALENDAR **2.** A TELESCOPE **3.** A TORCH **4.** SATURN'S RINGS
5. VAN GOGH'S *STARRY NIGHT* **6.** FIVE STARS **7.** MERCURY **8.** NEPTUNE
9. A WOOLLEN BEANIE AND A THERMOS FOR COLD STARRY NIGHTS

Answers on page 166

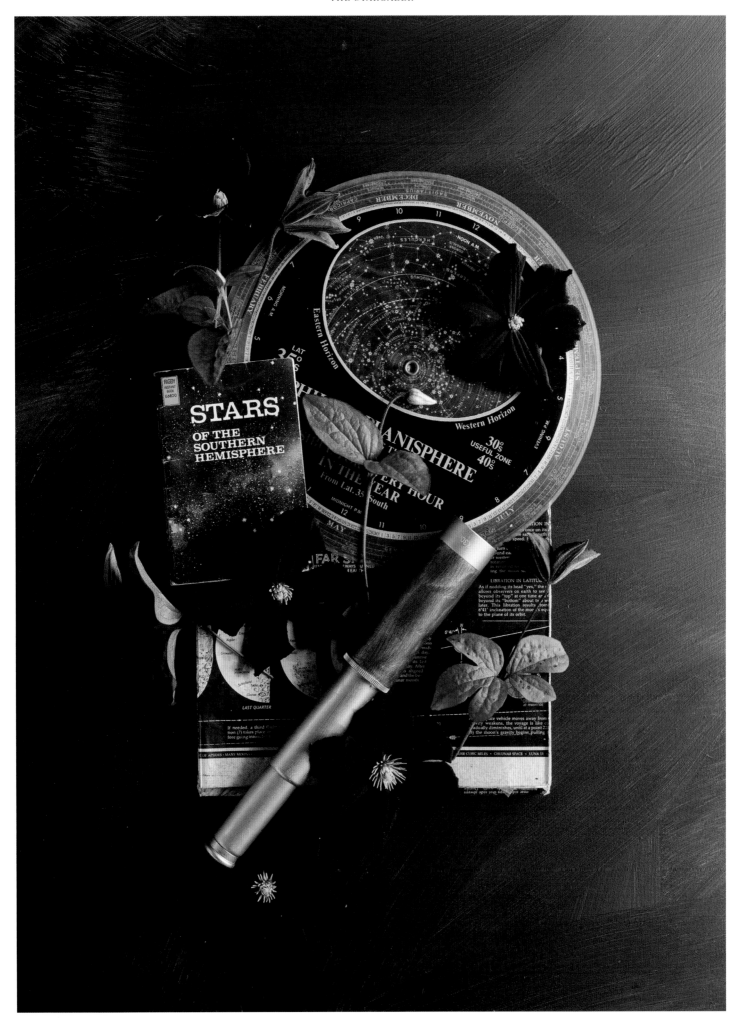

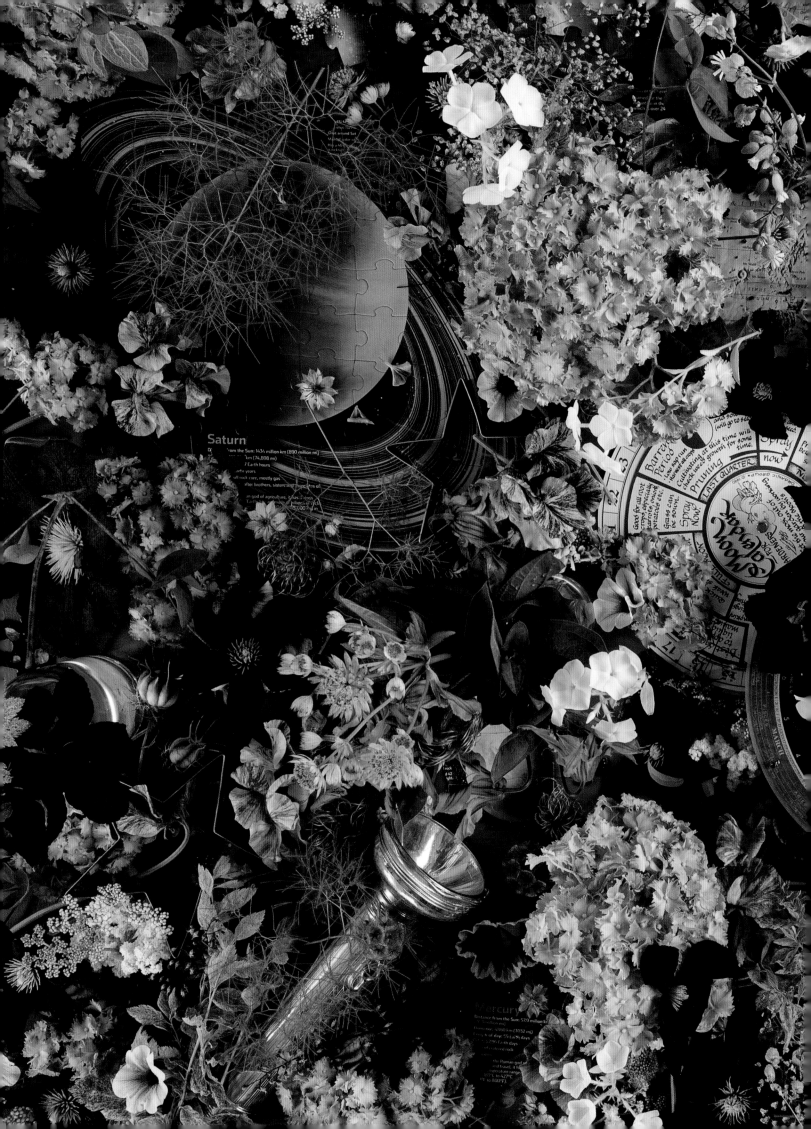

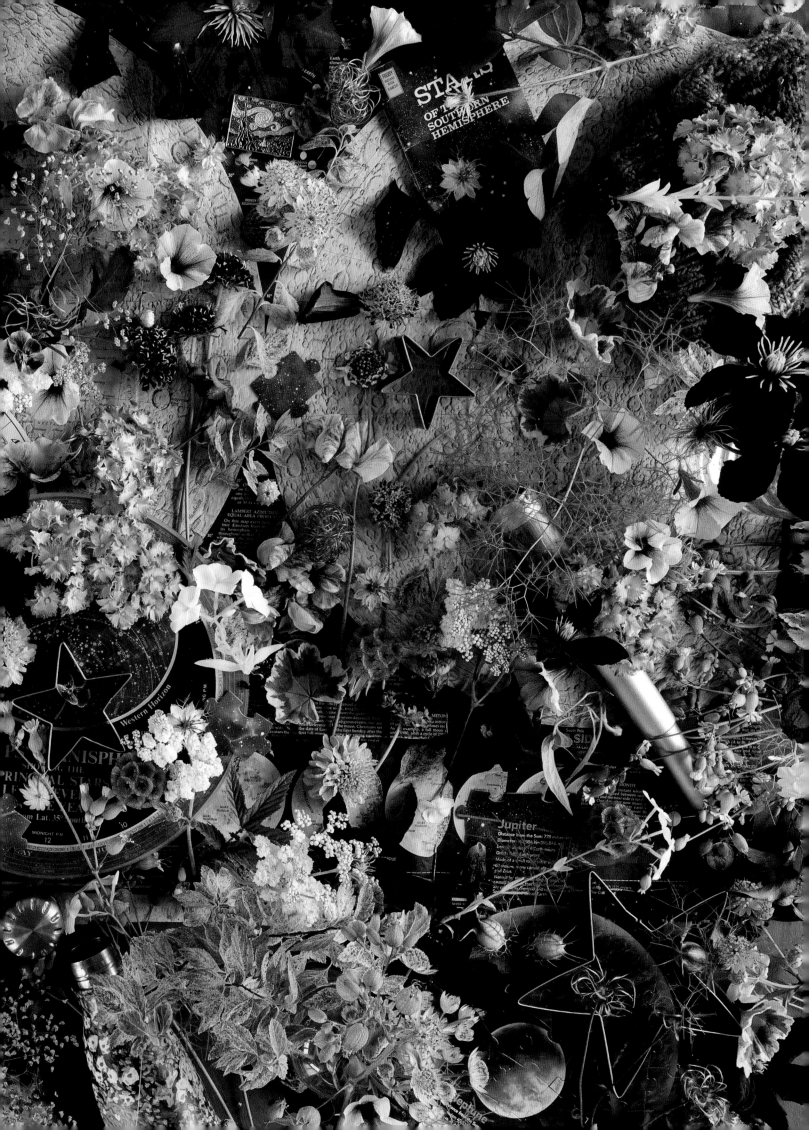

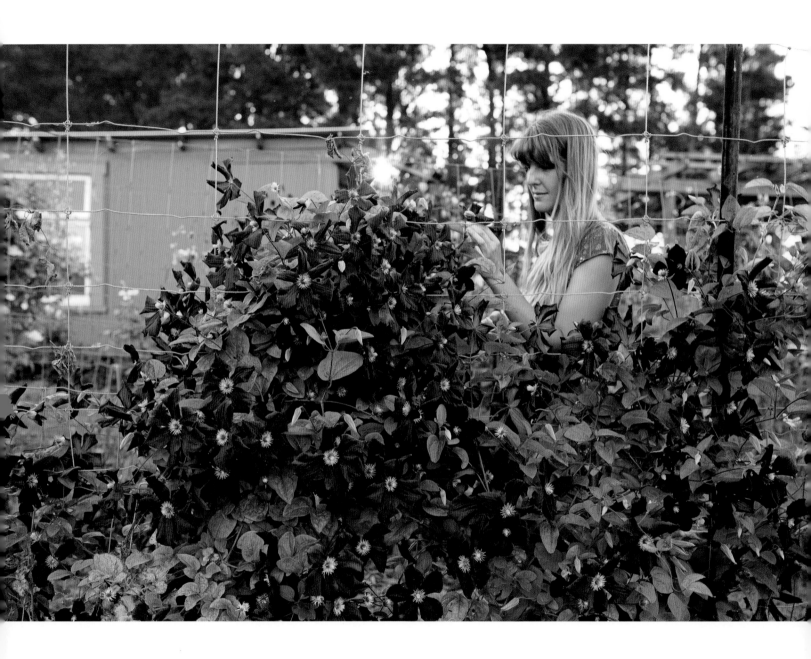

Tending to the rows of clematis 'Romantika'.

> "The Milky Way was startling, even to the naked eye. Her trail across the sky seemed dusted with violet, pulling me upward into infinite galaxies. I tracked across it slowly, trying to focus on twinkles that distracted but then disappeared the moment I paused."

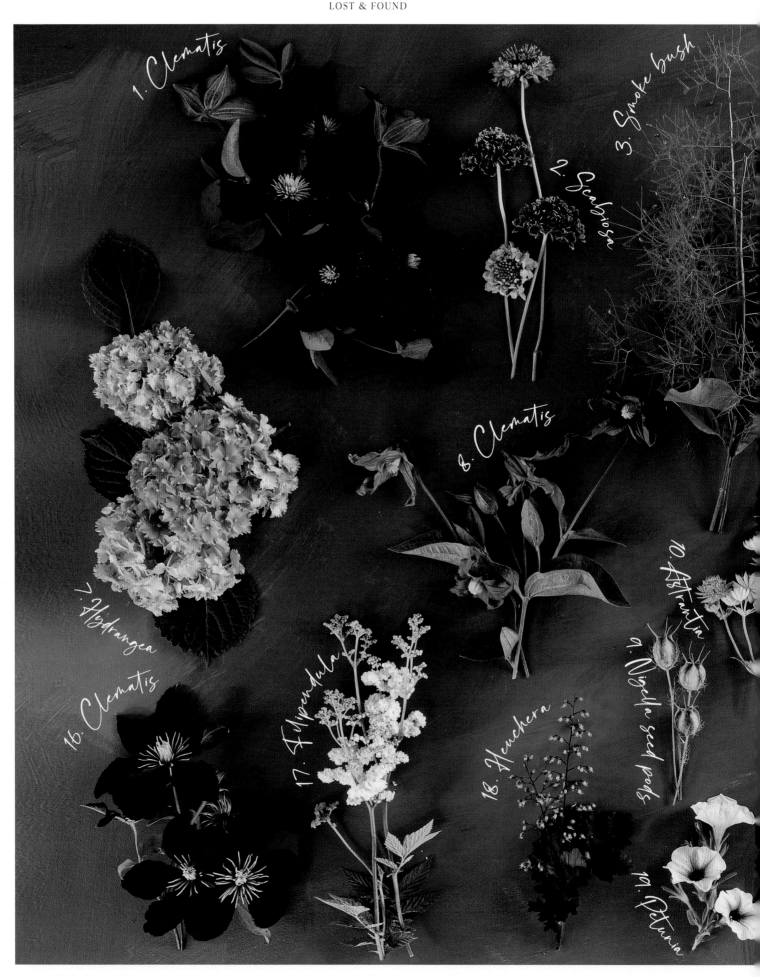

1. *Clematis x jackmanni* 'Romantika' 2. *Scabiosa atropurpurea* 3. *Cotinus coggygria* 4. *Spirea x vanhouttei* 'Pink Ice' 5. *Lathyrus odoratus* 'Chocolate Flake'
6. *Clematis* 'Haku Ookan' 7. *Hydrangea macrophylla* 'Frillibet' or similar 8. *Clematis integrifolia* 'Mongolian Bells' 9. *Nigella sativa* 'Persian Jewels Mix'
10. *Astrantia major* 11. *Pelargonium* 'Mrs Pollock' 12. *Viola cornuta* 'Plums & Peaches' 13. *Phlox drummondii* 'Alba' 14. *Scabiosa stellata* 'Starball' 15. *Briza media*

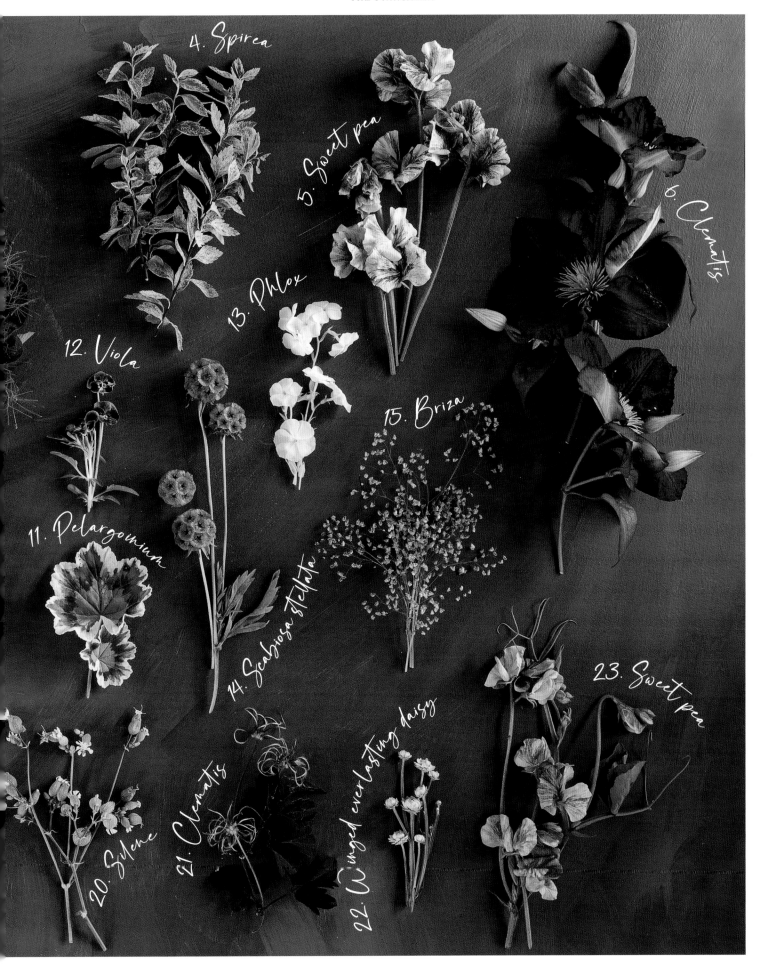

4. Spirea

5. Sweet pea

6. Clematis

13. Phlox

12. Viola

15. Briza

11. Pelargonium

14. Scabiosa stellata

23. Sweet pea

20. Silene

21. Clematis

22. Winged everlasting daisy

'Limouzi' **16.** *Clematis* 'Niobe' **17.** *Filipendula ulmaria* 'Flore Pleno' **18.** *Heuchera* 'Amethyst' **19.** *Petchoa x hybrida* 'BeautiCal French Vanilla' **20.** *Silene vulgaris*
21. *Clematis montana* 'Freda' **22.** *Ammobium alatum* **23.** *Lathyrus odoratus* 'Pandemonium'

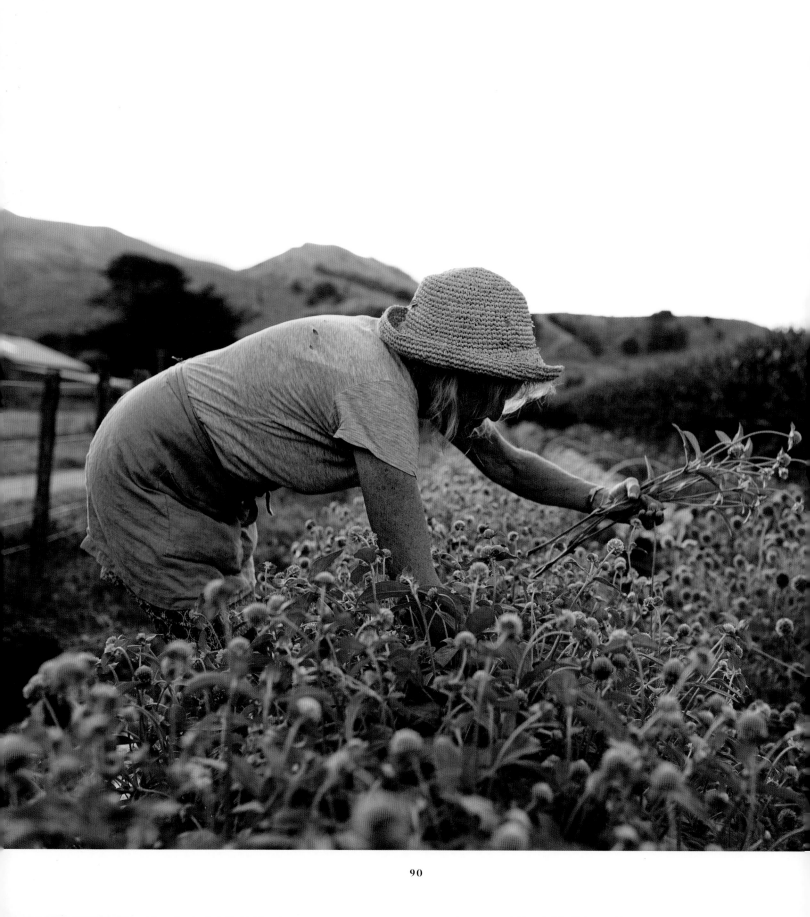

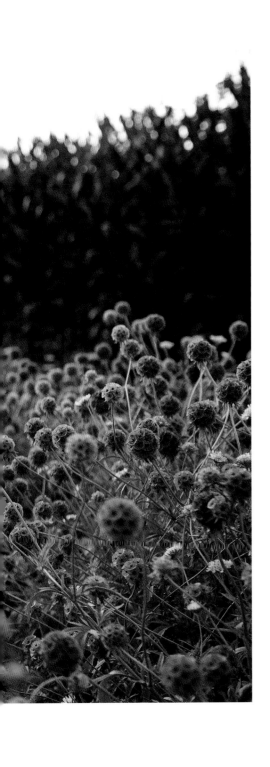

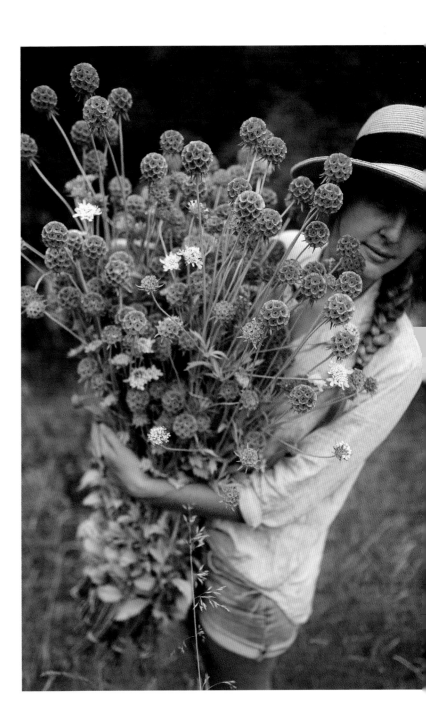

Opposite: Mum in the late afternoon sun picking bunches of 'Audray Bicolor Rose' gomphrena in the late afternoon. **Above:** A generous bunch of freshly picked *Scabiosa stellata* 'Starball'.

—THE—
DIY-ER

Despite the new belt holes I had punched in it for a better fit, my dad's old tool belt slung low on my hips. Its leather pouch and hammer loops were supple from years of use, aiding me in my projects – no matter how successful each one turned out to be. In some ways, it was my lucky charm, loaded with his can-do attitude and clever mind.

Hitching the belt up and clipping my tape measure onto it, I stepped back to eye up my progress, comparing the wooden growing support to my roughly sketched-out plan. 'Getting there,' I thought, reaching for my drill and the screws in my pocket.

It had taken a while for my confidence in construction to find an easy footing, but thanks to a list of completed tasks (and a steady build-up of handy tools), I now felt I could work out anything I put my mind to. The results were always functional, though sometimes lacking a little finesse.

My garden reflected this DIY spirit, with its grid of raised vegetable planters and the arched rose walk made from rebar and wire. The cold frame, in its spot against the fence, had been more than worth the hours of trial and error in its making, while the wine-barrel-turned-rain-collection-tank had inched me through water restrictions last summer. Aside from the growing of my garden, I have found no better satisfaction than the building of its supporting structure.

————— TURN THE PAGE TO SEEK & FIND —————

1. A TOOL BELT **2.** FIVE NAILS **3.** THREE MEASURING TAPES
4. A LEVEL **5.** A PENCIL **6.** A SAW BLADE **7.** THREE HAMMERS
8. A SCREWDRIVER **9.** A PLUG **10.** SOME BAND-AIDS

Answers on page 166

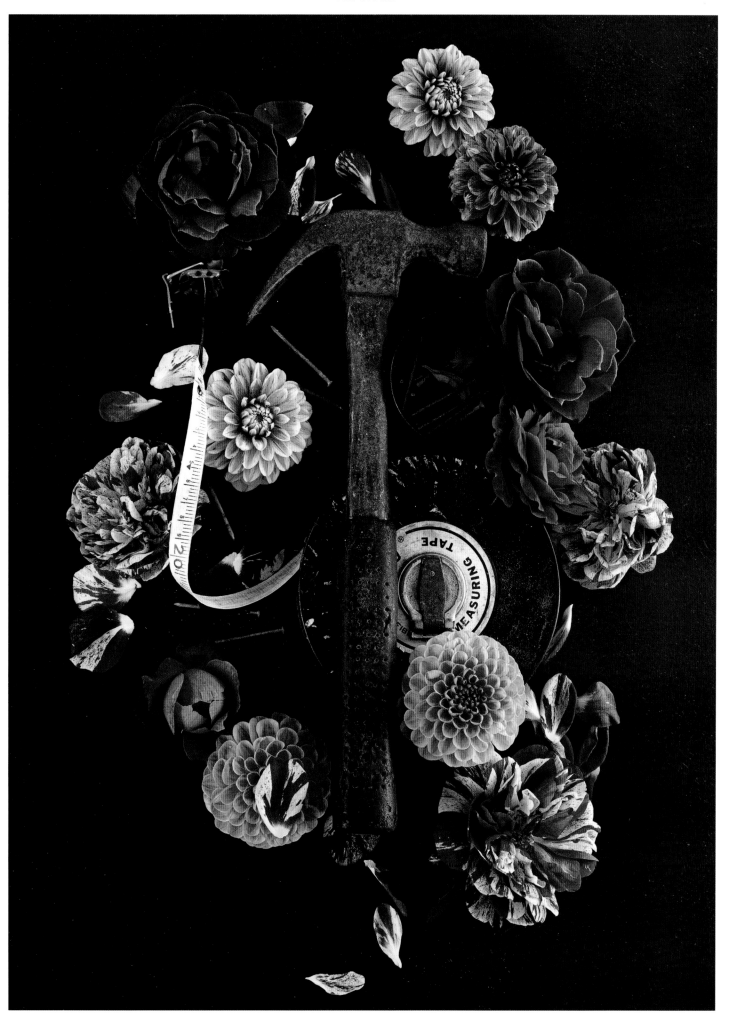

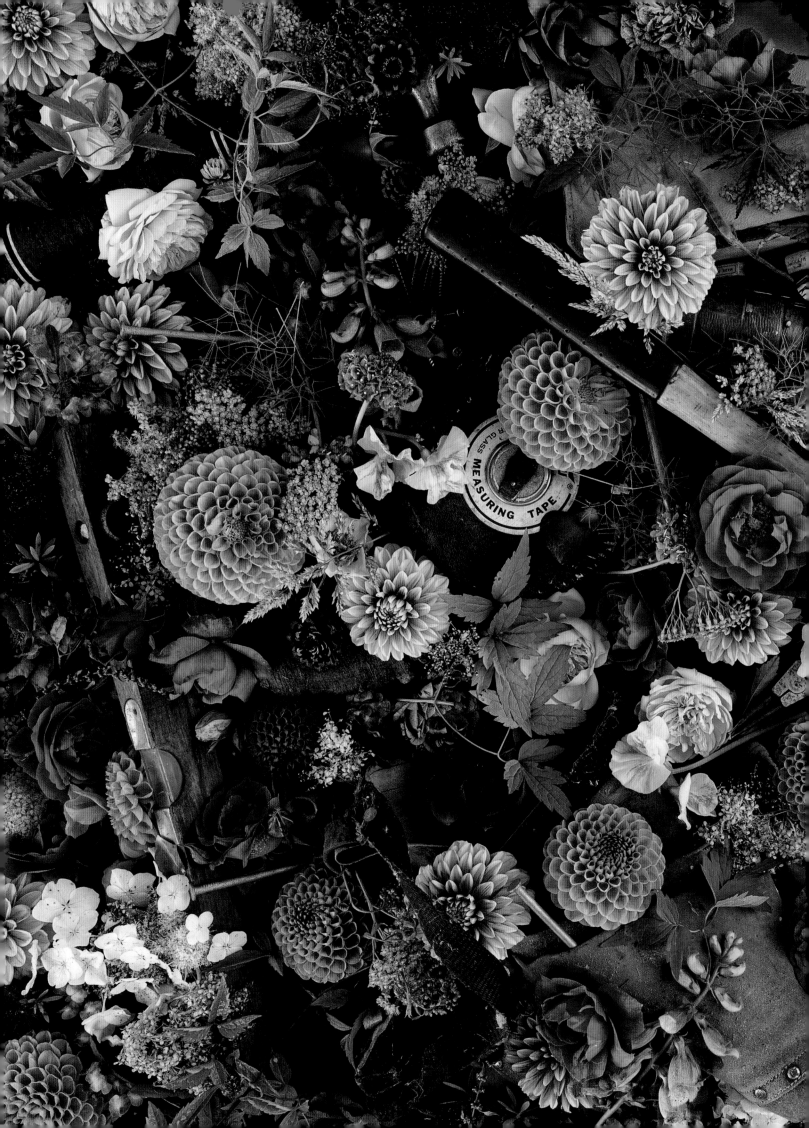

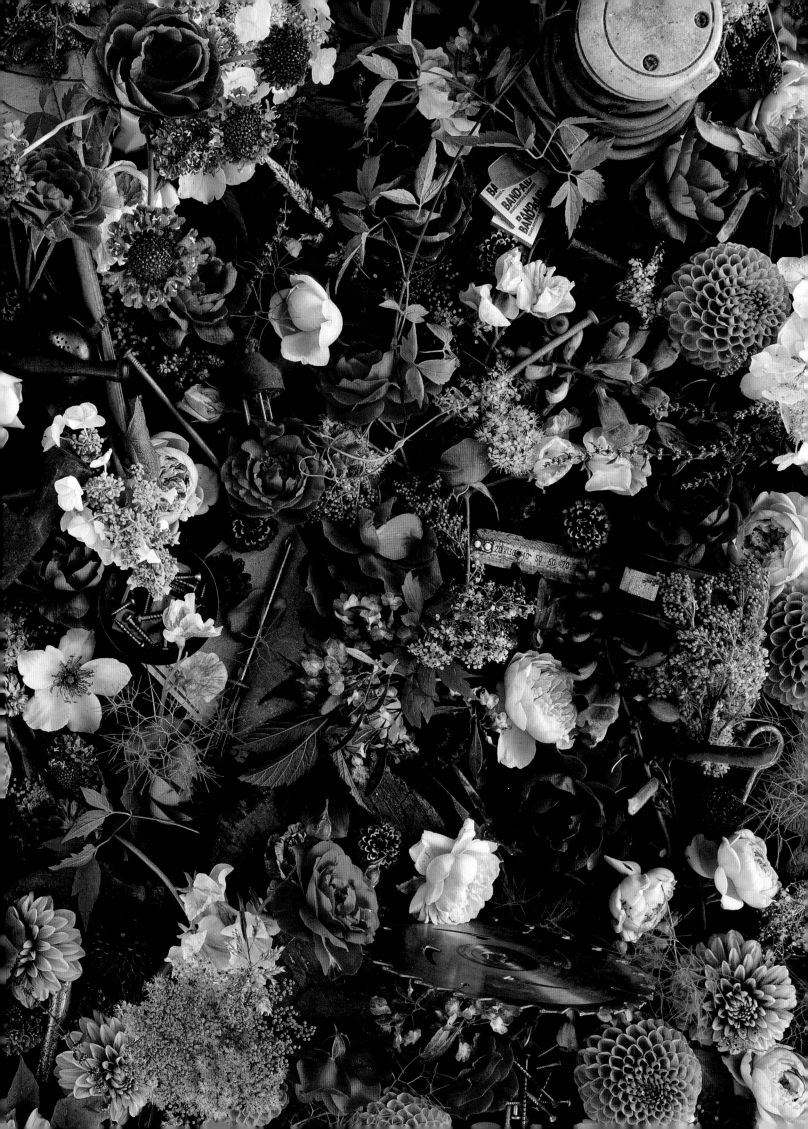

It had taken a while for my
confidence in construction
to find an easy footing, but
thanks to a list of completed
tasks (and a steady build-up
of handy tools), I now felt
I could work out anything
I put my mind to.

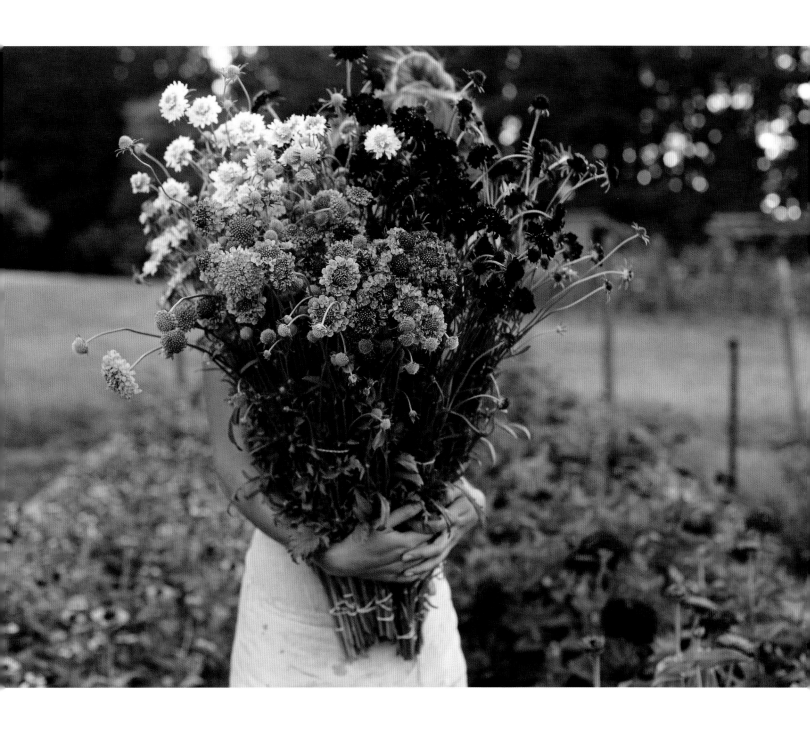

Bunched armfuls of *Scabiosa
atropurpurea* 'Salmon Rose',
'Snowmaiden' and 'Black Knight'.

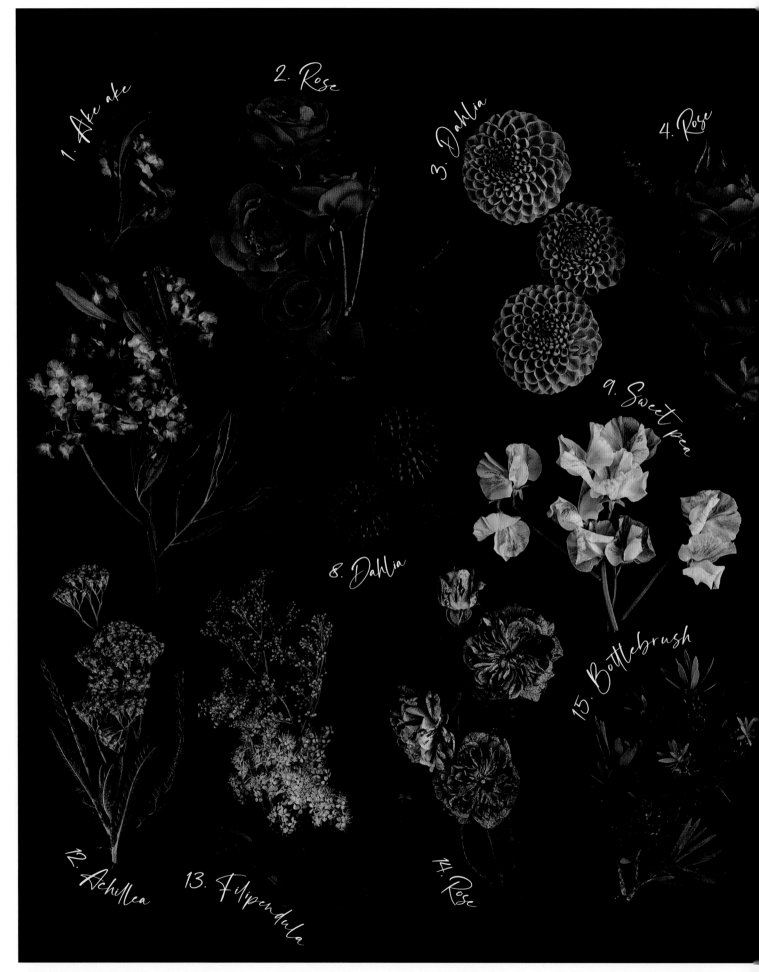

1. *Ake ake*
2. *Rose*
3. *Dahlia*
4. *Rose*
9. *Sweet pea*
8. *Dahlia*
15. *Bottlebrush*
12. *Achillea*
13. *Filipendula*
14. *Rose*

1. *Dodonaea viscosa* 'Purpurea' **2.** *Rosa* 'Hot Chocolate' **3.** *Dahlia* 'Hamari Rose' **4.** *Rosa* 'Kiwi' **5.** *Dahlia* 'Strawberry Cream' **6.** *Zinnia haageana* 'Aztec Burgundy Bicolour' **7.** *Clematis tangutica* Golden Bell Clematis **8.** *Dahlia* 'Burlesca' **9.** *Lathyrus odoratus* 'Vaudeville' **10.** *Rosa* 'The Alnwick Rose' **11.** *Lathyrus odoratus*

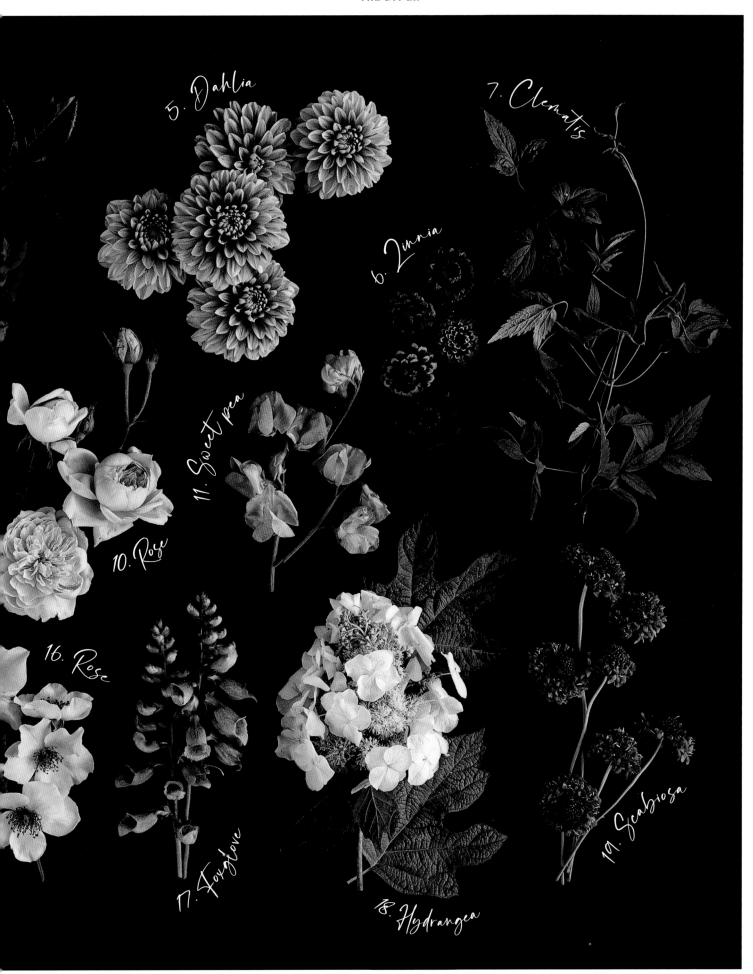

5. Dahlia

7. Clematis

6. Zinnia

11. Sweet pea

10. Rose

16. Rose

17. Foxglove

18. Hydrangea

19. Scabiosa

'Candyfloss' **12.** *Achillea millefolium* 'Summer Berries Mix' **13.** *Filipendula palmata* 'Rubra' **14.** *Rosa* 'Ziggy' **15.** *Callistemon viminalis* 'Red Cluster'
16. *Rosa* 'Dainty Bess' **17.** *Digitalis purpurea* 'Polkadot Pippa' **18.** *Hydrangea quercifolia* Oakleaf Hydrangea **19.** *Scabiosa atropurpurea* 'Salmon Rose'

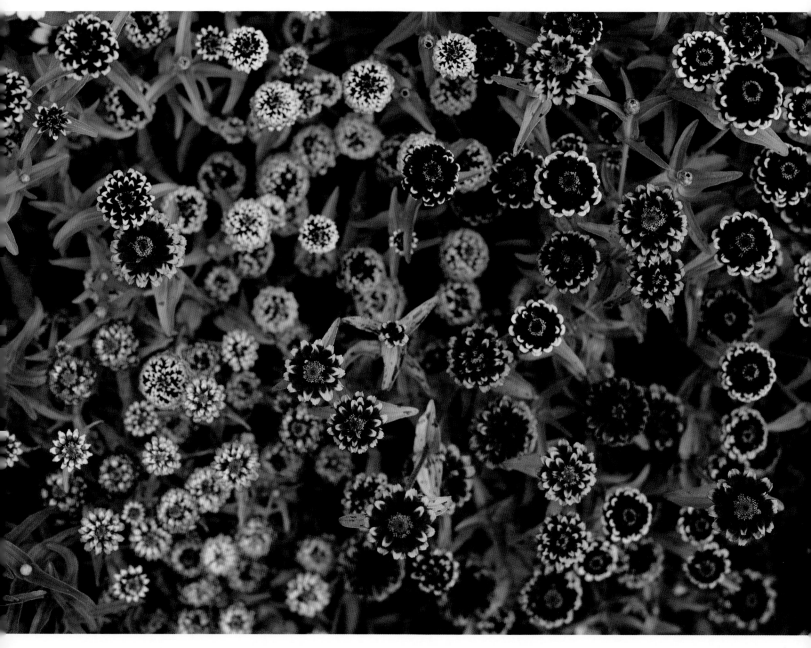

Opposite: A happy gaggle of *Zinnia haageana* 'Jazzy Mix'. **Below:** 'Crème Brûlée' phlox and 'Jazzy Mix' zinnias knitted together amongst the aisles.

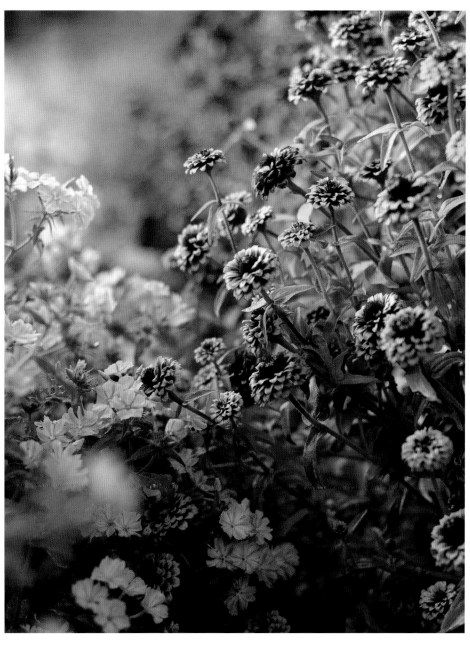

—THE—
ARTIST

With the last swipe of colour from the brush, I tip back on my stool to survey the painting. A canvas of bright strokes stares back at me, glistening in its wetness and saturated rainbow tones. The paint is so loaded in places it looks edible, like icing.

The lowering sun at my back tells me I have been lost in my painter's palette all afternoon. Time and the world disappeared and were replaced with nothing but creating and the soft tinkle of music from the radio.

My cat slides along my leg, a gentle reminder it's time for her dinner. I admire her glossy cream coat and those pale eyes, asking me to hurry along. 'How would I paint her?' I think, my fingers feeling out the colours I might mix.

It's so easy for daily life to zip past in a blur of normalcy. The flash of a yellow dahlia over a fence as you drive by, the blue label on a bottle of milk, the soft variation of moss green to lipstick red in an autumn apple. But these colours imbed themselves in my mind, allowing them to be recalled and channeled with little effort through my hand and brush. My very own way to see the world.

—— TURN THE PAGE TO SEEK & FIND ——

1. FOUR PAINT-COVERED PALETTES **2.** YELLOW MASKING TAPE
3. A RAG **4.** TWO COLOURS MIXED TO MAKE A NEW ONE
5. THREE PALETTE KNIVES **6.** SEVEN PAINT BRUSHES
7. EIGHT PAINT TUBES **8.** A JAR OF WATER **9.** A PINK MARKER
10. MONET'S QUOTE 'I MUST HAVE FLOWERS, ALWAYS, AND ALWAYS'

Answers on page 167

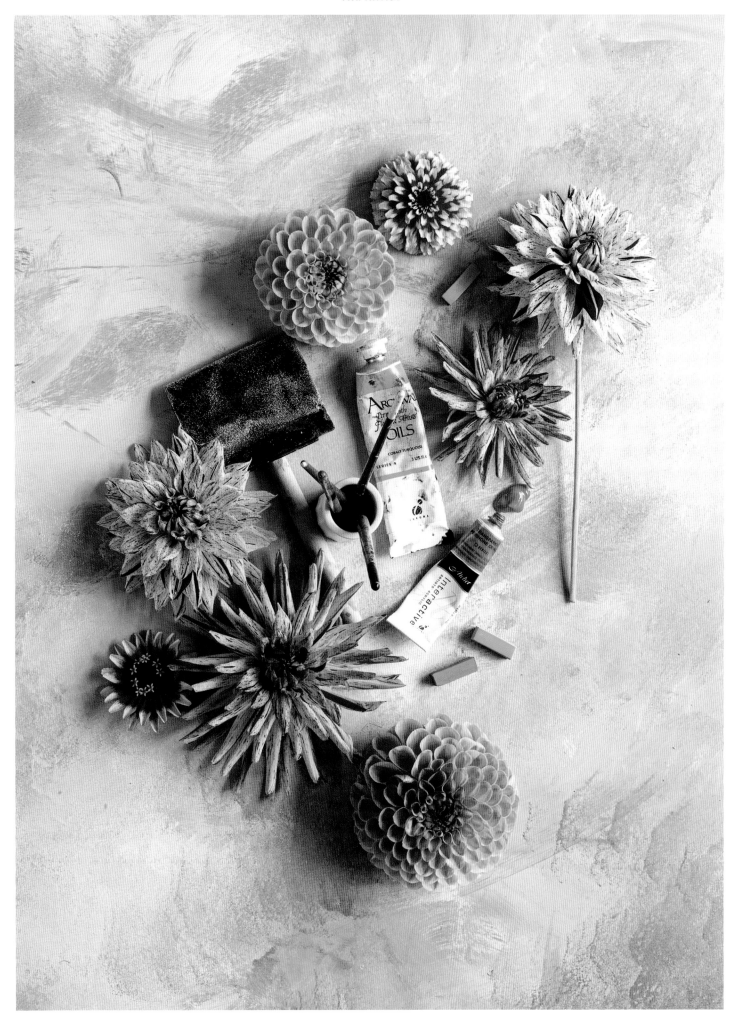

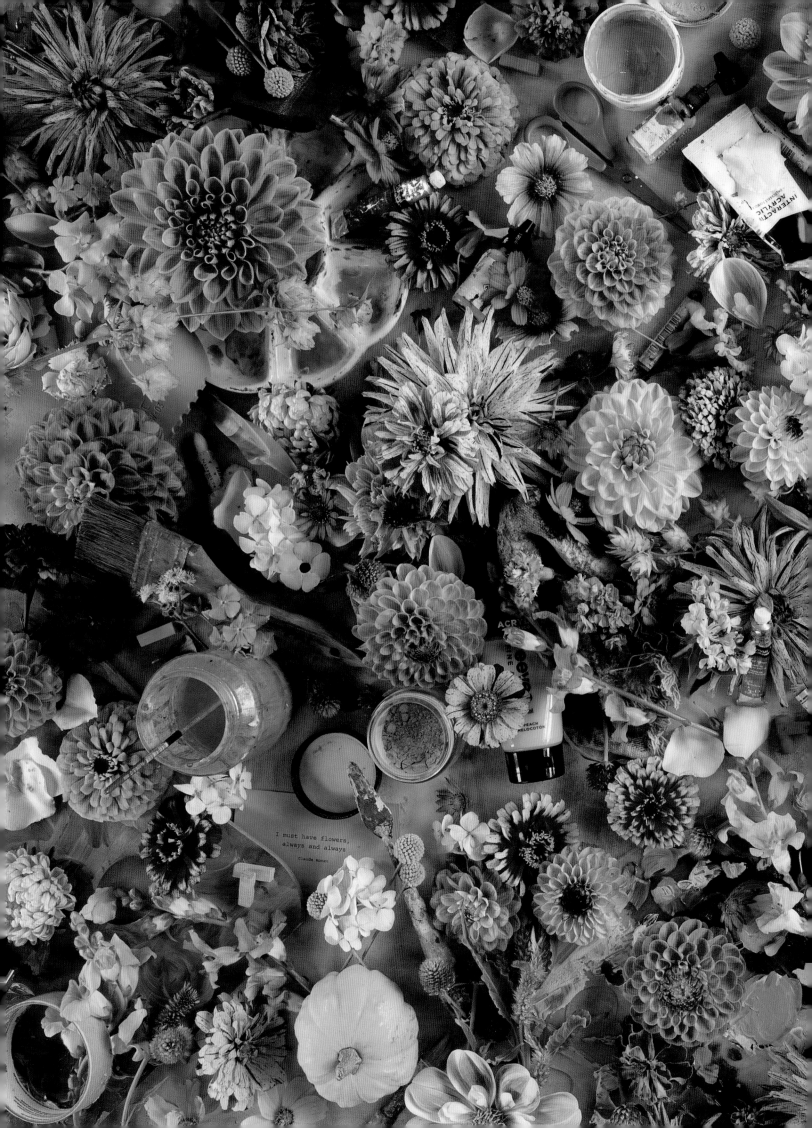

I must have flowers,
always and always

Claude Monet

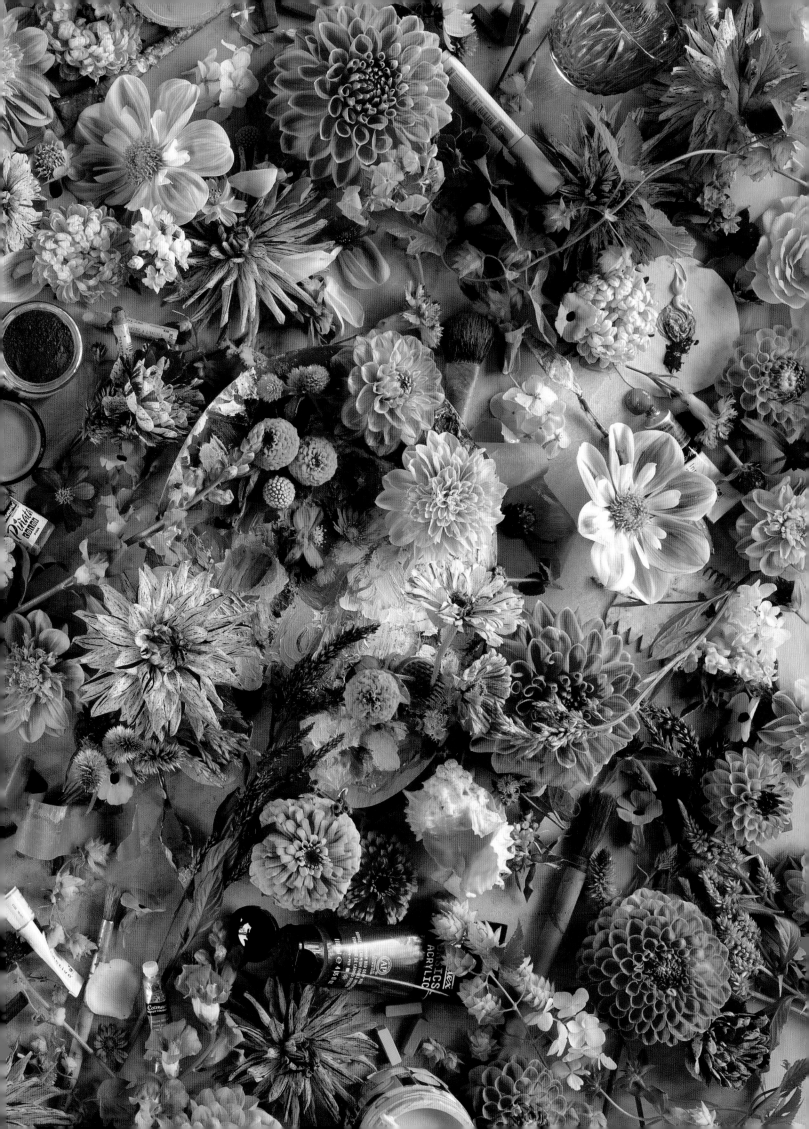

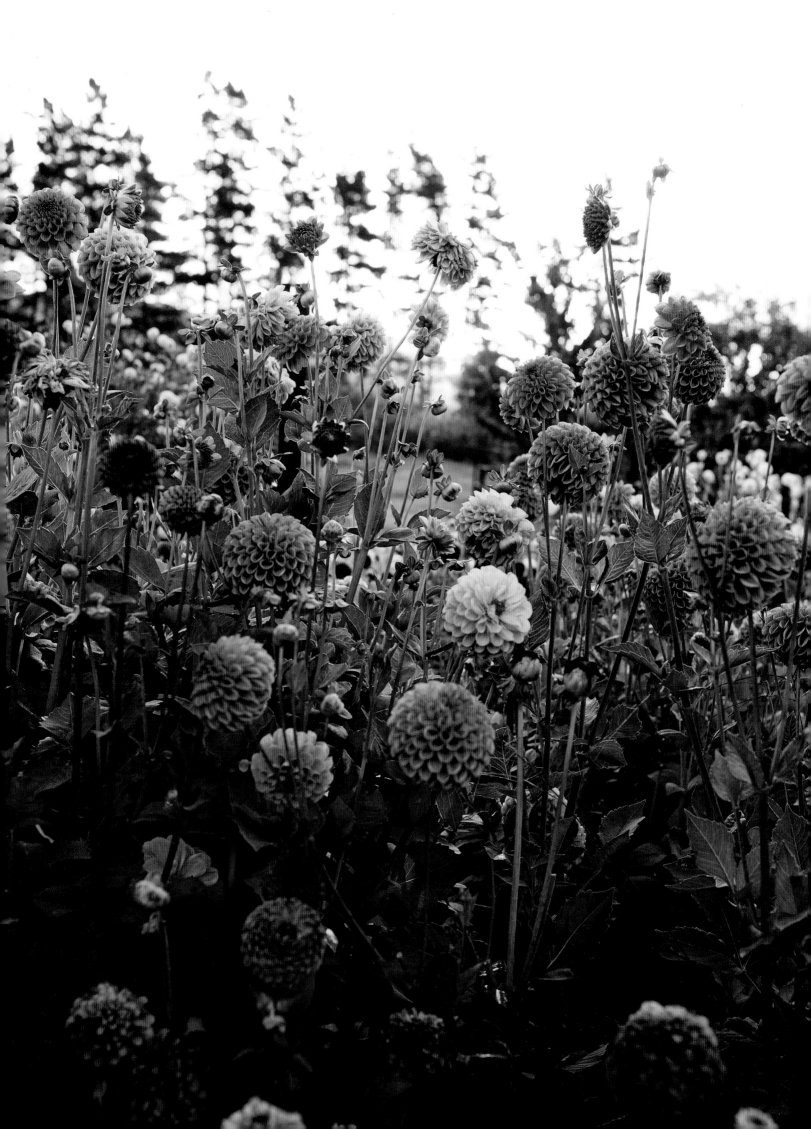

> "
> But these colours imbed themselves in my mind, allowing them to be recalled and channeled with little effort through my hand and brush. My very own way to see the world.
> "

Assorted dahlias, including 'Hamari Rose', 'Burlesca' and 'Jowey Winnie,' all singing together at golden hour.

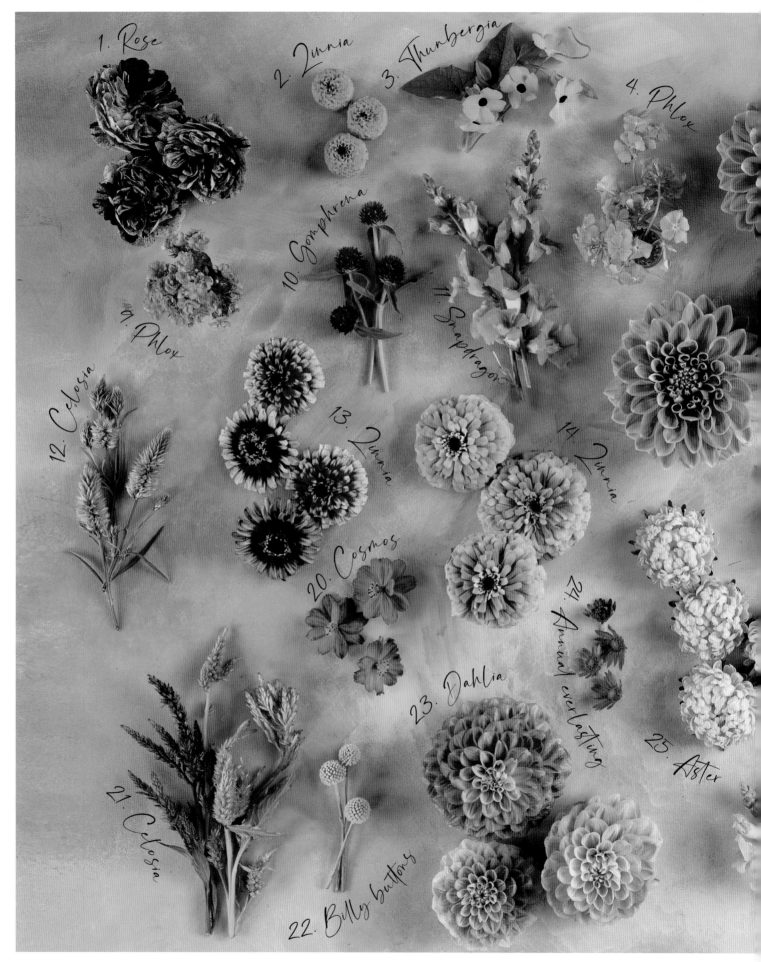

1. *Rosa* 'Ziggy' 2. *Zinnia elegans* 'Lilliput Mix' 3. *Thunbergia alata* Black-eyed Susan Vine 4. *Phlox drummondii* 'Phlox of Sheep Mix' 5. *Dahlia* 'Hy Pimento' 6. *Dahlia* 'Castle Drive' 7. *Dahlia* 'April Heather' 8. *Dahlia* 'Lifestyle' 9. *Phlox drummondii* 'Promise Rose' 10. *Gomphrena haageana* 'QIS Carmine' 11. *Antirrhinum majus* 'Chantilly Bronze' 12. *Celosia spicata* 'Flamingo Feathers' 13. *Zinnia elegans* 'Mazurkia' 14. *Zinnia elegans* 'Benary's Giant Salmon Rose' 15. *Targetes erecta* 16. *Dahlia* 'Alain Mimoun'

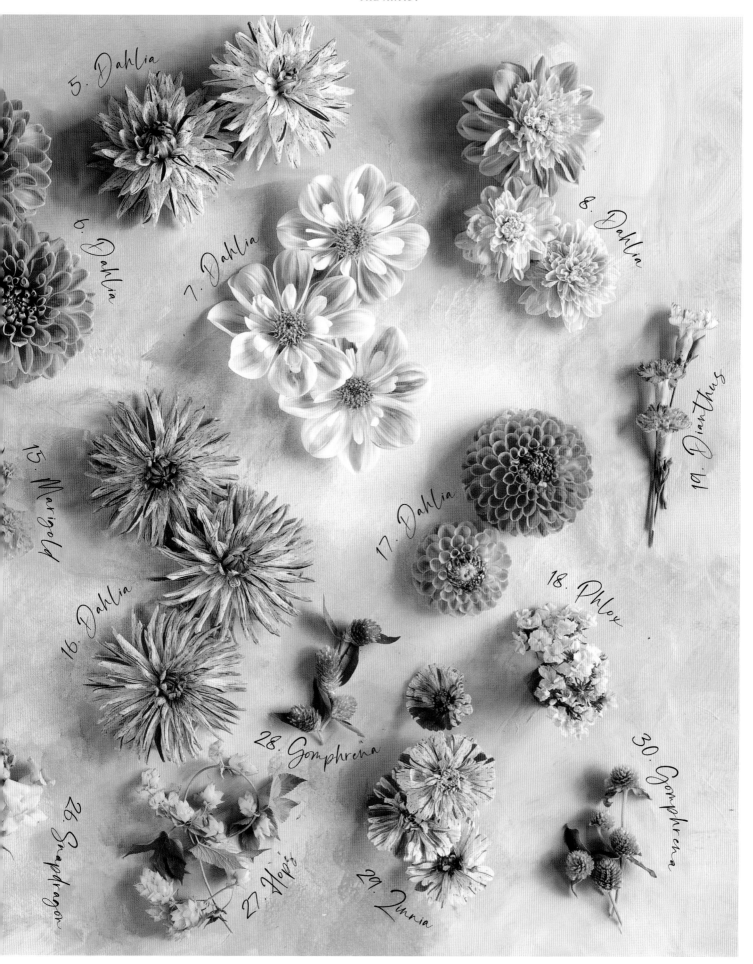

5. Dahlia
6. Dahlia
7. Dahlia
8. Dahlia
15. Marigold
16. Dahlia
17. Dahlia
18. Phlox
10. Dianthus
26. Snapdragon
27. Hops
28. Gomphrena
29. Zinnia
30. Gomphrena

17. *Dahlia* 'Jowey Paula' **18.** *Phlox drummondii* 'Promise Peach' **19.** *Dianthus caryophyllus* 'Chabaud Orange Sherbet' **20.** *Cosmos sulphureus* 'Tango' **21.** *Celosia argentea plumosa* 'Pampas Plume Mix' **22.** *Craspedia globosa* 'Golf Beauty' **23.** *Dahlia* 'Milena F' **24.** *Xeranthemum annuum* **25.** *Callistephus chinensis* 'King Size Apricot' **26.** *Antirrhinum majus* 'Chantilly Light Pink' **27.** *Humulus lupulus* **28.** *Gomphrena haageana* 'QIS Orange' **29.** *Zinnia elegans* 'Candy Cane Mix' **30.** *Gomphrena globosa* 'Pink'

Bouquet-making in our first little studio shed,
which we soon outgrew for weddings. A summery
mix of dahlias, roses, zinnias, snapdragons,
cosmos and amaranthus.

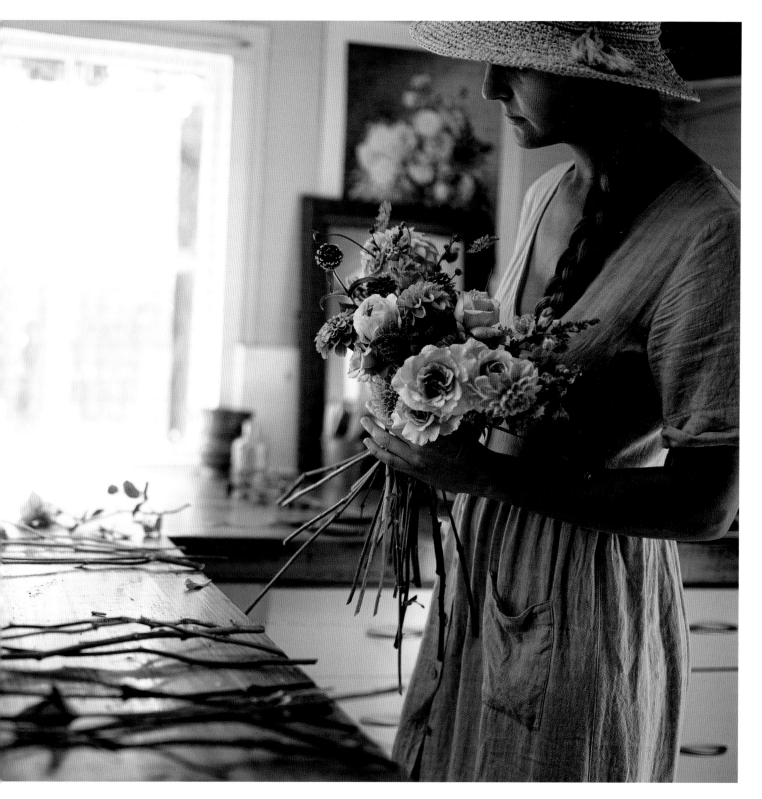

—THE—
TWITCHER

To be a twitcher is to procure sightings and memories, nothing more. It's an unusual form of collecting that asks for dedication, patience and reliance on the eyes to do the gathering. I undertake private hunting trips from which I will never return with a memento beyond the thrill of seeing an elusive bird, and the tick of a single pencil mark on my list.

Armed with binoculars, I have honed my quiet skills of observance in the garden. As an eager young bird lover, this was the place it all began for me, cross-referencing common species in the handbook I got for my birthday. As I grew older, every overseas holiday began with research into the fascinating birds I might be lucky enough to seek out. Tramping trips in our own native bush were stilted adventures; my body would freeze in anticipation at every rustle of a branch or beat of a wing.

When filing through my little notebook of bird sightings, I find I can recall each entry with ease. The falcon soaring above me on a mountain ridge, the grand span of the albatross skimming the whitecaps off a wild coast or the flit of a tiny rifleman in the shadows of the forest. All of these moments are frozen in little feathery time capsules in my mind, forever.

—— TURN THE PAGE TO SEEK & FIND ——

1. BINOCULARS **2.** FIVE BIRD NESTS **3.** A DOZEN EGGS **4.** A KIWI
5. BIRD SEED **6.** SIX FEATHERS **7.** A COLLECTION OF SHINY TREASURES
8. A PORCELAIN BIRD **9.** AN ID BOOK **10.** A SNAIL SHELL GRAVEYARD

Answers on page 167

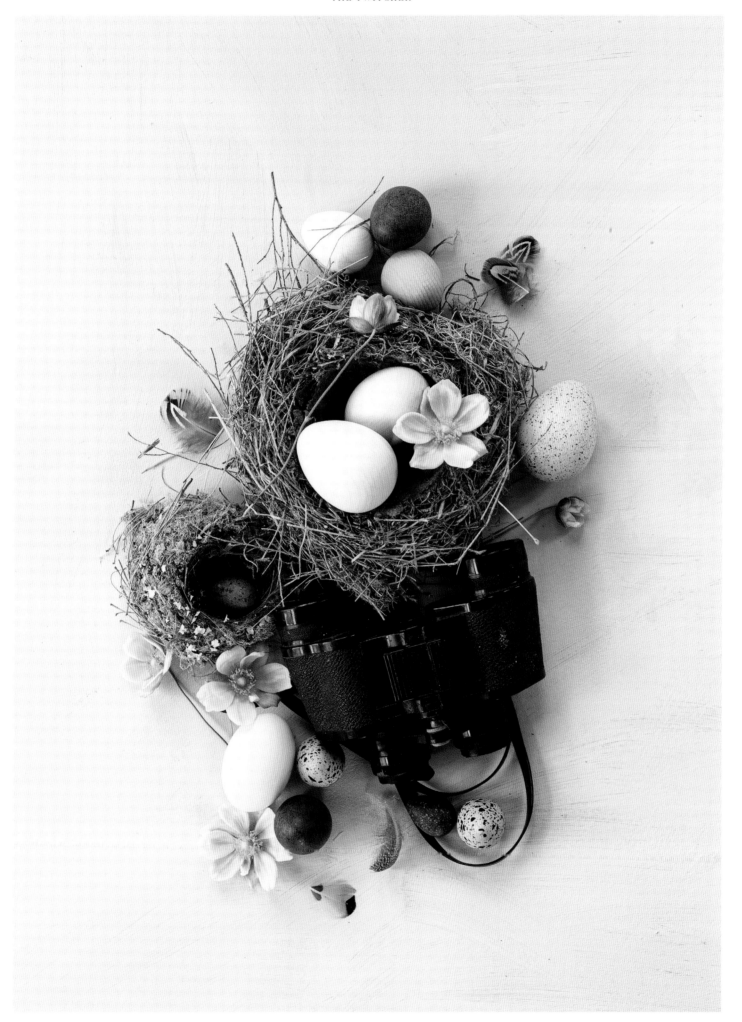

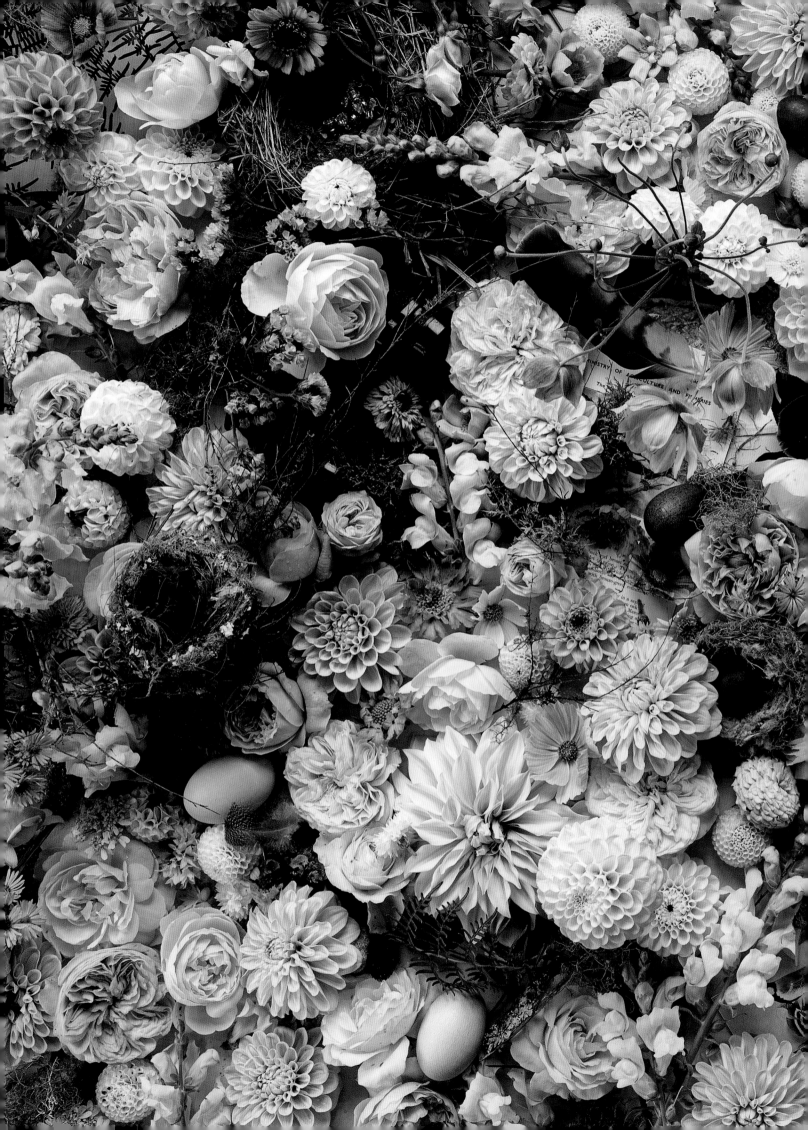

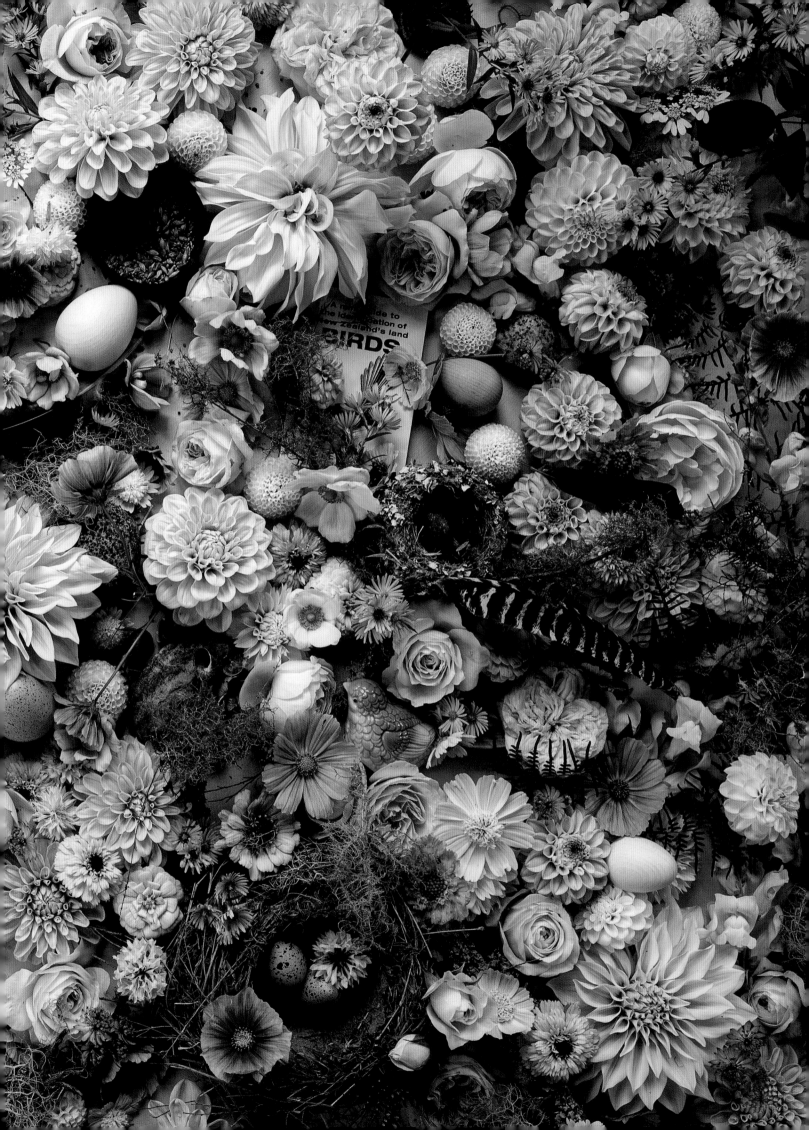

"

To be a twitcher is to procure sightings and memories, nothing more. It's an unusual form of collecting that asks for dedication, patience and reliance on the eyes to do the gathering.

"

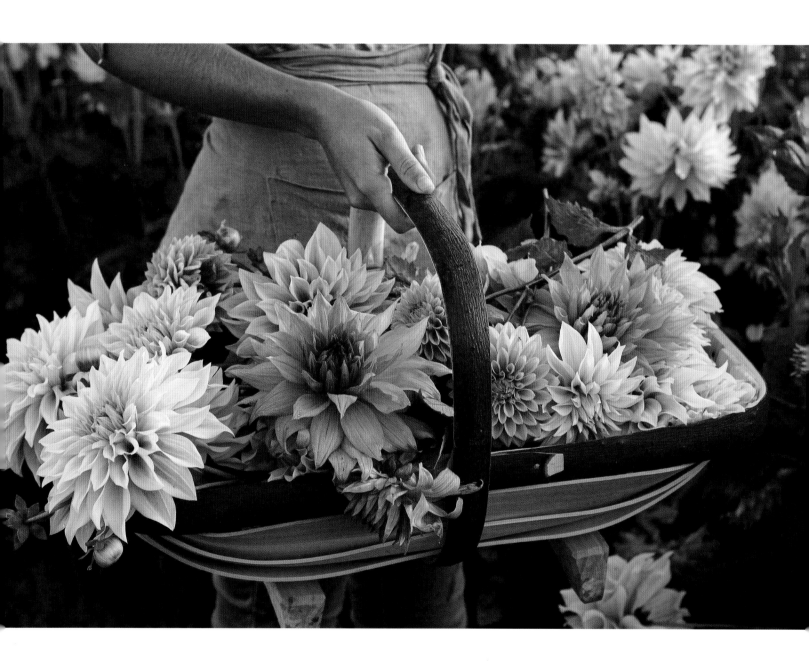

A trug full of freshly cut 'Café au Lait', 'Sherwood Peach' and 'Coralie' dahlias.

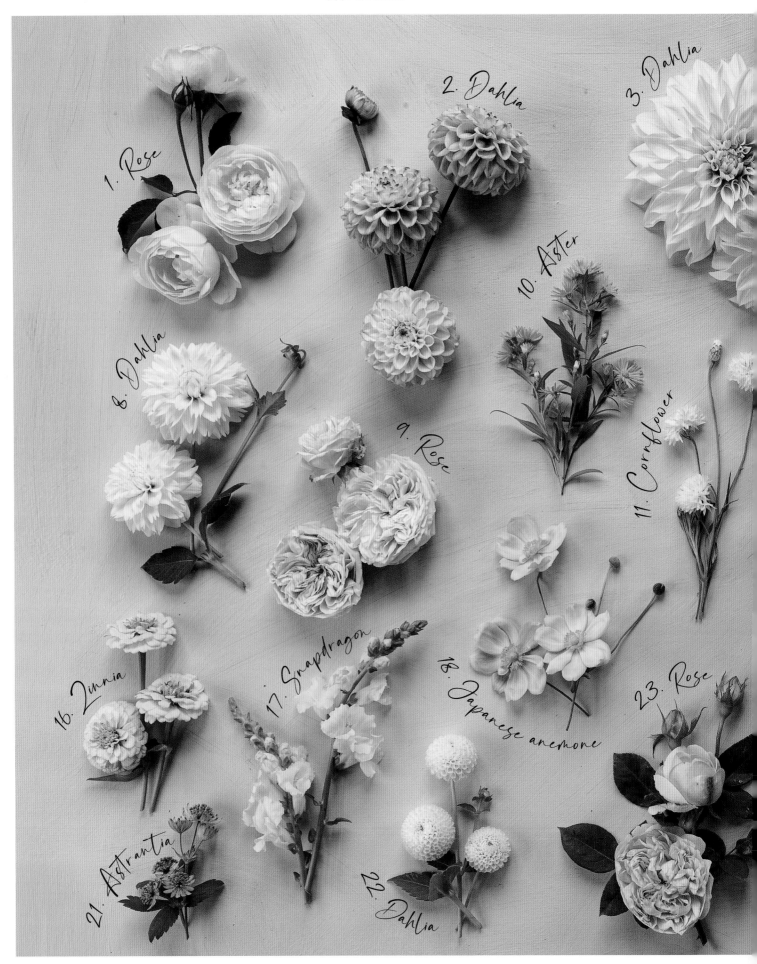

1. *Rosa* 'Lichfield Angel' 2. *Dahlia* 'Genova' 3. *Dahlia* 'Café au Lait' 4. *Rosa* 'Perdita' 5. *Dahlia* 'Light Wizard' 6. *Antirrhinum majus* 'Potomac Ivory White'
7. *Cosmos bippinnatus* 'Apricot Lemonade' 8. *Dahlia* 'Myama Fubuki' 9. *Rosa* 'Claire Rose' 10. *Aster amellus* Michaelmas Daisy 11. *Centaurea cyanus* 'Snow Man'
12. *Dahlia* 'Sweet Nathalie' 13. *Cosmos bipinnatus* 'Daydream' 14. *Dahlia* 'Small World' 15. *Centaurea cyanus* 'Classic Fantastic' 16. *Zinnia elegans* 'Oklahoma

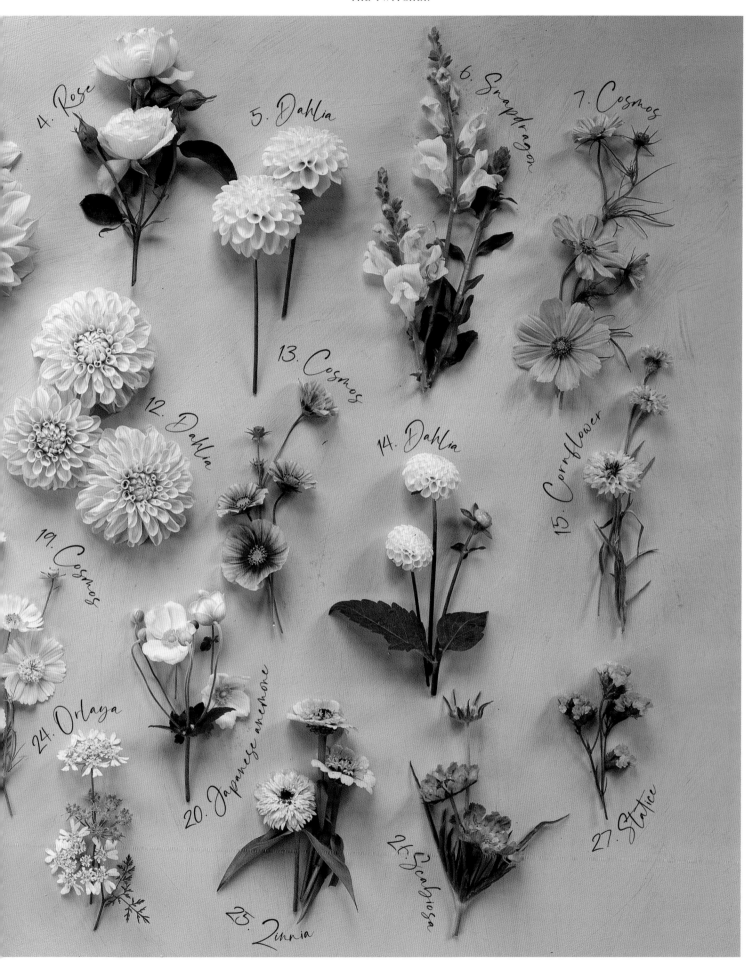

4. Rose
5. Dahlia
6. Snapdragon
7. Cosmos
13. Cosmos
12. Dahlia
14. Dahlia
15. Cornflower
19. Cosmos
24. Orlaya
20. Japanese anemone
25. Zinnia
26. Scabiosa
27. Statice

White' **17.** *Antirrhinum majus* 'Chantilly White' **18.** *Anemone x hybrida* Pale Pink **19.** *Cosmos bipinnatus* 'White Popsocks' **20.** *Anemone x hybrida* White
21. *Astrantia major* Masterwort **22.** *Dahlia* 'Tiny Treasure' **23.** *Rosa* 'Evelyn' **24.** *Orlaya grandiflora* White Lace Flower **25.** *Zinnia elegans* 'Zinderella Lilac'
26. *Scabiosa caucasica* 'Fama Blue' **27.** *Limonium sinuatum* 'QIS Apricot'

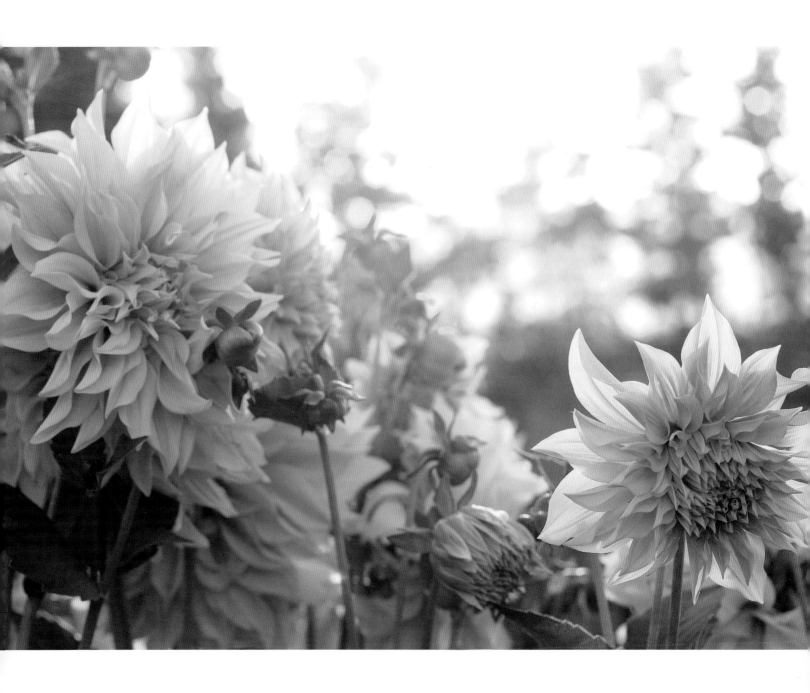

Above: 'Café au Lait' dahlias basking in the hazy sun.
Opposite: Late-season 'Café au Lait' dahlias' last
beautiful blooms as they wind down for the winter.

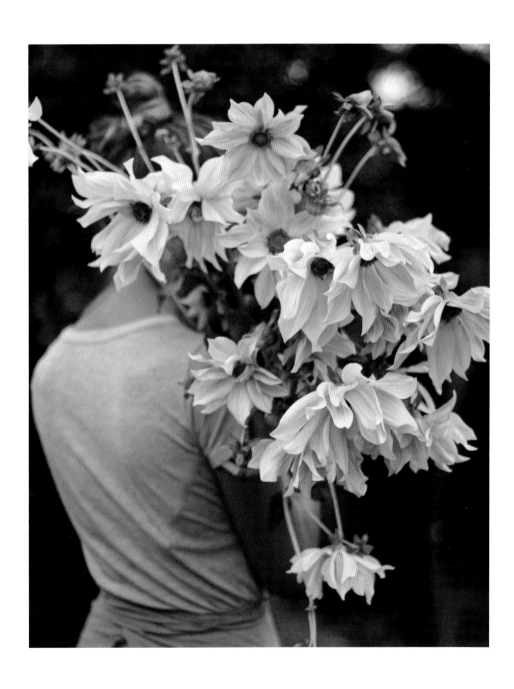

— THE —
BOTANIST

It was my grandfather and his botanical passion that fueled my own desire to gather and grow interesting specimens. With the puff of his pipe, we'd launch off into his dense garden, stopping every few steps to collect cones, examine leaves and ponder the wonders of every plant in his wild property. We'd stoop low to admire the little parachute blooms of cyclamens and squint high up the towering trunks of his exotic conifers. He opened my eyes to the kingdom of plants and I have never been able to look away.

My own home now reflects his in so many ways. Tiny potted cacti and succulents find narrow spots on window sills, while ferns tumble forward from tables. A large pinboard is smothered with postcards and prints gathered on my trips to botanical gardens and arboretums around the world.

At the table I gently open his old scrapbook, carefully turning each page to reveal pressed and notated stems, his tight handwriting hard to read. Pipe smoke and an earthy fragrance waft up from the dry paper. In addition to his library of reference books, this collection, curated over a lifetime, was my first introduction to botanical names and the wonderful window they provided into the intricacies of plant families and their characteristics. With so many pages still left in my own book, I can only hope to continue his legacy.

— TURN THE PAGE TO SEEK & FIND —

1. A HIKING BOOT **2.** A SCALPEL **3.** FOUR MAGNIFYING GLASSES
4. A PLANT PRESS **5.** A NOTEBOOK **6.** TWO SOIL SAMPLES
7. THREE VARIETIES OF TREE CONES **8.** A POCKET TOOL
9. ANATOMY OF A FLOWER **10.** GRANDPA'S PIPE

Answers on page 168

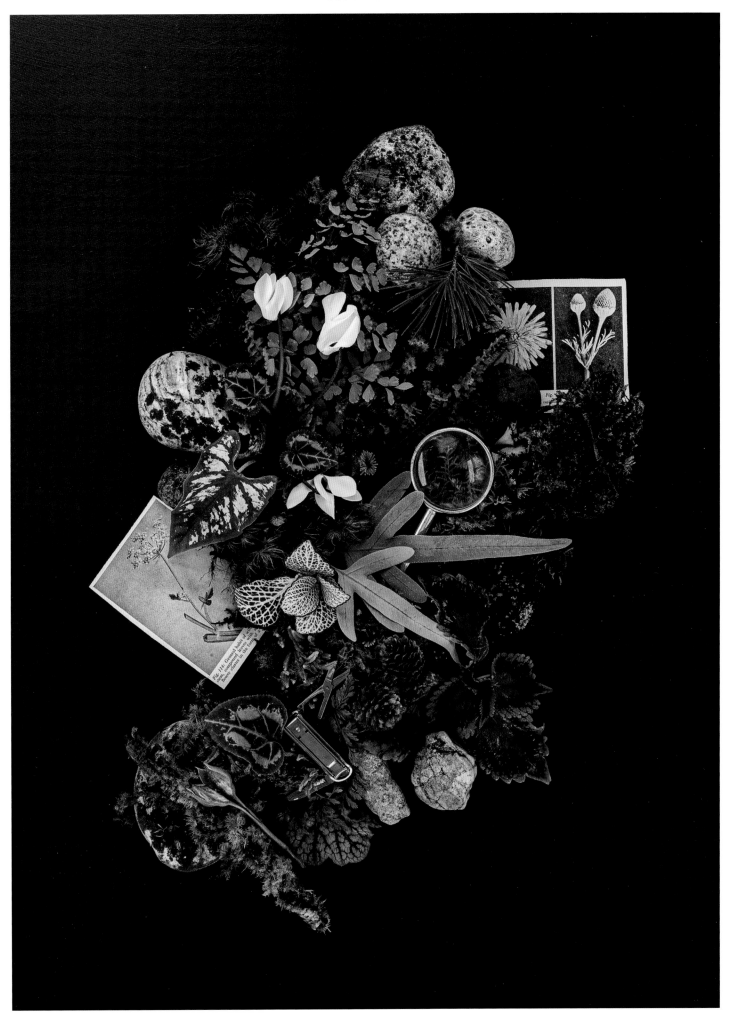

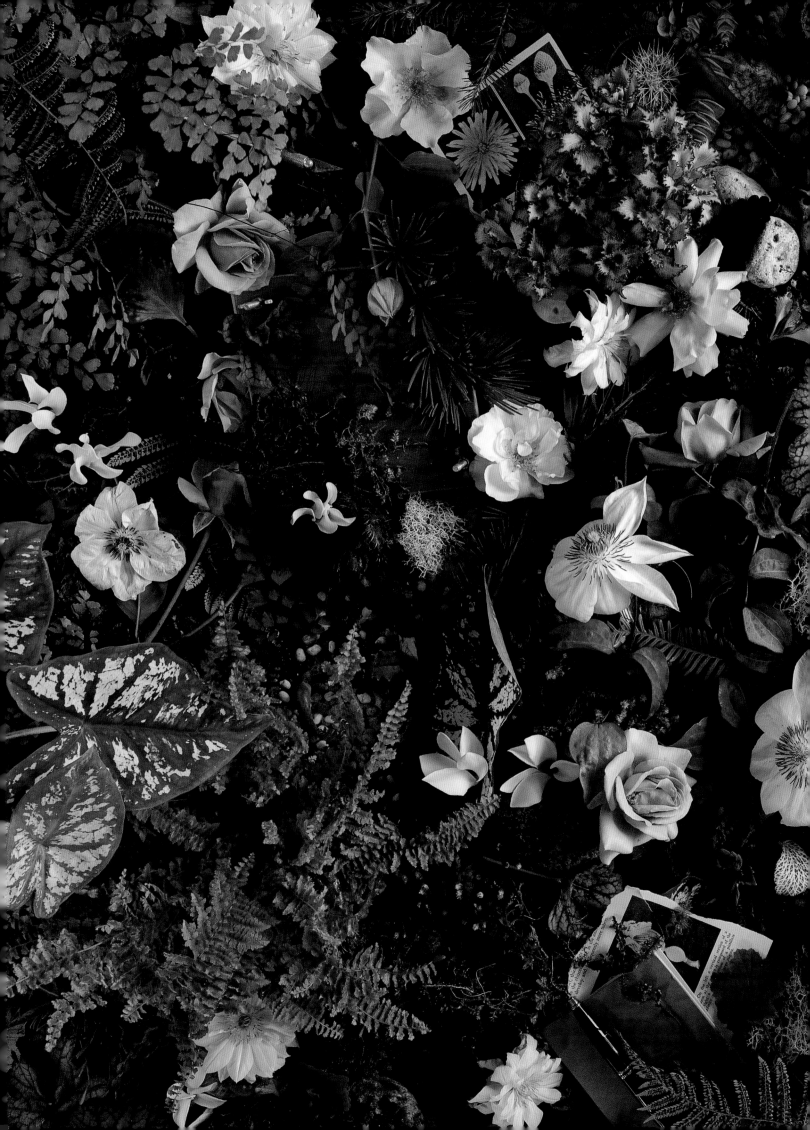

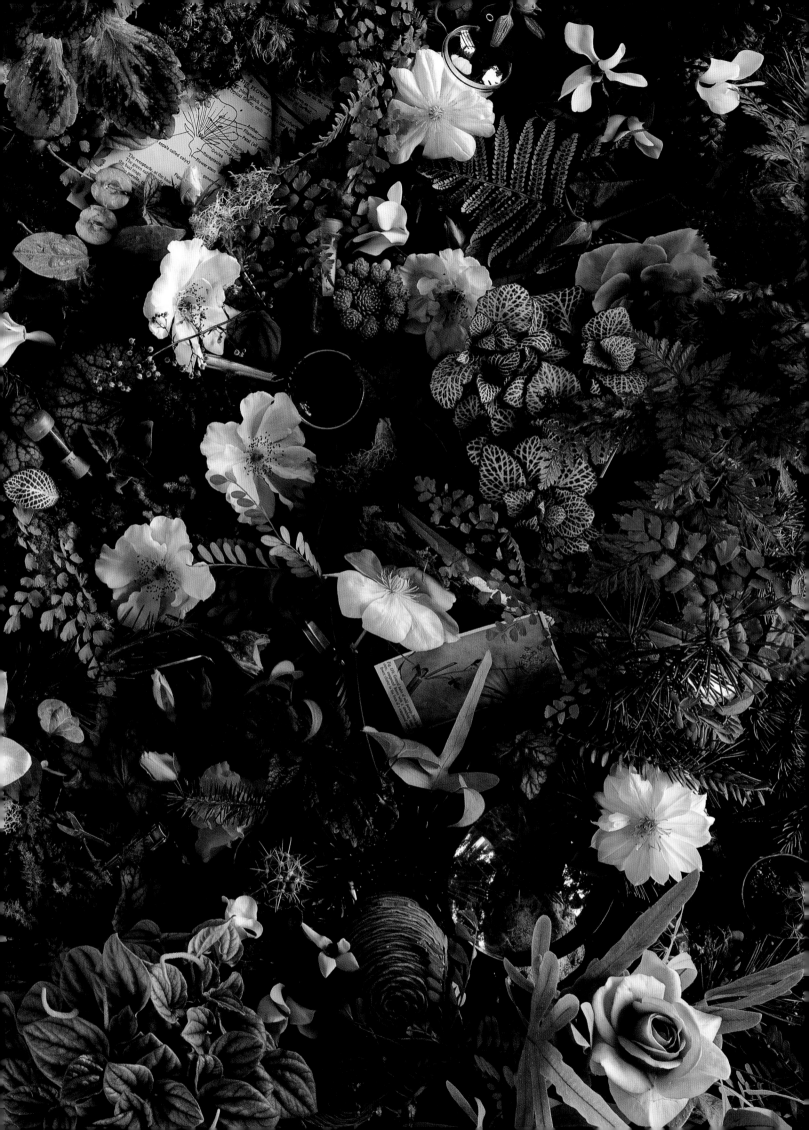

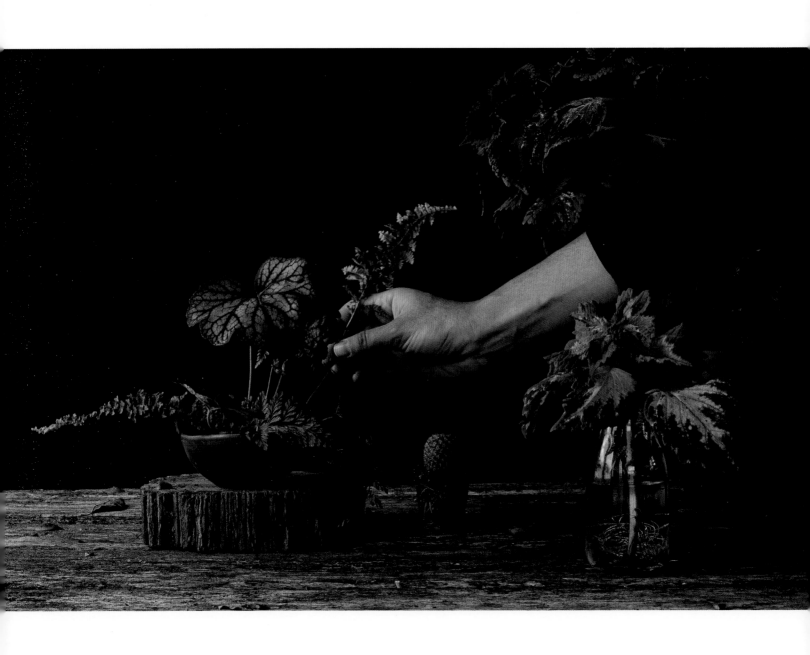

A simple arrangement of foliages. Darkly veined heuchera, ruffled ferns and beautiful pink painted coleus.

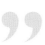

We'd stoop low to admire
the little parachute blooms
of cyclamens and squint high
up the towering trunks of his
exotic conifers. He opened my
eyes to the kingdom of plants
and I have never been able to
look away.

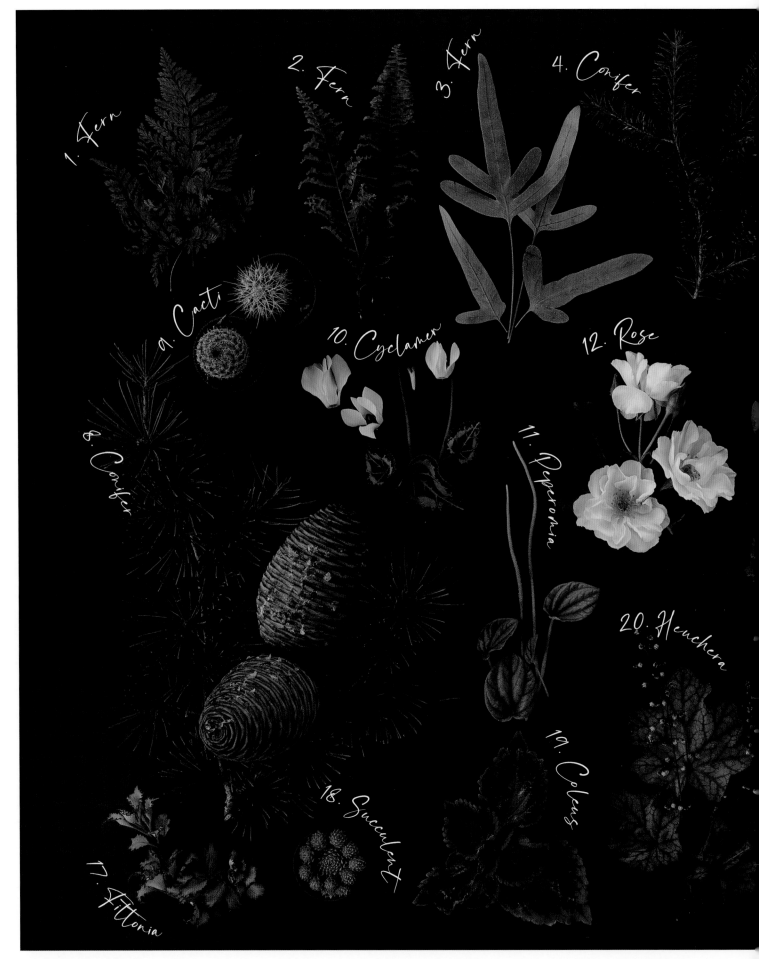

1. *Davallia fejeensis* Rabbit's Foot Fern 2. *Nephrolepis exaltata* 'Fluffy Ruffles' 3. *Phlebodium aureum* Blue Star Fern 4. *Picea sitchensis* Sitka Spruce
5. *Caladium bicolor* 'White Christmas' 6. *Clematis* 'Guernsey Cream' 7. *Clematis* 'Henryii' 8. *Cedrus deodara* Himalayan Cedar 9. Various species of cacti
10. *Cyclamen persicum* 'White' 11. *Peperomia caperata* 'Moonlight' 12. *Rosa* 'White Sparrieshoop' 13. *Clematis* 'Duchess of Edinburgh' 14. *Rosa* 'Cup Fever'

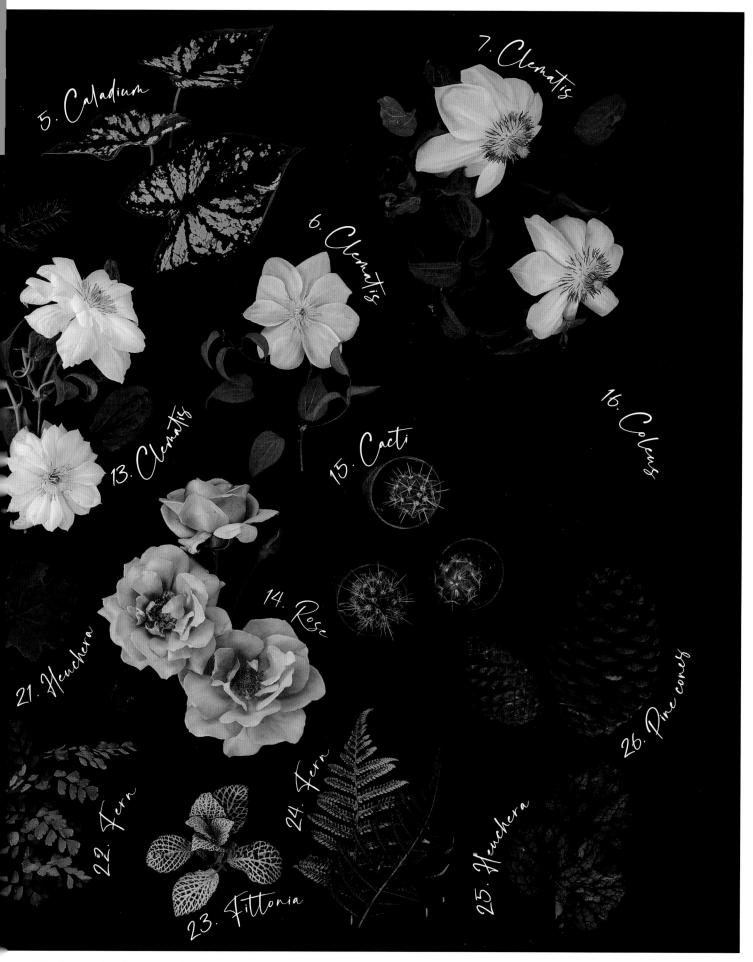

5. Caladium

7. Clematis

6. Clematis

16. Coleus

13. Clematis

15. Cacti

21. Heuchera

14. Rose

26. Pine cones

22. Fern

24. Fern

25. Heuchera

23. Fittonia

15. Various species of cacti **16.** *Coleus scutellarioides* **17.** *Fittonia* 'Frilly Pink' **18.** Succulent **19.** *Coleus scutellarioides* **20.** *Heuchera villosa* 'Plum Power'
21. *Heuchera x villosa* 'Kassandra' **22.** *Adiantum aethiopicum* Maidenhair Fern **23.** *Fittonia argyroneura* 'White Anne' **24.** *Cyathea dealbata* Silver Fern
25. *Heuchera americana hybrid* 'Peppermint Spice' **26.** *Pinus radiata* cones

Below: Morning mist rolling through the rose field.
Opposite: Freshly cut assorted antique-toned roses
'Ash Wednesday', 'Julia's Rose', 'Cup Fever' and
'Rebecca Susan'.

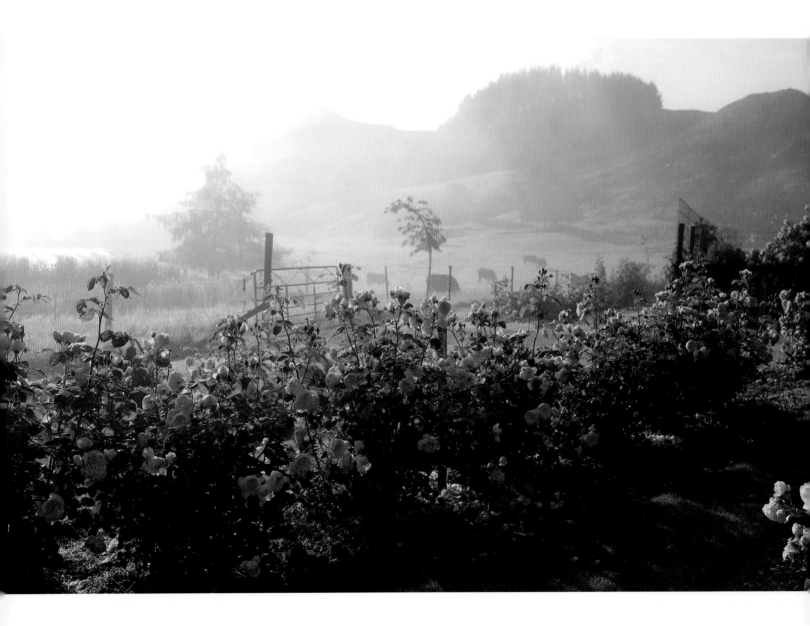

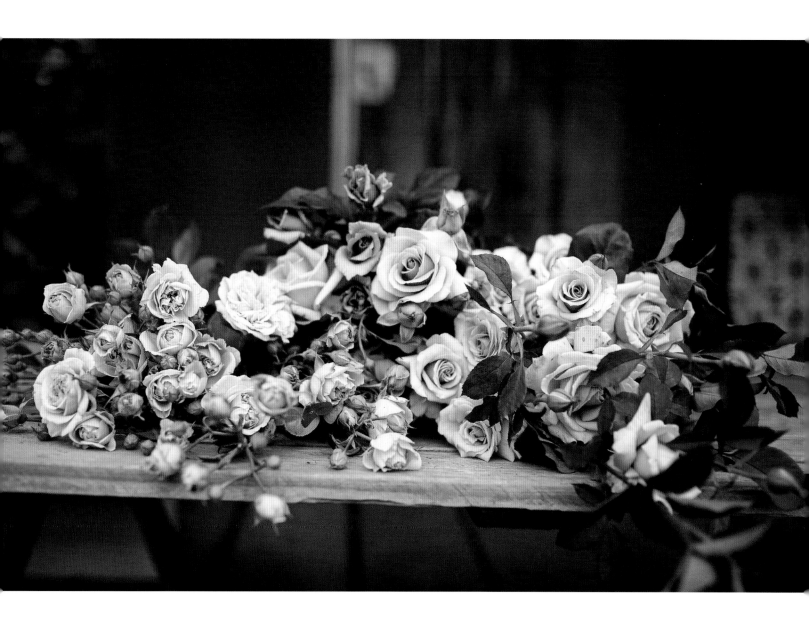

—THE—
NATURAL DYER

In the warmth of the early autumn sun, I picked my way along the clothesline, unpegging flowing silk ribbons as they danced in the wind. I'd had a rewarding week experimenting with my late-season dahlias, onion skins and fennel, edging closer to the results I hoped for due to tweaks with my mordant.

Using my garden and surrounding roadsides as harvesting grounds, I haul baskets of flowers, leaves and vegetables into my little studio. Roots, nuts and lichen are never left behind. Jars of rusty nails, teabags and bark wait on the window sill, while containers of potash are filed under the bench.

I find it impossible to look at any plant specimen without wondering what sort of pigment I could pull from its fibre. Natural dying is a captivating mystery - one to be explored, while accepting that one is never guaranteed a perfect result when trialling new materials within such an uncontrollable process. I relish the magical chaos and thrive on the surprise results.

———— TURN THE PAGE TO SEEK & FIND ————
1. A SPOOL OF SILK **2.** MEASURING SPOONS **3.** RUSTED NAILS
4. A SIEVE **5.** TEABAGS **6.** SODA ASH **7.** THREE CLOTHES PEGS
8. TONGS **9.** PH STRIPS **10.** A WOODEN SPOON

Answers on page 168

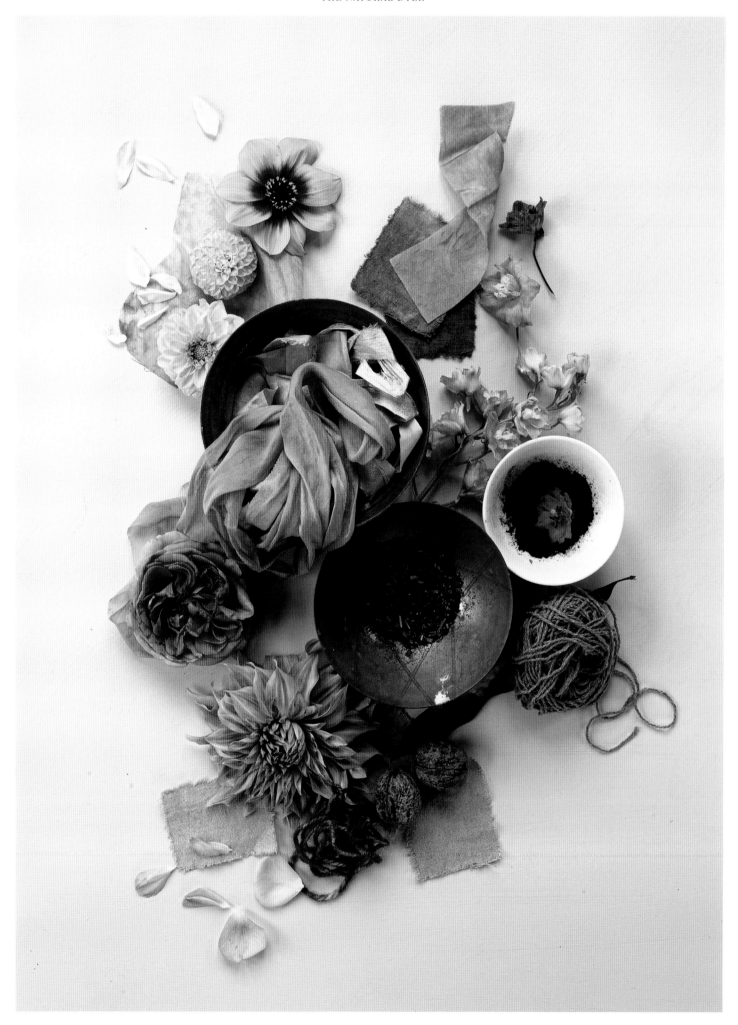

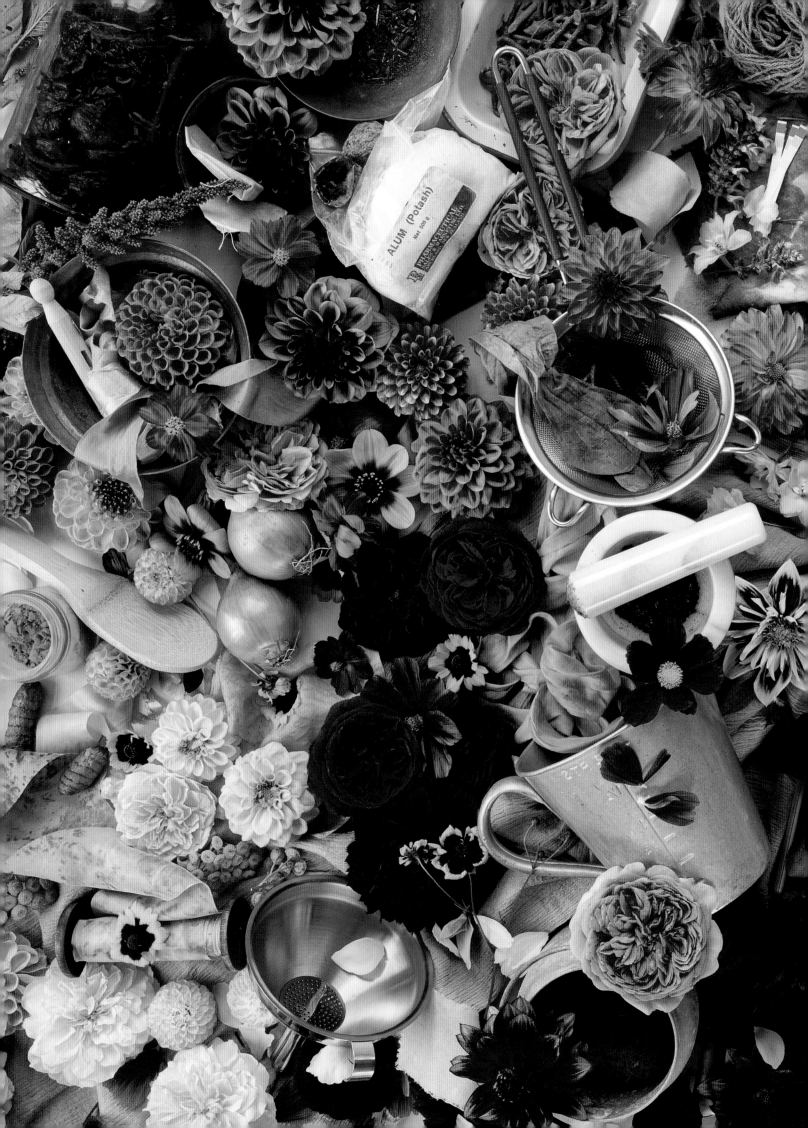

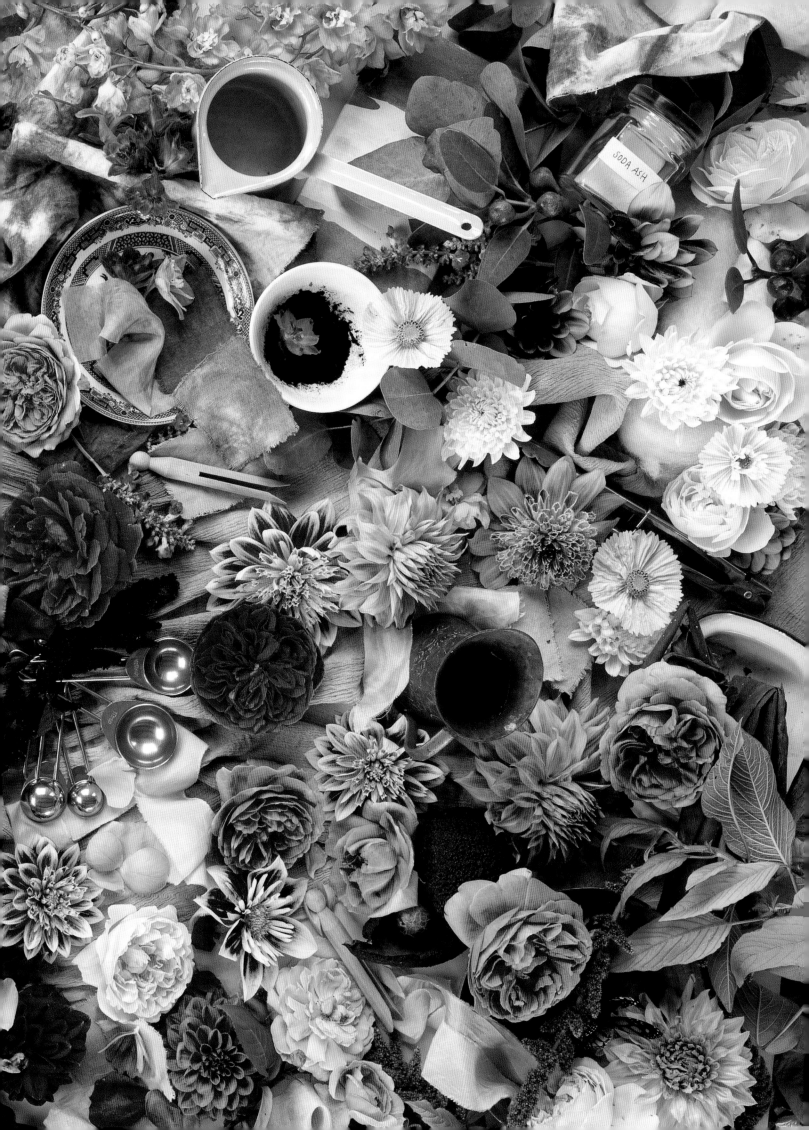

"

Natural dying is a captivating mystery – one to be explored, while accepting that one is never guaranteed a perfect result when trialling new materials within such an uncontrollable process. I relish the magical chaos and thrive on the surprise results.

"

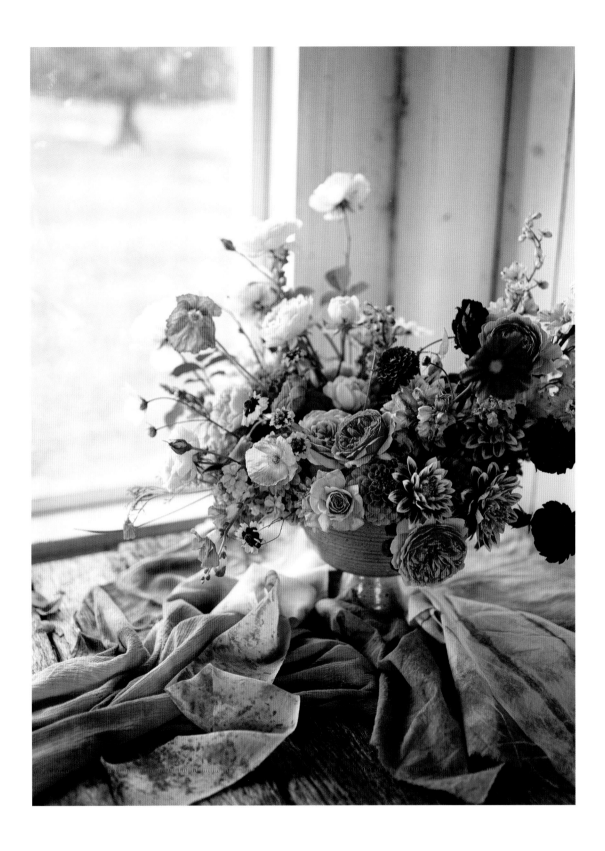

Rainbow tones of roses, dahlias, delphinium, snapdragons, stock, foxgloves, coreopsis, poppies and bog sage.

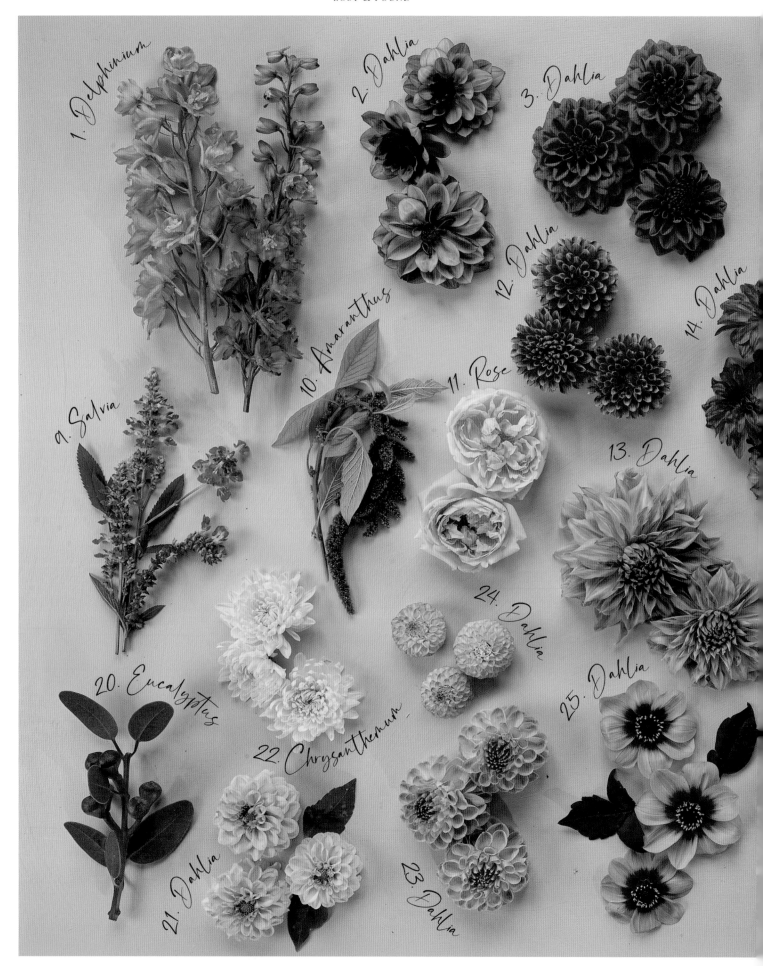

1. *Delphinium* Pacific Giant 2. *Dahlia* 'Crème de Cassis' 3. *Dahlia* 'Salmon Runner' 4. *Cosmos sulphureus* 'Tango' 5. *Rosa* 'Summer Song' 6. *Coreopsis hybrida* 'Incredible Tall Mix' 7. *Cosmos bipinnatus* 'Rubenza' 8. *Amaranthus cruentus* 'Hot biscuits' 9. *Salvia uliginosa* Bog Sage 10. *Amaranthus caudatis* 'Coral Fountain' 11. *Rosa* 'Kathryn Morley' 12. *Dahlia* 'Chimacum Luke' 13. *Dahlia* 'Penhill Watermelon' 14. *Dahlia* 'Belfloor' 15. *Dahlia* 'Fashion Monger' 16. *Dahlia*

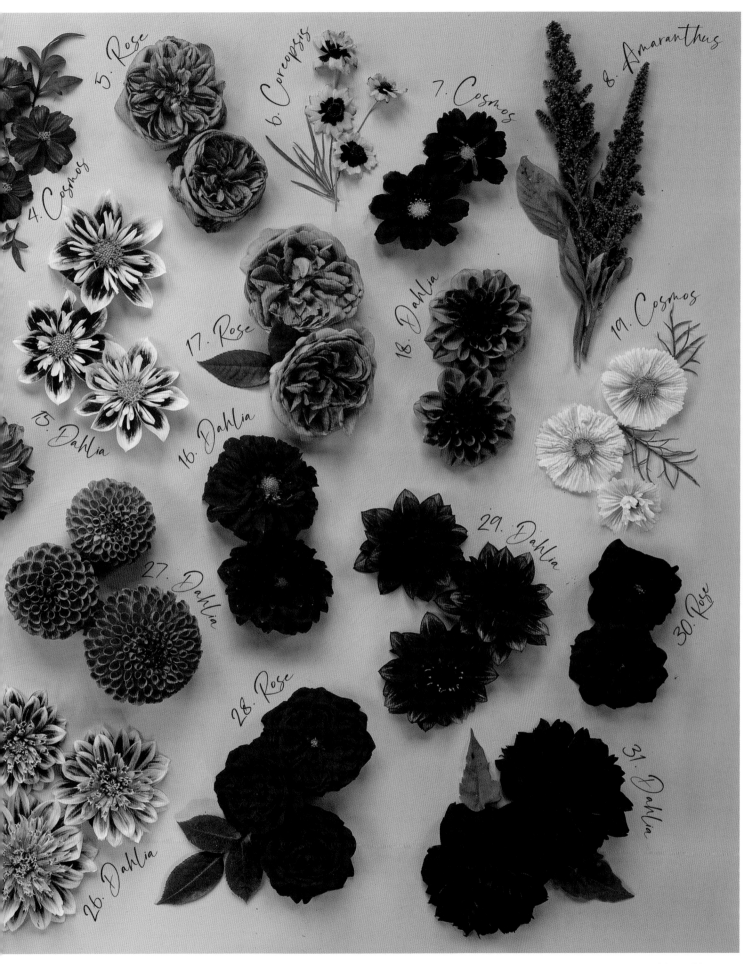

5. Rose
6. Coreopsis
7. Cosmos
8. Amaranthus
4. Cosmos
17. Rose
18. Dahlia
19. Cosmos
15. Dahlia
16. Dahlia
29. Dahlia
27. Dahlia
30. Rose
28. Rose
31. Dahlia
26. Dahlia

'Perch Hill' **17.** *Rosa* 'The Endeavour' **18.** *Dahlia* 'Crème de Cognac' **19.** *Cosmos bipinnatus* 'Cupcakes Blush' **20.** *Eucalyptus preissiana* **21.** *Dahlia* 'Golden Scepter' **22.** *Chrysanthemum* 'Pooly's Champagne' **23.** *Dahlia* 'Crichton Honey' **24.** *Dahlia* 'Minley Carol' **25.** *Dahlia* 'Esther' **26.** *Dahlia* 'Garden Show' **27.** *Dahlia* 'Jowey Winnie' **28.** *Rosa* 'L.D. Braithwaite' **29.** *Dahlia* 'Darkarin' **30.** *Rosa* 'Tradescant' **31.** *Dahlia* 'Dark Fubuki'

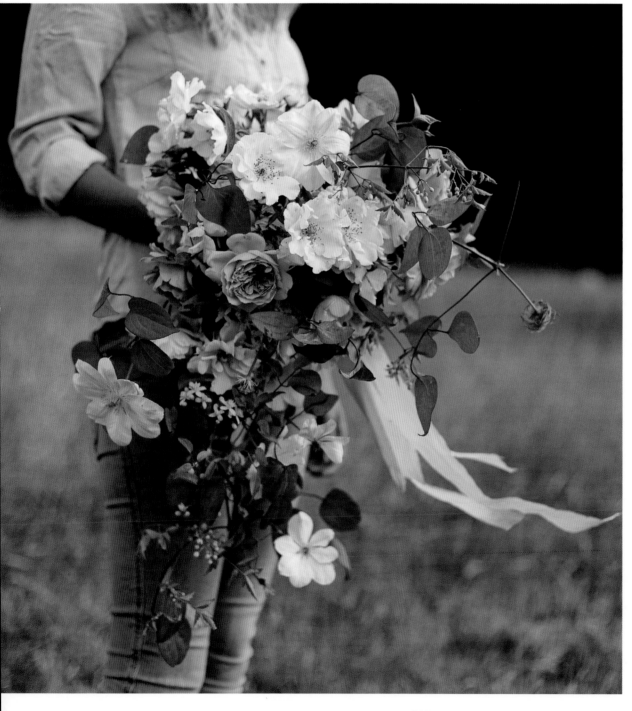

Opposite: A wedding bouquet close to my heart, created for my cousin – filled with peachy 'Tea Clipper' roses, single-petalled 'Sparrieshoop' and 'Guernsey Cream' clematis. **Below:** We hand dye all the ribbons we use in our weddings, adding that special touch to our bouquets .

—THE—
HERBALIST

As a child I would collect and press herbs, carefully taping my flattened specimens into a large scrapbook, noting what each was in immature print. I'd leaf through its pages, inhaling the rich scents and admiring their silhouetted forms. To fuel my interest, my aunt gave me a dog-eared manual of herbs and the substitutions they could provide for products we would normally pick up, with little thought, at the supermarket. My early experimentation was patchy at best, with a crumbling ball of rosemary soap and ineffective shampoo infused with lemon balm. Let's just say that neither quite made it into rotation with the rest of my family.

These days, my own productive garden reflects what has become a lifelong passion – only now my work is more refined, and the results are useful and enriching to my daily life and wellbeing.

Feverfew tea helps me ward off migraines, while mint mixed with dry, crushed fennel seeds offers a refreshing hot drink. Mint, thyme and nasturtium are tossed into salads, which are then decorated with a bright sprinkle of marigold petals. The healthy crop of borage fuels the production of honey in my garden hives, a sweet treat I love to share with my loved ones. And on the cusp of each season, I walk my home with a smouldering bundle of white sage, a small ritual to keep me connected to Mother Nature and her cycles.

——— TURN THE PAGE TO SEEK & FIND ———

1. A MORTAR AND PESTLE **2.** TWO SYRINGES FOR PRECISE MEASUREMENTS
3. FOUR DROPPERS **4.** TWO GLASS BEAKERS **5.** A THERMOMETER
6. PRIMROSE OIL **7.** A KETE (WOVEN BASKET) FULL OF HERBS
8. A GLASS STIRRING ROD **9.** A BOWL OF DRIED ROSE BUDS
10. SEVEN BROWN BOTTLES

Answers on page 169

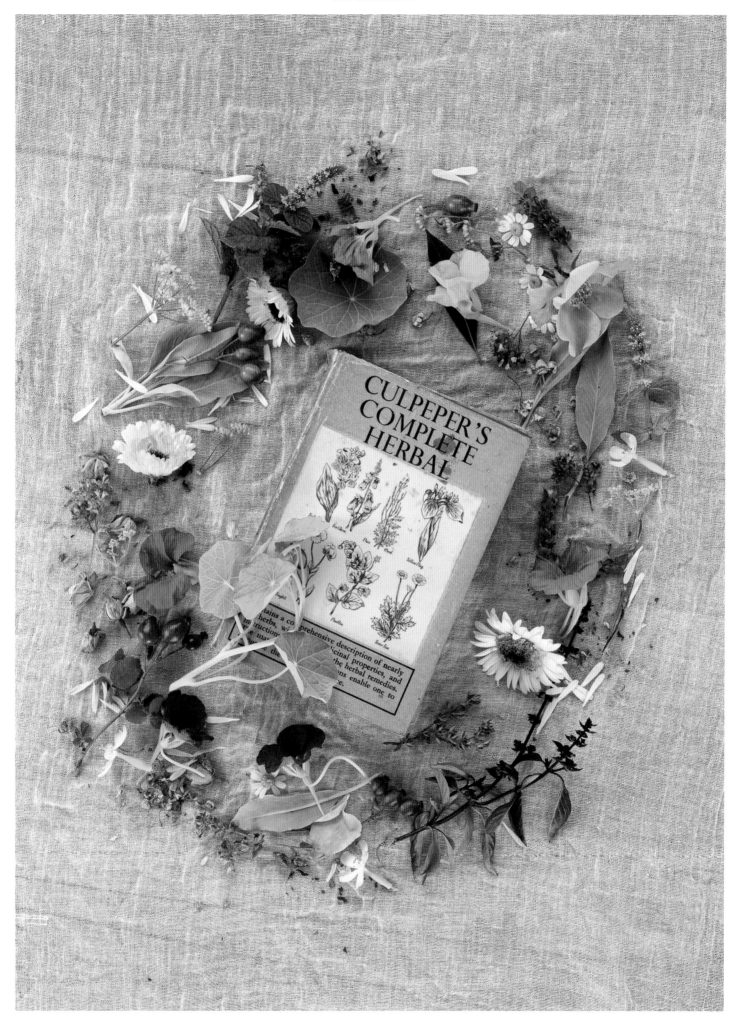

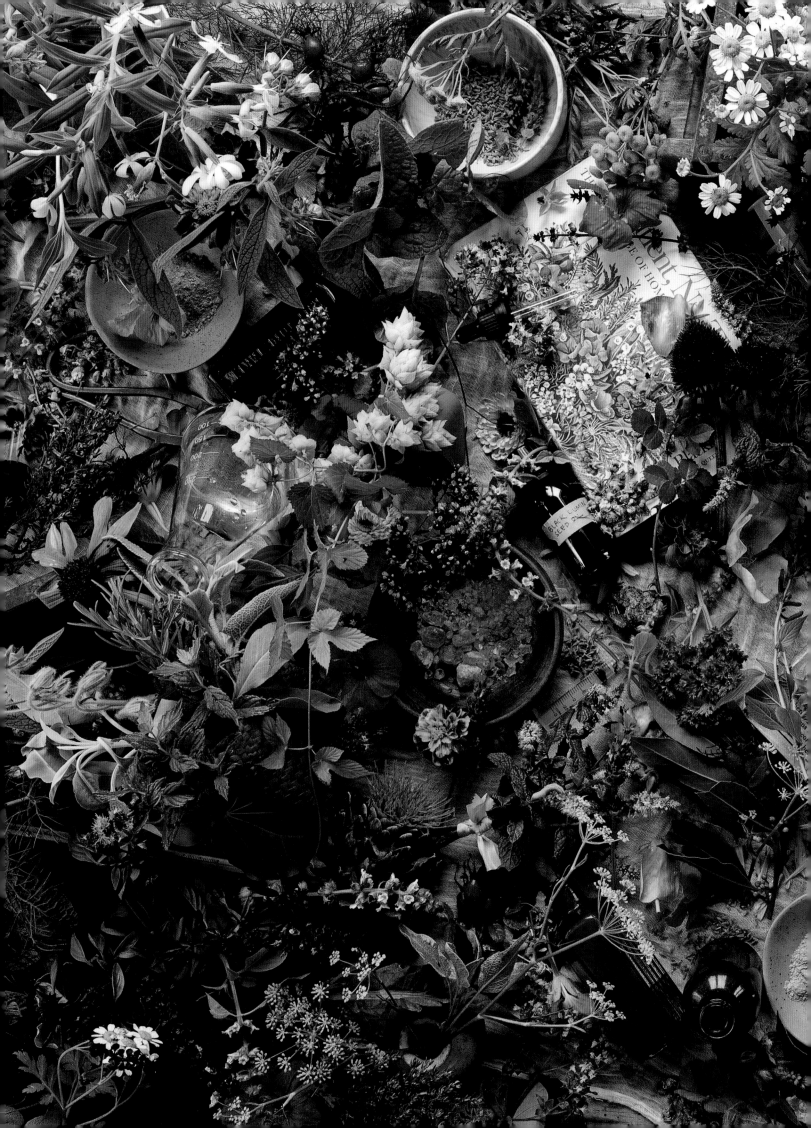

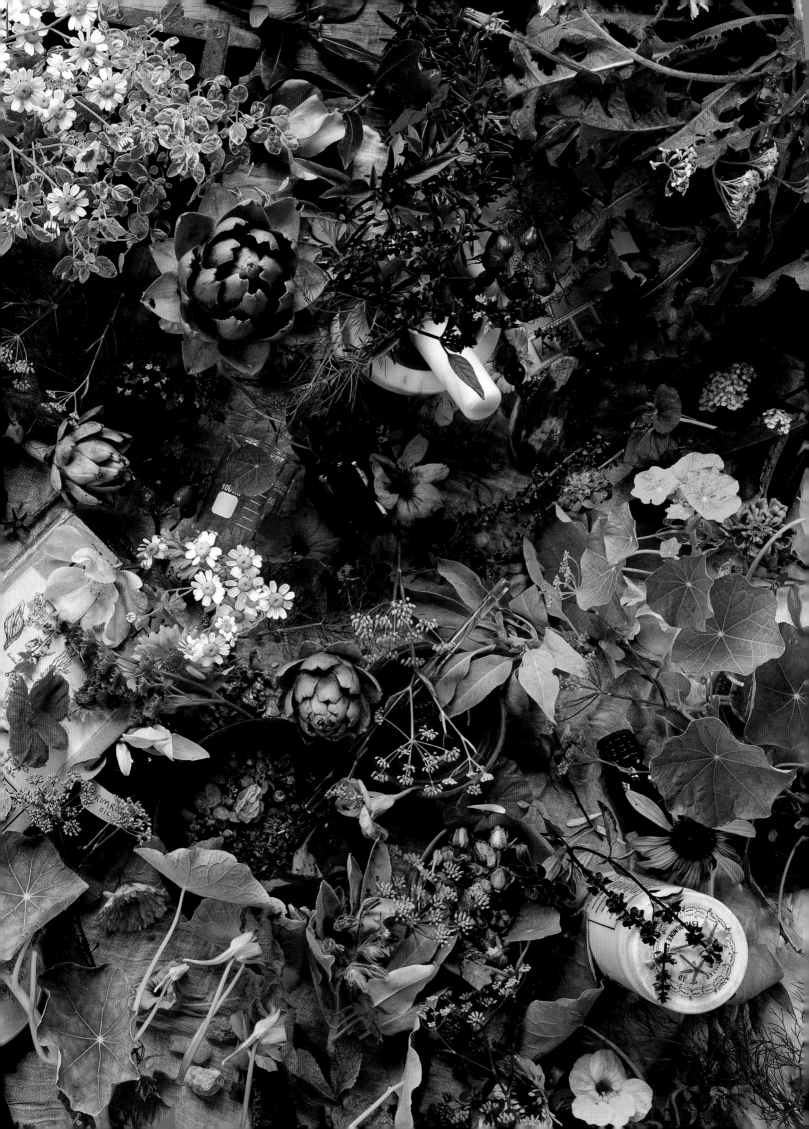

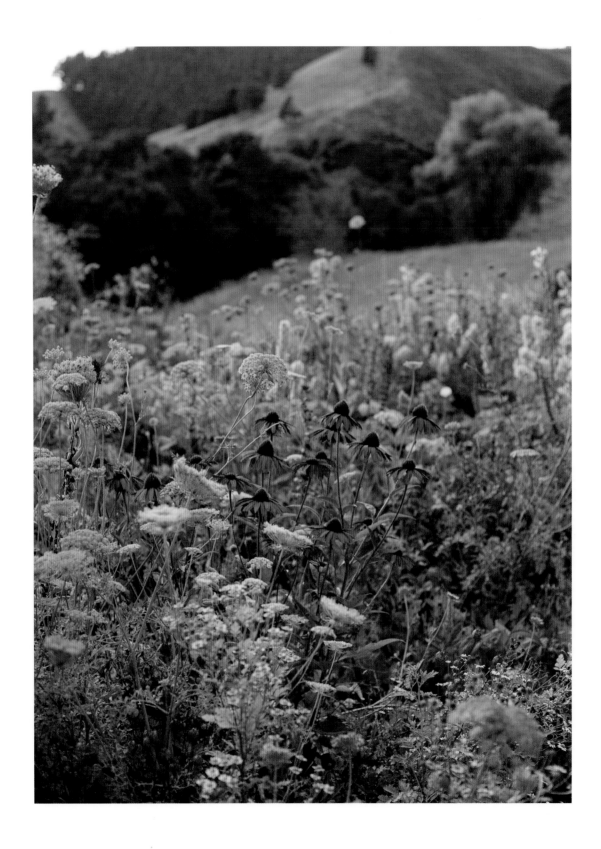

Vibrant echinacea standing out amongst the muted tones of the summer perennial garden.

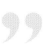

These days, my own productive garden reflects what has become a lifelong passion – only now my work is more refined, and the results are useful and enriching to my daily life and wellbeing.

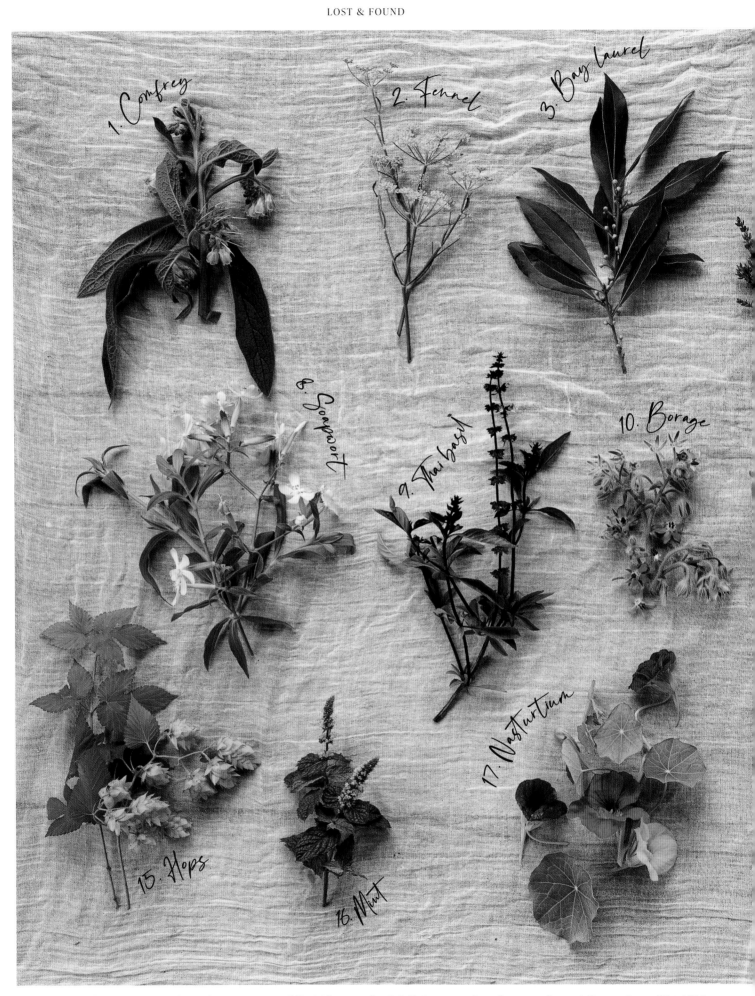

1. Comfrey
2. Fennel
3. Bay laurel
8. Soapwort
9. Thai basil
10. Borage
15. Hops
16. Mint
17. Nasturtium

1. *Symphytum officinale* 2. *Foeniculum vulgare* 3. *Laurus nobilis* 4. *Thymus vulgaris L.* 5. *Cynara cardunculus* var. *scolymus* 6. *Rosa x odorata* 'Mutabilis'
7. *Tagetes tenuifolia* 'Starfire Mix' 8. *Saponaria officinalis* 9. *Ocimum basilicum* var. *thyrsiflora* 10. *Borago officinalis* 11. *Salvia apiana* 12. *Tanacetum*

4. Garden thyme
5. Globe artichoke
6. Rose
7. Marigold
11. White sage
12. Feverfew
13. Calendula
14. Kawakawa
18. Tansy
19. Basil
20. Echinacea
21. Oregano

parthenium **13.** *Calendula officinalis* 'Cantelope' **14.** *Piper excelsum* **15.** *Humulus lupulus* **16.** *Mentha* **17.** *Tropaeolum majus* **18.** *Tanacetum vulgare*
19. *Ocimum basilicum* var. *citriodora* 'Mrs Burns' Lemon' **20.** *Echinacea purpurea* **21.** *Origanum vulgare*

Late spring views of our rose field,
the calm before the riot of colour
that is the spring flush.

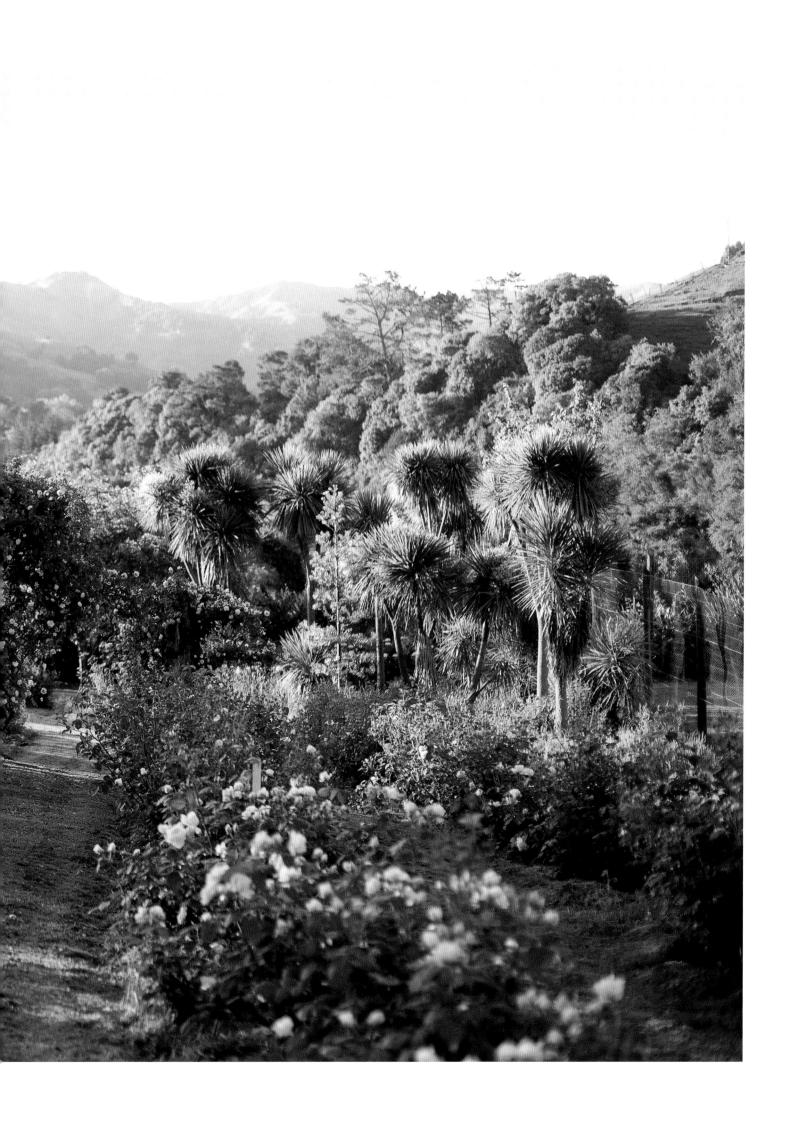

—THE—
PHOTOGRAPHER

One of the rewards of the passing seasons is the change of light in my garden. I ache for the autumn sun to take its late, low swoop over my fence, where it dances with the birch tree and traces rings of gold around leaf and stem. I love to point my camera into the light, pulling forward another world through lens flares and shallow depth of field.

I feel compelled to take photographs that magnify the sense of magic I feel in my garden, the moments I can't quite see with my naked eye. Playing with composition and exposure reveals nature's minute details; translucency in petals; glossy saturated colour; and the extraordinary beauty of texture and form. In these quiet moments, I can interpret this place as I choose, freezing my little piece of nature in time.

It took me many years to realise that I could be a passionate photo taker without being a professional one. That indulging time and creative energy into capturing a record of my place didn't require qualification. Over time my library of images has served me well in my garden, both as a reference for planning and as a reflection of the great joy I have had in making it.

— TURN THE PAGE TO SEEK & FIND —

1. A CAMERA STRAP 2. A POLAROID PHOTO 3. TWO NEGATIVE STRIPS
4. FOUR CAMERAS 5. TWO LENSES 6. A MEMORY CARD
7. FOUR LENS CAPS 8. A NAME ENGRAVED
9. A PHOTO OF A FLOWER 10. A CAPTURED REFLECTION

Answers on page 169

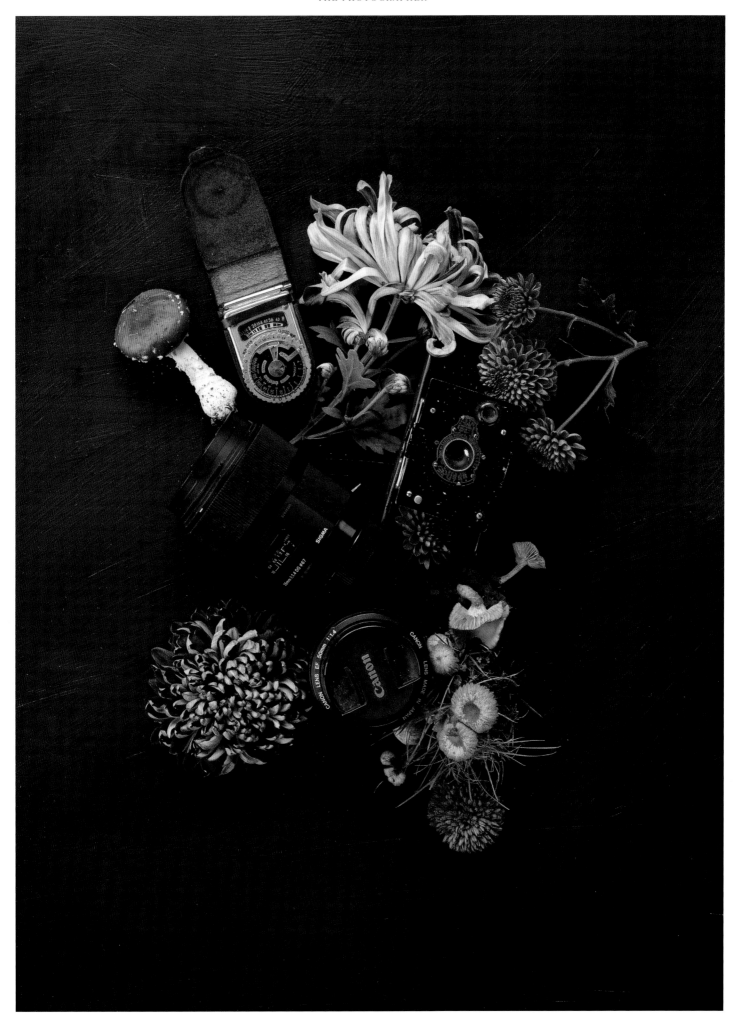

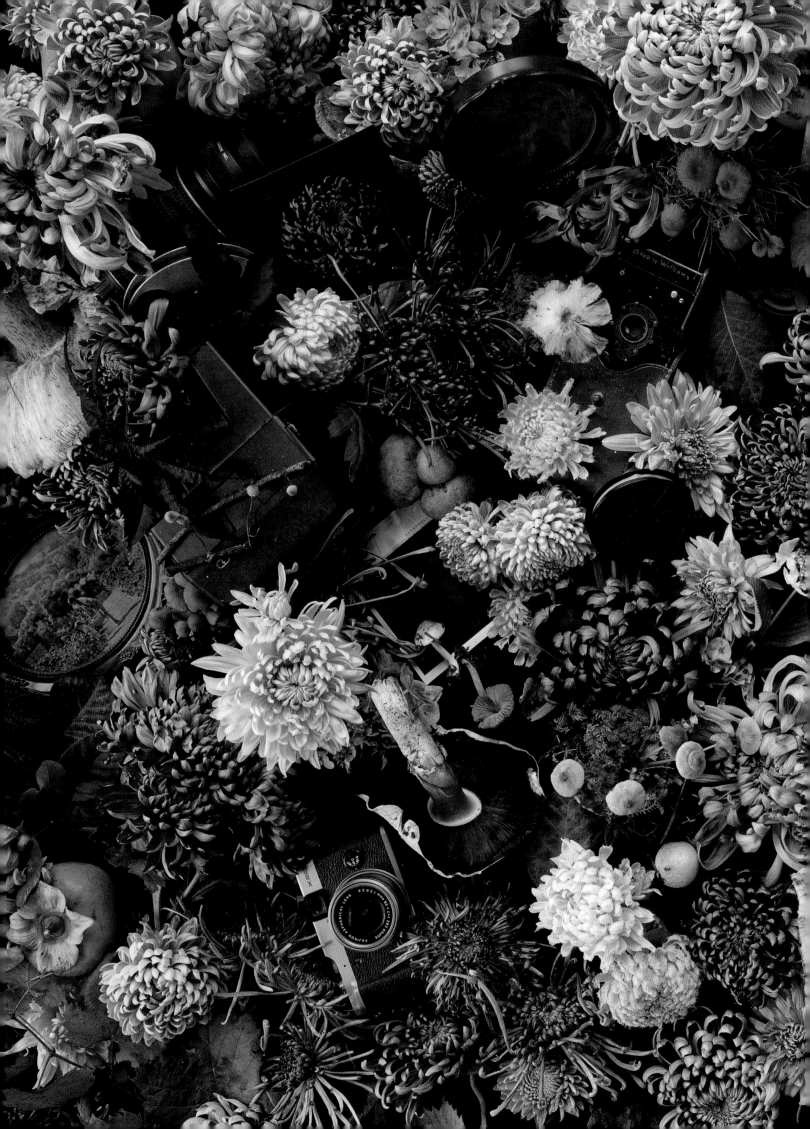

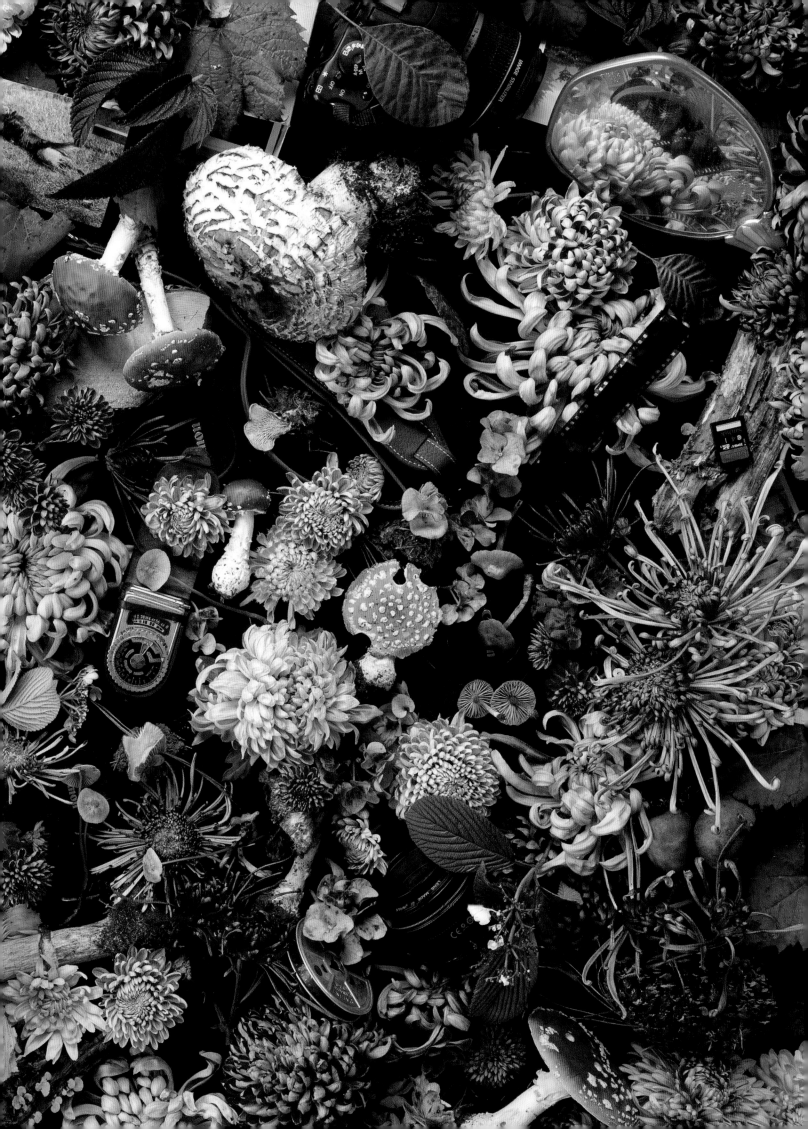

Playing with composition and exposure reveals nature's minute details; translucency in petals; glossy saturated colour; and the extraordinary beauty of texture and form. In these quiet moments, I can interpret this place as I choose, freezing my little piece of nature in time.

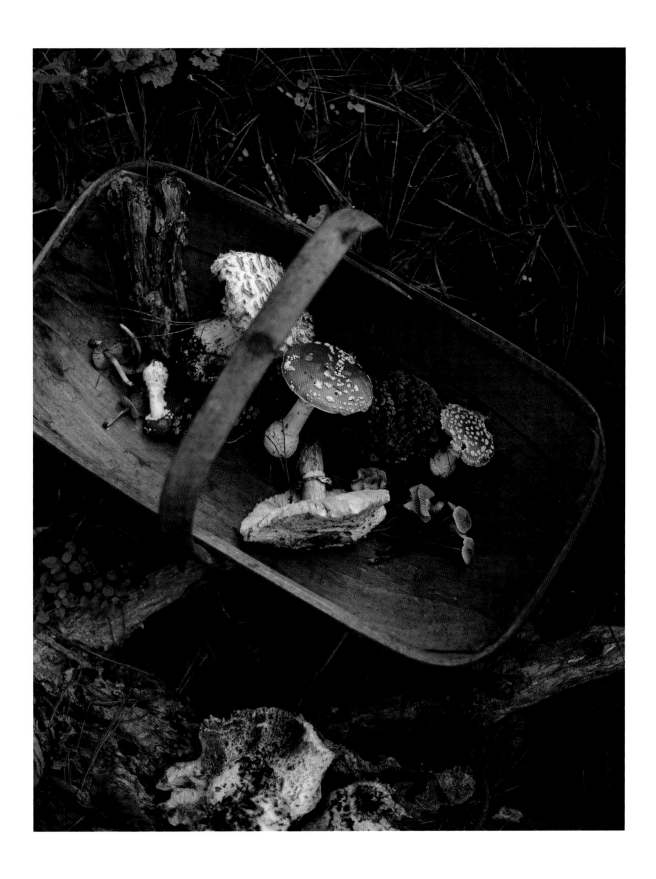

A trug of foraged autumnal mushrooms, many not fit for eating but beautiful in colour and form netherthless.

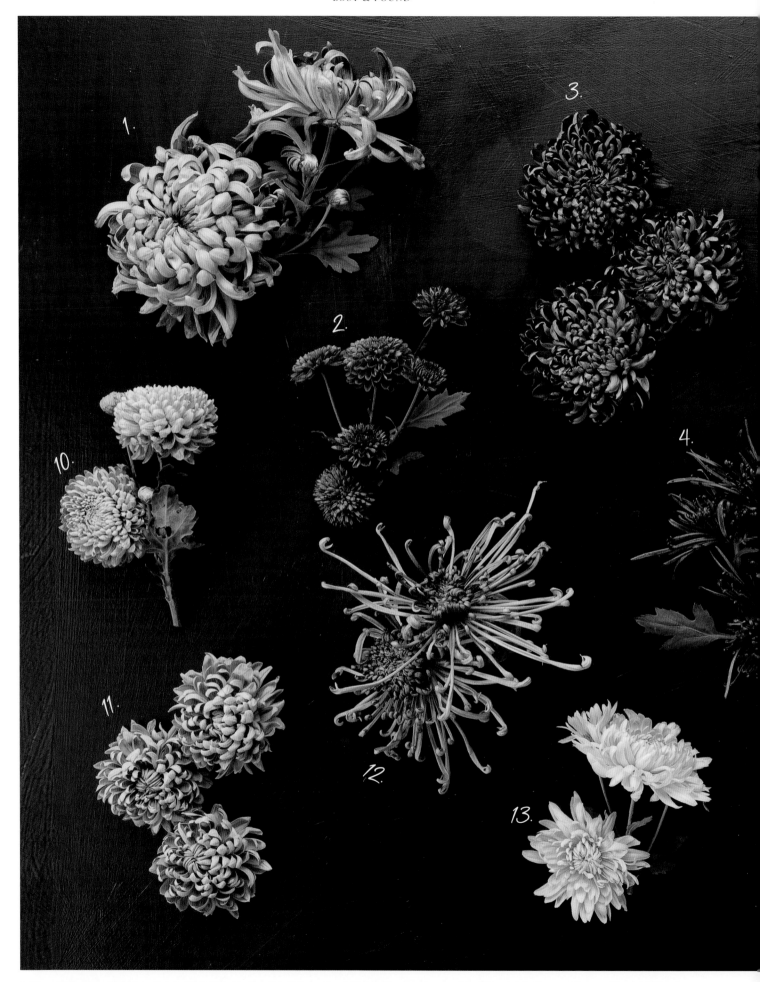

1. *Chrysanthemum* 'Kokka no Kotabuki' 2. *Chrysanthemum* 'Kelvin Mandarin' 3. *Chrysanthemum* 'Geoff Brady' 4. *Chrysanthemum* 'Scarlet O'Hara'
5. *Chrysanthemum* 'Shirley Fashion' 6. *Chrysanthemum* 'Apricot Alexis' 7. *Chrysanthemum* 'Bridesmaid' 8. *Chrysanthemum* 'Seatons Flirt'

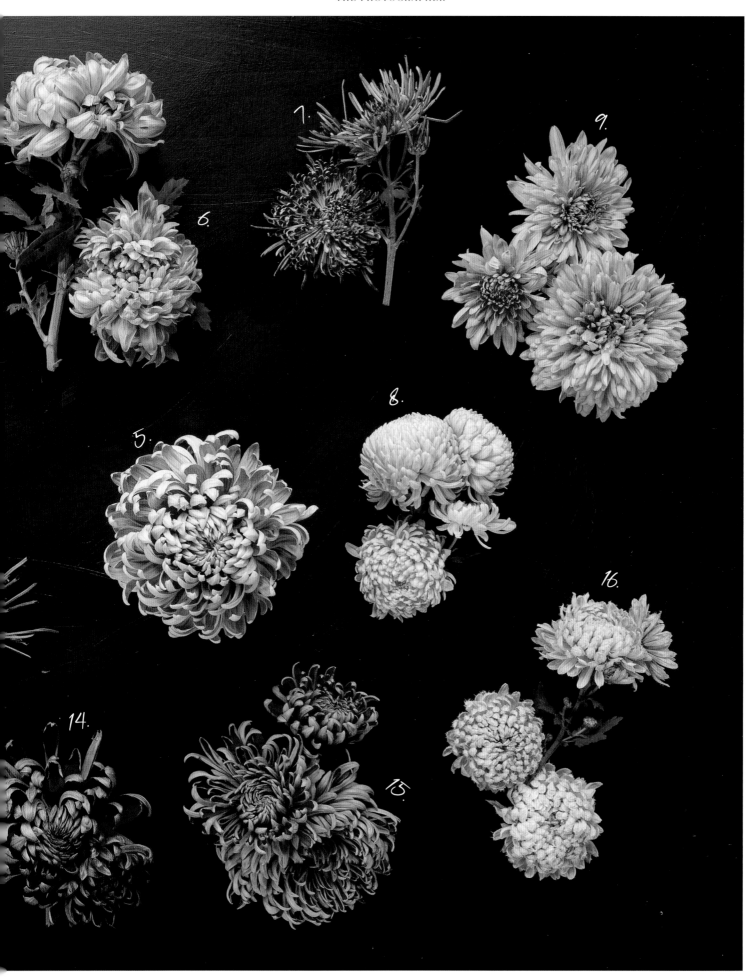

9. *Chrysanthemum* 'John Wingfield' 10. *Chrysanthemum* 'Roy Coopland' 11. *Chrysanthemum* 'Gillian Fitton' 12. *Chrysanthemum* 'Dusky Queen'
13. *Chrysanthemum* 'Pink Chiffon' 14. *Chrysanthemum* 'Kokka Shyzan' 15. *Chrysanthemum* 'Pat Brophy' 16. *Chrysanthemum* 'Gertrude'

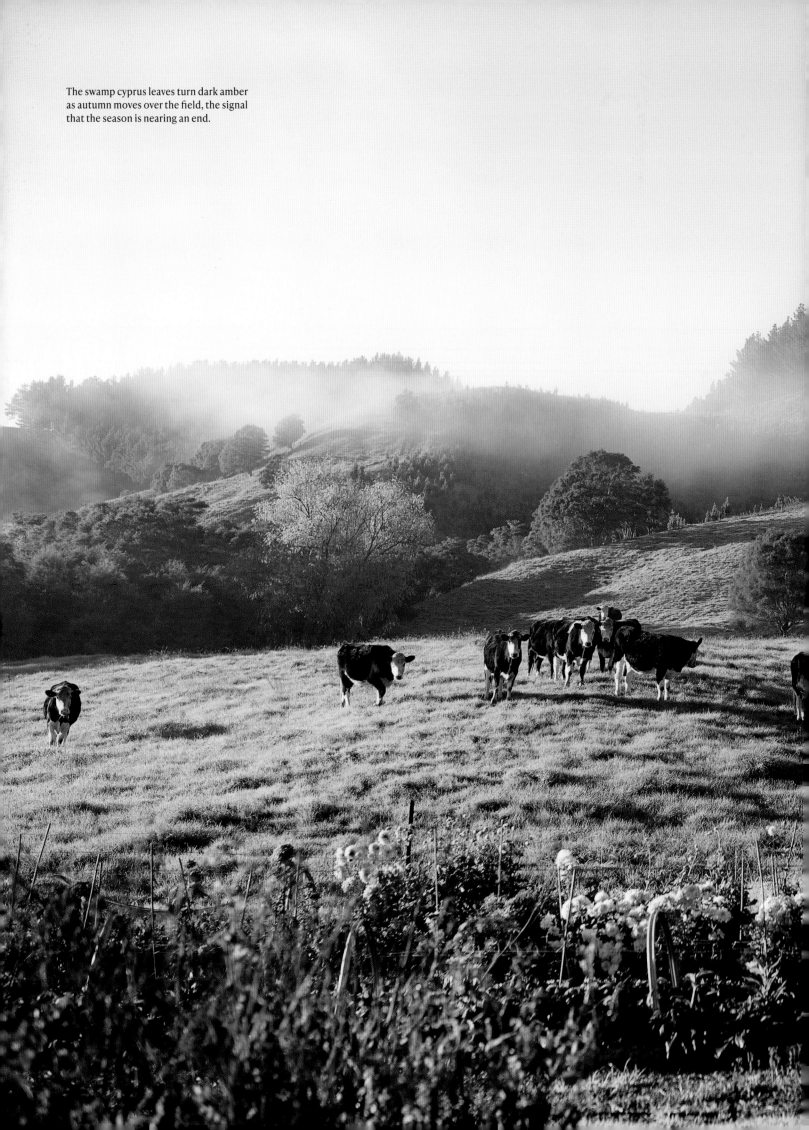

The swamp cyprus leaves turn dark amber as autumn moves over the field, the signal that the season is nearing an end.

ANSWERS

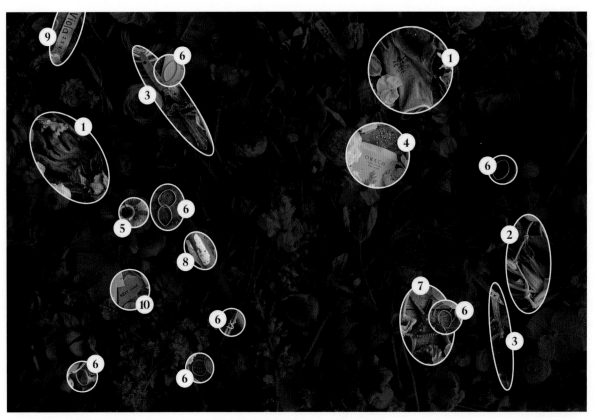

THE FLOWER FARMER

1. A PAIR OF MUDDY GLOVES **2.** A PIECE OF TWINE KNOTTED THREE TIMES **3.** TWO KNIVES
4. A SPILLED SEED PACKET **5.** FOUR DROPS OF DEW **6.** NINE RUBBER BANDS **7.** BROKEN SNIPS
8. A WORN-OUT LABEL **9.** A WOODEN TAG FROM A DATE LONG PASSED **10.** THE WORDS 'NEXT TIME'

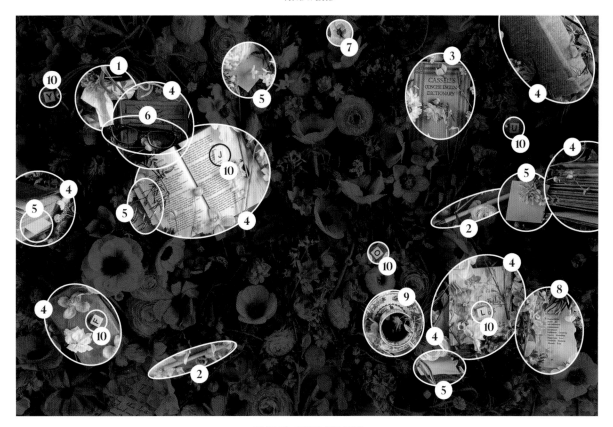

THE WRITER

1. CRUMPLED-UP PAPER **2.** TWO PENS **3.** A DICTIONARY **4.** EIGHT BOOKS **5.** FIVE POST-IT NOTES
6. READING GLASSES **7.** AN INK BLOT **8.** A PAGE TORN FROM A BOOK **9.** A COLD, FORGOTTEN CUP OF TEA
10. SIX UPPERCASE LETTERS THAT SPELL OUT A WORD ('JOYFUL')

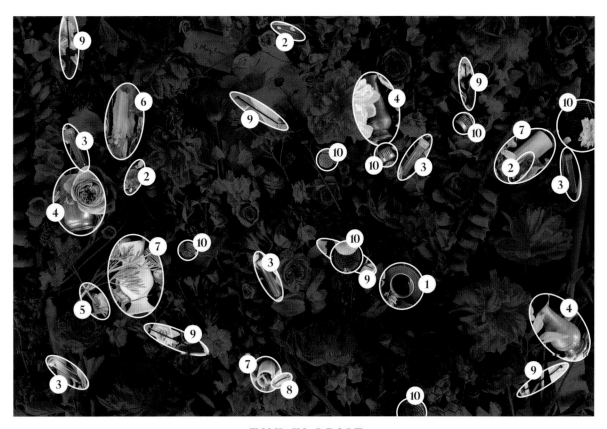

THE FLORIST

1. FLORISTRY TAPE **2.** THREE PEARL PINS **3.** FIVE WATER TUBES **4.** THREE BRASS VASES
5. WIRE WRAPPED ROUND A STEM **6.** A CANDLE HALF BURNT THROUGH **7.** THREE CERAMIC VASES
8. A BOBBY PIN **9.** SIX ZIP TIES **10.** SEVEN KENZAN (FLOWER FROGS)

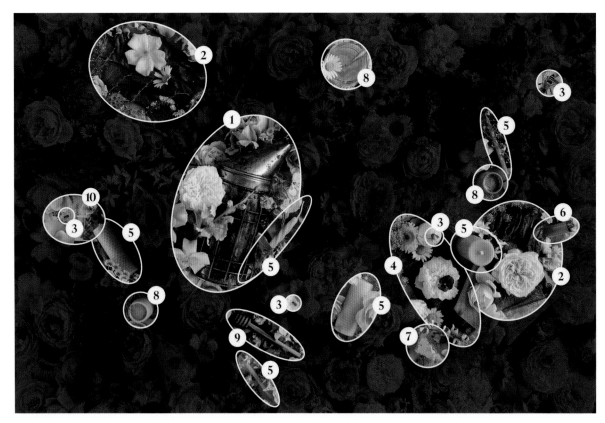

THE BEEKEEPER

1. A SMOKER **2.** A PAIR OF LEATHER GLOVES **3.** FOUR BEES **4.** A BRUSH
5. SIX BEESWAX CANDLES **6.** A LIGHTER **7.** FRESH HONEYCOMB **8.** THREE POTS OF HONEY
9. A DRIZZLER **10.** A PACKET OF 'HONEY BEE GARDEN' SEEDS

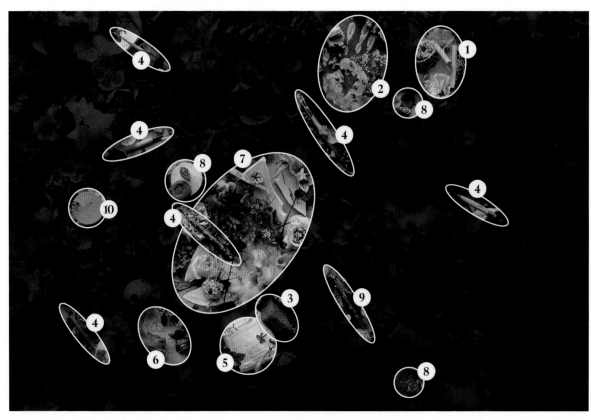

THE POTTER

1. A WIRE WITH TOGGLE ENDS **2.** A MUDDY HANDPRINT **3.** A SPONGE
4. SIX SCULPTING TOOLS WITH WOODEN HANDLES **5.** GLAZE **6.** A QUICK SKETCH
7. A BROKEN DISH **8.** THREE STAMPS **9.** A PENCIL **10.** THE MAKER'S MARK

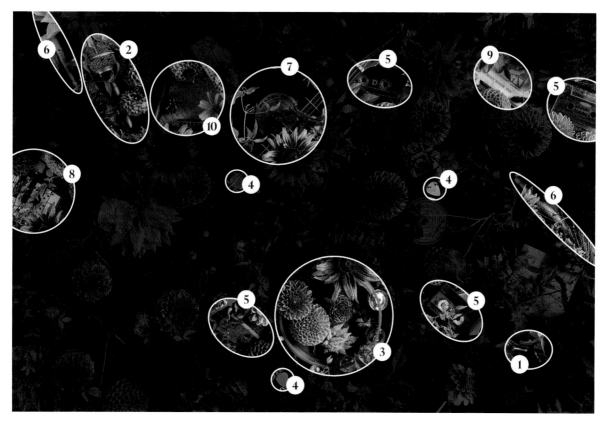

THE MUSICIAN

1. A HARMONICA ON A SET OF KEYS **2.** A MICROPHONE **3.** A TAMBOURINE
4. THREE GUITAR PICKS **5.** FOUR CASSETTE TAPES **6.** A PAIR OF DRUMSTICKS **7.** A GOLDEN RECORD
8. PIANO KEYS **9.** 'THE MINOR CHORDS' **10.** SCRIBBLED LYRICS

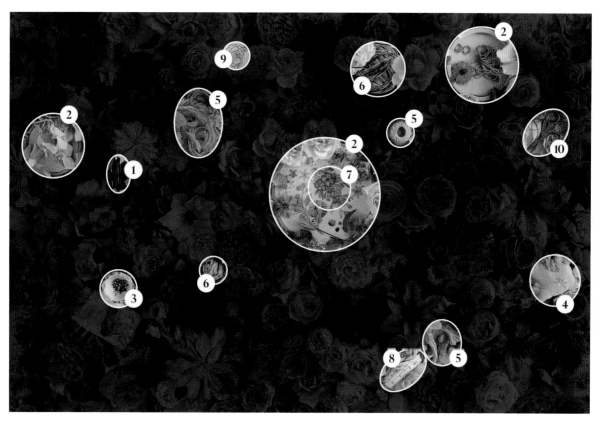

THE EMBROIDERER

1. FOUR NEEDLES **2.** THREE WOODEN HOOPS **3.** A BOWL OF BEADS **4.** A PINCUSHION
5. THREE YELLOW THREADS **6.** TWO BALLS OF YARN **7.** PINK EMBROIDERED FLOWERS
8. A MEASURING TAPE **9.** A SKETCH OF A ROSE **10.** SCISSORS

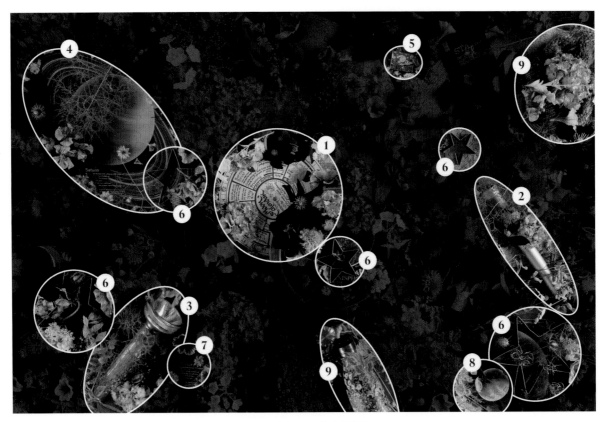

THE STARGAZER

1. A MOON CALENDAR **2.** A TELESCOPE **3.** A TORCH **4.** SATURN'S RINGS
5. VAN GOGH'S *STARRY NIGHT* **6.** FIVE STARS **7.** MERCURY **8.** NEPTUNE
9. A WOOLLEN BEANIE AND A THERMOS FOR COLD STARRY NIGHTS

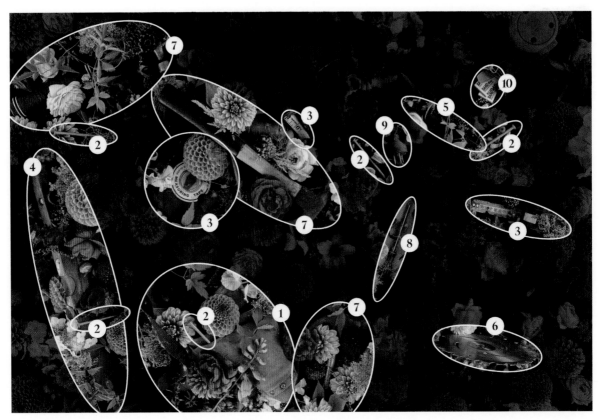

THE DIY-ER

1. A TOOL BELT **2.** FIVE NAILS **3.** THREE MEASURING TAPES **4.** A LEVEL
5. A PENCIL **6.** A SAW BLADE **7.** THREE HAMMERS **8.** A SCREWDRIVER
9. A PLUG **10.** SOME BAND-AIDS

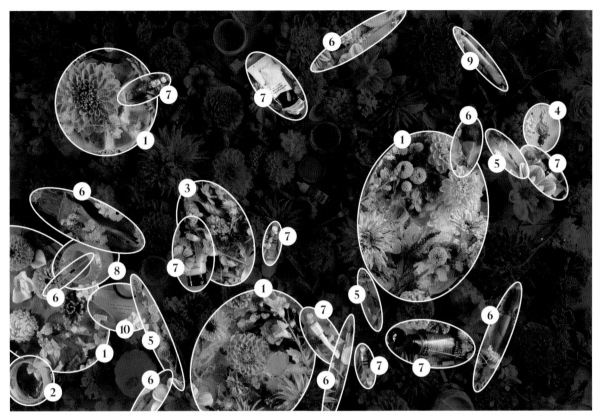

THE ARTIST

1. FOUR PAINT-COVERED PALETTES **2.** YELLOW MASKING TAPE **3.** A RAG **4.** TWO COLOURS MIXED TO MAKE A NEW ONE **5.** THREE PALETTE KNIVES **6.** SEVEN PAINT BRUSHES **7.** EIGHT PAINT TUBES **8.** A JAR OF WATER **9.** A PINK MARKER **10.** MONET'S QUOTE 'I MUST HAVE FLOWERS, ALWAYS, AND ALWAYS'

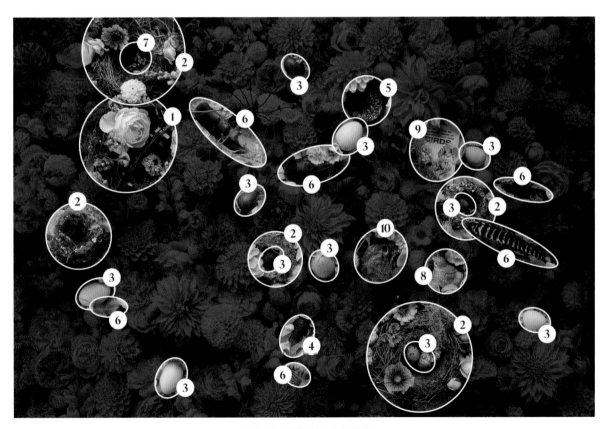

THE TWITCHER

1. BINOCULARS **2.** FIVE BIRD NESTS **3.** A DOZEN EGGS **4.** A KIWI **5.** BIRD SEED **6.** SIX FEATHERS **7.** A COLLECTION OF SHINY TREASURES **8.** A PORCELAIN BIRD **9.** AN ID BOOK **10.** A SNAIL SHELL GRAVEYARD

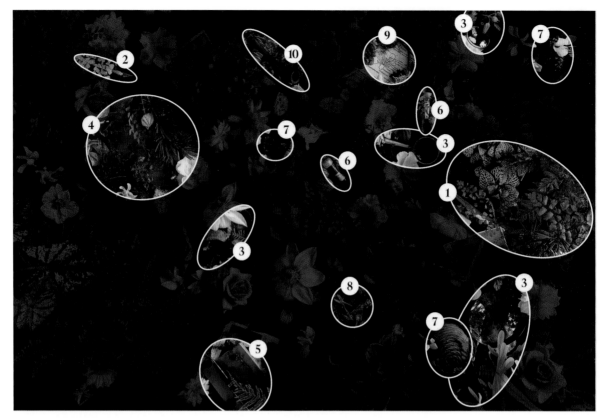

THE BOTANIST

1. A HIKING BOOT **2.** A SCALPEL **3.** FOUR MAGNIFYING GLASSES **4.** A PLANT PRESS
5. A NOTEBOOK **6.** TWO SOIL SAMPLES **7.** THREE VARIETIES OF TREE CONES
8. A POCKET TOOL **9.** ANATOMY OF A FLOWER **10.** GRANDPA'S PIPE

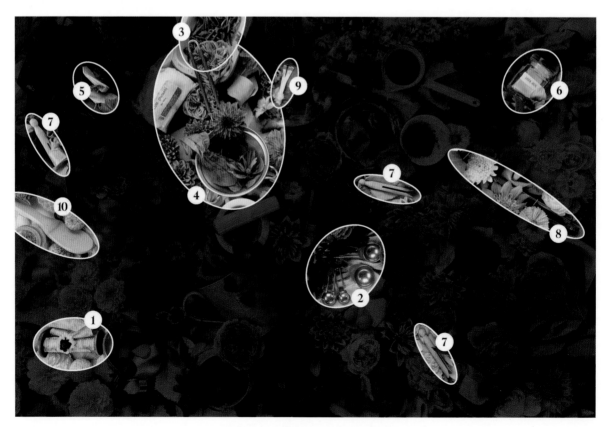

THE NATURAL DYER

1. A SPOOL OF SILK **2.** MEASURING SPOONS **3.** RUSTED NAILS
4. A SIEVE **5.** TEABAGS **6.** SODA ASH **7.** THREE CLOTHES PEGS **8.** TONGS
9. PH STRIPS **10.** A WOODEN SPOON

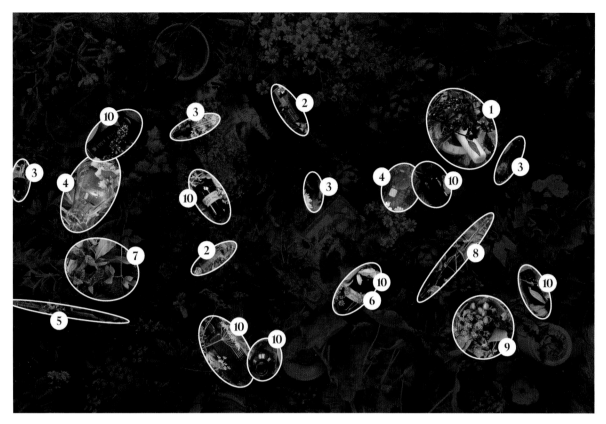

——————— THE HERBALIST ———————

1. A MORTAR AND PESTLE **2.** TWO SYRINGES FOR PRECISE MEASUREMENTS **3.** FOUR DROPPERS
4. TWO GLASS BEAKERS **5.** A THERMOMETER **6.** PRIMROSE OIL **7.** A KETE (WOVEN BASKET) FULL OF HERBS
8. A GLASS STIRRING ROD **9.** A BOWL OF DRIED ROSE BUDS **10.** SEVEN BROWN BOTTLES

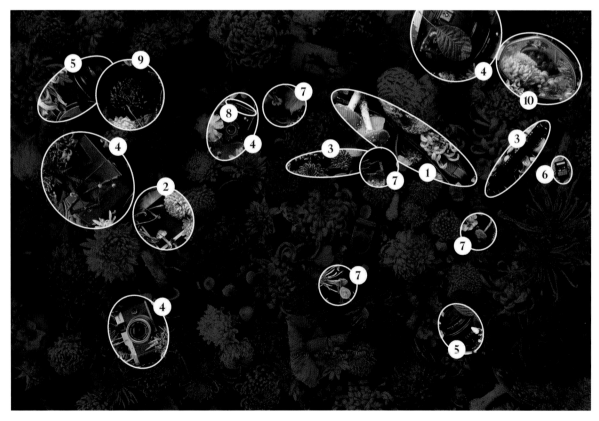

——————— THE PHOTOGRAPHER ———————

1. A CAMERA STRAP **2.** A POLAROID PHOTO **3.** TWO NEGATIVE STRIPS
4. FOUR CAMERAS **5.** TWO LENSES **6.** A MEMORY CARD **7.** FOUR LENS CAPS
8. A NAME ENGRAVED **9.** A PHOTO OF A FLOWER **10.** A CAPTURED REFLECTION

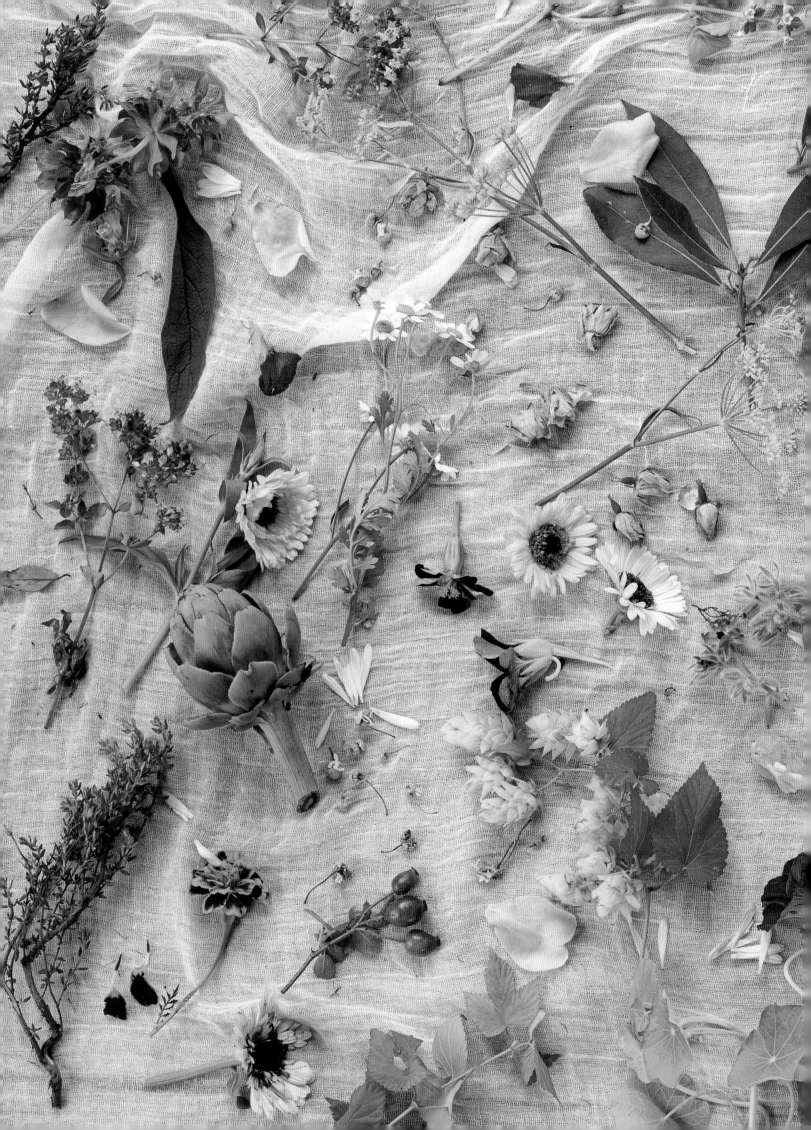

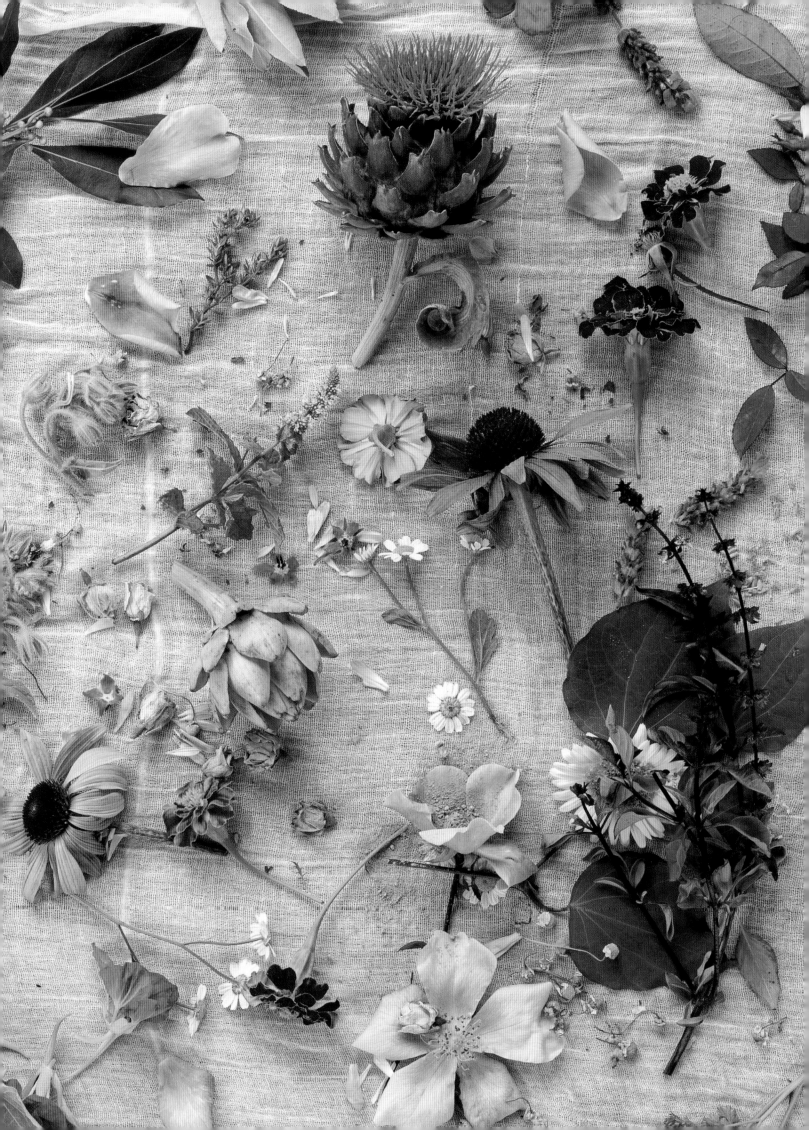

THANK YOU

Firstly a big thank you to Tonia Shuttleworth of Koa Press. You grew my idea for a book into something more beautiful than I ever could have envisioned – it has been a joy to work with you.

Julia Atkinson-Dunn, your gift of the written word gave voice to each of the characters, and you truly brought them to life. Thank you also for your enthusiasm as one of the first people I shared my idea with; your encouragement to reach out to Koa Press gave me the confidence to pursue this.

Mum, thank you for being the best wing lady to all my many ideas. You are the greatest encourager and most patient soundboard. No words come close to the gratitude I feel for having you by my side on this journey.

Thank you to the many other people who contributed to this book. Rhonda Haag, for so generously sharing your flower field and studio of treasures. I am so happy that our paths crossed in this flower world. Marion Clark: your eye for hidden treasures on second-hand shelves and lifetime collection of interesting and beautiful knick-knacks was a godsend. Thank you also to the Clement family, for your endless support throughout this project.

And to the many creatives who have crossed my path that helped inspire the pages:
Dale Coppin for her beekeeping tools; Phoebe Gander for letting me raid her art supplies; Fleur Woods for her beautiful embroidery kits that inspired the embroiderer's page; Erin Benzakein for all her encouragement (tucking her beautiful seed packets into the flower farmer's page was a small nod to all she has done for this community); Sarah Hawkless of Emerden, for helping me to indentify my many mislabeled dahlias and for sourcing and providing such an incredible range of plants for so many of us to enjoy in our own fields and gardens. Tanya Shaw, whose 'Oh Flora' vases are always my go-to; Rhonda, because the potter and natural dyer sections wouldn't be what they are without her archive of work from over the years; Dad, the DIY-er, thanks for the tools . . .
I think I put them all back.

Mum and I holding our favourite 'Golden Celebration' rose.

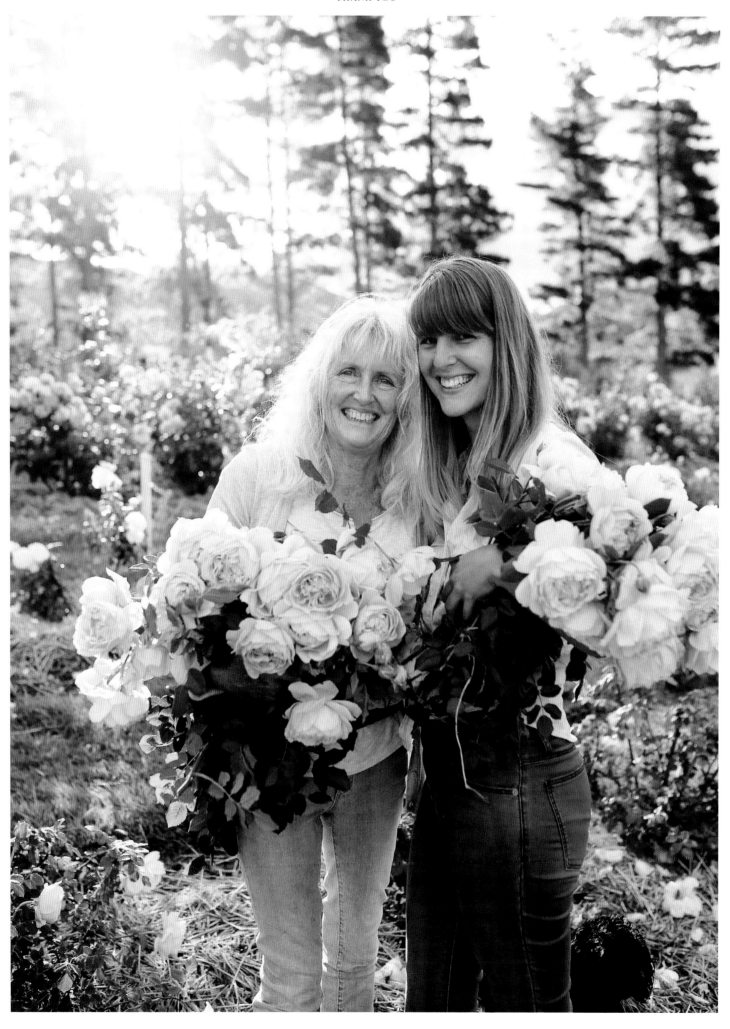

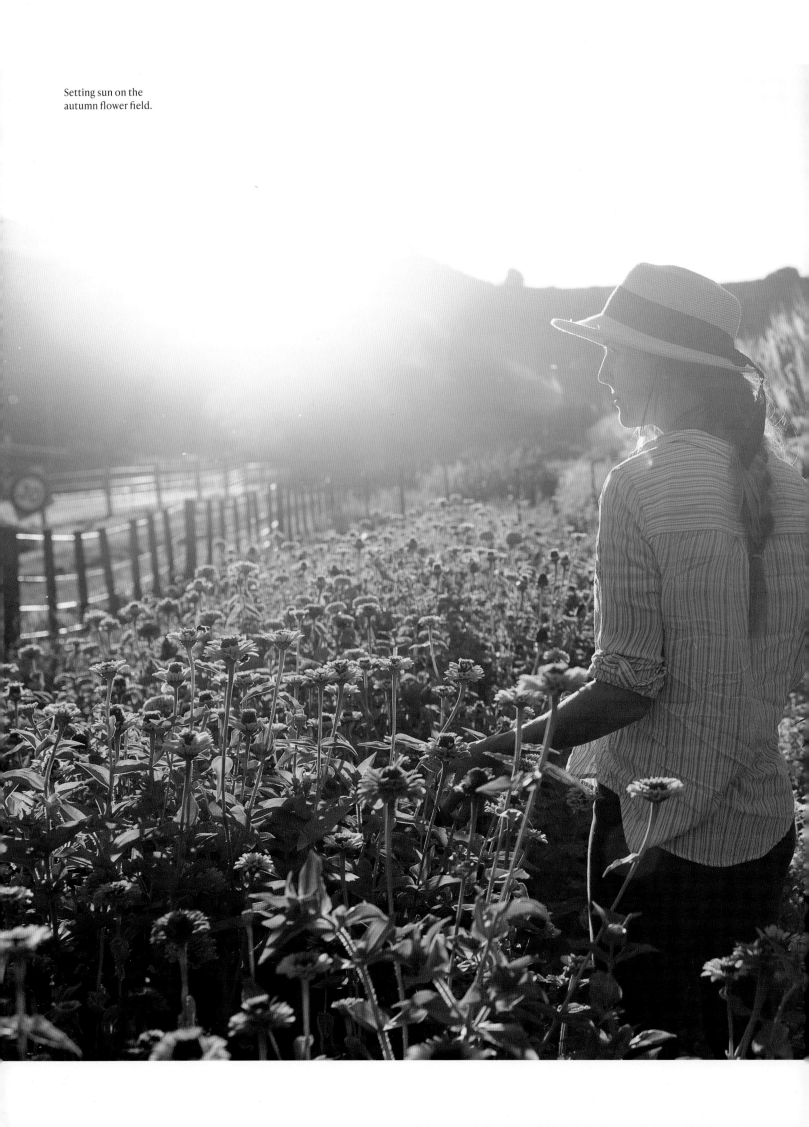

Setting sun on the
autumn flower field.

KOA PRESS

Published in 2022 by Koa Press Limited.
www.koapress.co.nz
@koapress

Lost & Found
ISBN: 978-0-473-63444-5

10 9 8 7 6 5 4 3 2

Publisher and Director: Tonia Shuttleworth
Editors: Zoë and Sue Field @field0froses
Writer: Julia Atkinson-Dunn @studiohomegardening
Photographer: Zöe Field, except page 5 © Zara Staples;
page 8 and 173 © Mandi Nelson
Sub-editor and proofreader: Tessa King
@tessaroseking_editorial
Designer: Tonia Shuttleworth

A catalogue record of this book is available from the National Library of New Zealand.

Printed and bound in China by 1010 Printing.

FSC
www.fsc.org

MIX
Paper | Supporting
responsible forestry
FSC® C016973